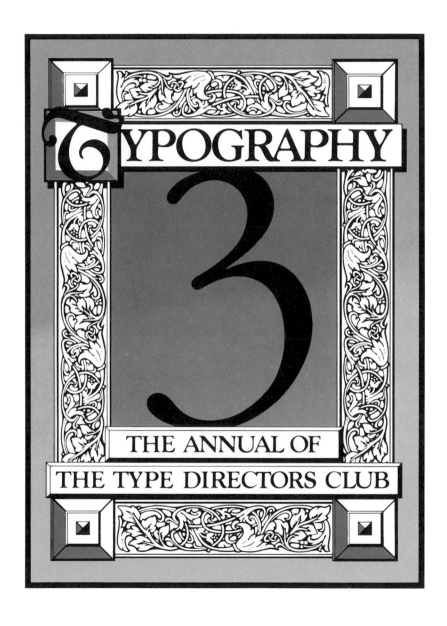

TYPOGRAPHY

3

THE ANNUAL OF
THE TYPE DIRECTORS CLUB

TYPOGRAPHY 3

The

Annual of

The Type Directors Club

Watson-Guptill

Publications

New York

ISBN 0-8230-5537-X
Manufactured in U.S.A.

❦

First Printing, 1982
1 2 3 4 5 6 7 8 9/89 88 87 86 85 84 83 82

❦

Distributed outside U.S.A. and Canada by

Fleetbooks, S.A.
% Feffer & Simons, Inc.
100 Park Avenue
New York, New York 10017

❦❦

Edited by Susan Davis
Art direction by Tom Carnase
Typography/Design by Joe Feigenbaum
Page layout by Brian Mercer
Graphic production by Hector Campbell
Photography by Spindler Slides
Composition by Trufont Typographers

❦❦

C O N T E N T S

JERRY SINGLETON,
the Executive Secretary of the
Type Directors Club for the
past 20 years, is going into well-deserved
retirement.

He is a man who has helped guide the Club
through some sunny and some rainy years.

He never lost his foresight, and he contributed
immeasurably toward achieving the success of
which the Club members are so proud.

And most of all, he is a man who has been
unselfish in his dedication to his job, to the
Club and to furthering knowledge of the
typographic arts.

The Type Directors Club dedicates
Typography 3 to him.

❦

CHAIRMAN'S STATEMENT

The eminent British typographer, Stanley Morison, taught us that "typography is the efficient means to an essentially utilitarian and only accidentally aesthetic end." In the classic sense, type should communicate and not necessarily interpret the contents. It should not call attention to itself.

Yet, it is a characteristic of our time that a well-designed printed piece is seldom a mere transport mechanism for information. Effective design has become a synthesis of logic, artistry, and commercial necessity. Typography has grown into a creative tool, frequently transcending established rules of readability. The rather ephemeral area of advertising and promotion was always a proving ground for typographic experimentation. The ubiquitous human desire to search for the new, to crave variety, is visualized here.

No jury awarding "Typographic Excellence" has an easy task. The TDC-28 judges conscientiously selected from the substantial and the ephemeral, the harmonic and the dynamic, the beautiful and the exciting.

Typography 3 mirrors modern typographic articulation. It shows the 26 letters of our alphabet in interesting and often innovative combinations.
We trust you will enjoy them.

Klaus F. Schmidt

**Klaus F. Schmidt
Chairman, TDC-28**

J U D

ANN BROWN
Director of Typography
Ogilvy & Mather
New York

*A*cknowledged
by her peers
to be one of those most
capable in the effective use of
type, Ann Brown brought to
the judging panel the
versatile experience that
comes at one of the world's
largest advertising agencies.
The print that Ogilvy
generates for its clients more
often than not bears witness
to Ann Brown's ability to
know well that which is
"Typographic Excellence."

TOM CARNASE
Designer/Calligrapher
President,
World Typeface Corp.
New York

*L*etterforms
by Tom Carnase
have brought him a
worldwide reputation for
creativity. The excellence of
his designs and the sheer
beauty of his hand work is
such that his "style" is
instantly recognized and, as a
corollary, constantly copied.
Carnase has art directed this
volume, *Typography 3*, and in
addition, has designed the
typeface used for its headlines
and dust jacket.

MARTIN FOX
Editor
Print magazine
New York

*P*rint
serves as a showcase for
the best material to come off
the presses of the nation's
graphics producers. As the
individual responsible for the
selection of what will be
featured monthly, Martin Fox
spends most of his days as an
untitled judge of excellence
in print. As a judge of
TDC-28 he found himself
sharing an experience in
graphic evaluation with a
diversified group, in effect,
substantiating his own
everyday activities.

G E S

MALCOLM GREAR
President and Art Director
Malcolm Grear Designers
Partner
Grear/Wissing Associates
Professor of Design
Rhode Island School of
Design
Providence

An
unusual combination, an individual not only able to produce graphics of prize-winning quality but also able to show others how they too can move toward such design accomplishment, Malcolm Grear brought to the panel of TDC 28 both theory and reality. His versatility of experience helped him select from among the entries that were rated on the degree to which they achieved the goal of "Typographic Excellence," the basic of such recognition.

ALLAN HALEY
Director,
Typographic Marketing
International Typeface
Corporation
New York

Understanding
the problems of today's type users and combining that with knowledge of how those problems are most effectively resolved were attributes that Allan Haley brought to the judging that selected the material reproduced in this volume. Good typography, he feels, comes from the application of the many components of a well-printed piece in such a way that the message is readily apparent.

JACK ODETTE
Vice President,
Communications Design
Citibank
New York

While
his shop produces as much, if not more, printed matter than any of the other members of the judging group, Jack Odette represented the "user." Citibank constantly needs material in order to deliver hundreds of messages to many audiences. Versatility there is the order of the day. In his capacity as a buyer but with the knowledge that can only come as a producer, Jack Odette focused on that which was outstanding in the display.

STANLEY MARKOCKI
Account Executive
Royal Composing Room
New York

Since
no one knows what may happen next, the TDC judging panel annually includes the chairman of the previous year's exhibit as an alternate. Stan Markocki, though his talents were not called upon, brought to this assignment wide experience gained as a major agency type director, as service representative of a quality printer, and as account executive for his present shop, which serves many major advertising agencies.

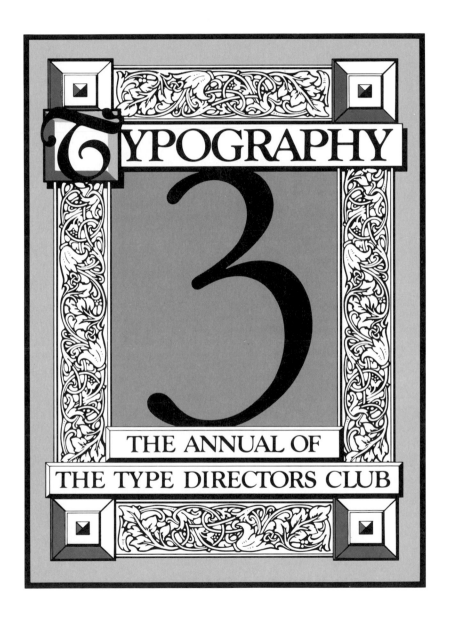

TYPOGRAPHY

3

THE ANNUAL OF
THE TYPE DIRECTORS CLUB

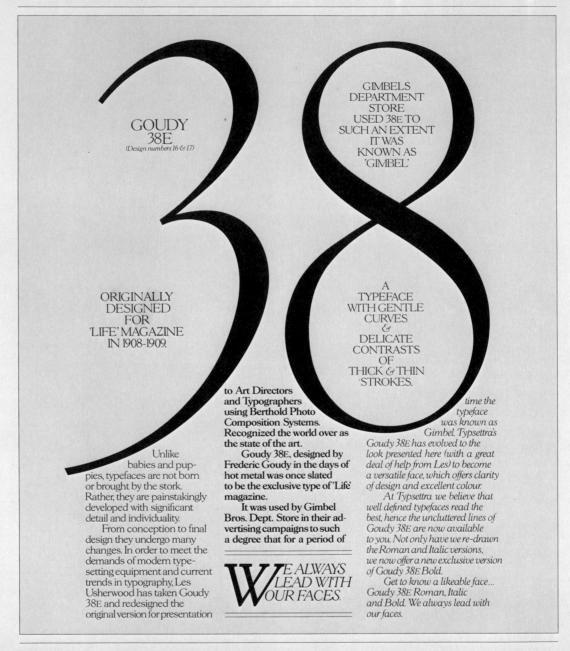

Typography/Design | Les Usherwood
Typographic Supplier/Client | Typsettra Ltd.
Principal Type | Goudy 38E
Dimensions | 14 x 19 in. (36 x 48 cm)

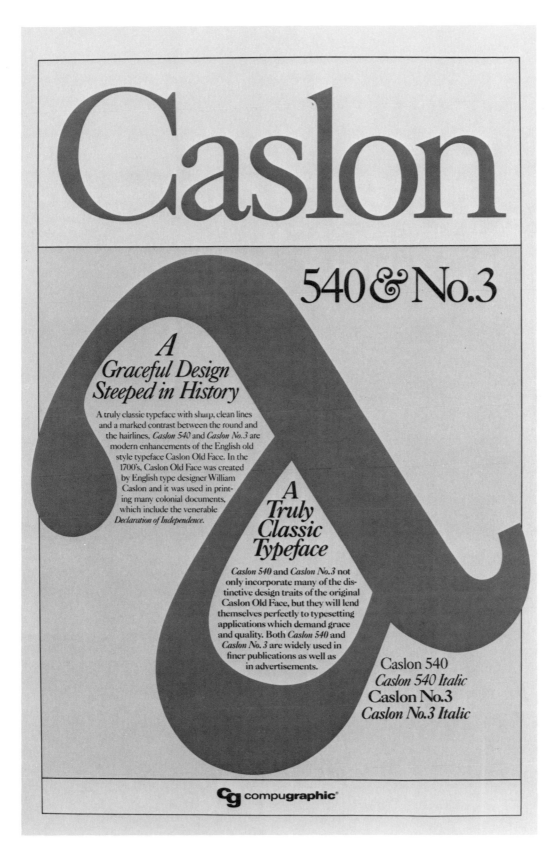

Caslon

540 & No.3

A Graceful Design Steeped in History

A truly classic typeface with sharp, clean lines and a marked contrast between the round and the hairlines, *Caslon 540* and *Caslon No.3* are modern enhancements of the English old style typeface Caslon Old Face. In the 1700's, Caslon Old Face was created by English type designer William Caslon and it was used in printing many colonial documents, which include the venerable *Declaration of Independence.*

A Truly Classic Typeface

Caslon 540 and *Caslon No.3* not only incorporate many of the distinctive design traits of the original Caslon Old Face, but they will lend themselves perfectly to typesetting applications which demand grace and quality. Both *Caslon 540* and *Caslon No. 3* are widely used in finer publications as well as in advertisements.

Caslon 540
Caslon 540 Italic
Caslon No.3
Caslon No.3 Italic

Cg compugraphic®

Typography/Design	Norbert Florendo
Typographic Supplier/Client	Compugraphic Corporation
Principal Type	Caslon 540/No. 3
Dimensions	11 x 17 in. (28 x 43 cm)

F R A G A

UMA FÁBULA REAL

Conta a lenda que um dia o rei de um reino como qualquer outro acordou, chamou os sábios como era seu hábito e consultou-se sobre a situação.

– Como está a situação?, berrou o rei na penumbra.

– Tudo bem, responderam os sábios em coro.

– Detalhes, quero detalhes!, gritou o rei na semi-escuridão.

– Os sábios então pegaram seus gráficos, estatísticas e outras referências e calcularam os índices, a cor, o peso, as medidas e o tamanho da situação. Concluíram pelo otimismo.

– Majestade, a situação é límpida, clara, leve e ampla.

– O rei resmungou qualquer coisa a respeito das cortinas fechadas e ordenou que abrissem as cortinas imediatamente, porque de mesmo queria conferir os dados dados.

Os sábios então fecharam as cortinas silenciosamente e depois abriram as cortinas ruidosamente.

– Não enxergo nada!, reclamou o rei.

– A luz está sob controle, Majestade, falaram os sábios ao mesmo tempo.

Com a luz sob controle o rei ficou satisfeito e demitiu de olhar as informações. Mas quis saber a quantas ia a situação lá fora.

– Selem o Povo, mandou o rei.

Selaram o Povo. E o rei montou no Povo e foi ver a quantas andava a situação no seu reino.

Esbarrando em tudo, tropeçando em todos, o rei chegou ao pátio do castelo.

Então o rei fez perguntas aos vultos que se mexiam nas trevas.

– Como é que está a situação?

– Está preta!, berrou a multidão de vultos que se mexiam nas trevas.

O rei não indagou duas vezes. Chamou os sábios.

– Eles dizem que a situação está preta. Como é que é isso?

Os sábios acenderam archotes e mais archotes em pleno dia e mostraram ao rei como tudo estava bem.

O rei se acalmou e seguiu adiante, sempre perguntando coisas para seus súditos.

– O que vocês acham da situação?

– Inusustentável, esclareceu a multidão de vultos escuros ao redor do rei.

O rei insistiu com os sábios.

– Que quer dizer "inusustentável"?

– Nada, Majestade. Significa que não sustentarão essa afirmativa perante a guilhotina.

O rei assentiu e continuou o passeio pela noite eterna do seu reinado.

Aí o rei chamou todos os súditos e falou que queria a sinceridade de todo mundo ali presente. Que dissessem, honestamente, como estava a situação.

Os súditos escolheram um representante para falar de perto ao seu rei.

On súditos, ao ouvirem aquilo, se apresuraram em desmentir o representante dos súditos.

– Majestade, garantimos que tudo está bem, a visibilidade é ótima e o sol está no zênite. Pode ficar tranquilo, Majestade.

– Mas o meu súdito afirma que a situação está preta. Todos dizem isso!

– Não sabem o que dizem, Majestade. A situação apresenta-se maravilhosa.

Diante de tão fortes argumentos, o rei decidiu encerrar o passeio e voltou ao castelo.

E seguiu por um túnel para chegar até ao palácio.

– E a luz no fim do túnel?

– Sob controle, Majestade.

E seguia a comitiva dos sábios, tateando, tateando.

E no escuro pensaram que bela idéia tinha sido cegar o rei para confundi-lo. A situação não podia ser melhor. Para eles.

Moral: Quando a situação está azul como breu pode custar os olhos da cara de qualquer um.

Fraga

Chamado Fraga, um mais famoso como ilustrador de Luiz Fernando Veríssimo. Gaúcho também, ganhou coluna própria na "Folha da Manhã" de Porto Alegre. Publicitário, trocou a MPM dos Pampas pela GPM-Propeg de Salvador, onde passou o último ano. Mas já está de volta à terrinha, onde lança no meio deste ano seu primeiro livro, "Parodos Venceremos".

F R A G A

Ilustração: Oswaldo Miranda (Miran)

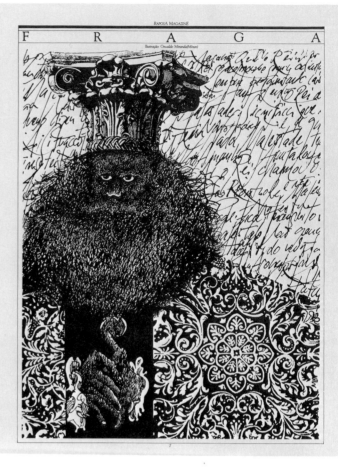

Typography/Design/Calligraphy	Oswaldo Miranda (Miran)
Typographic Supplier	Digital
Studio	Miran Studio
Client	*Raposa* newspaper
Principal Type	Heads: Goudy Old Style Body: Press Roman Italic
Dimensions	21¼ x 13⅜ in. (54 x 34 cm)

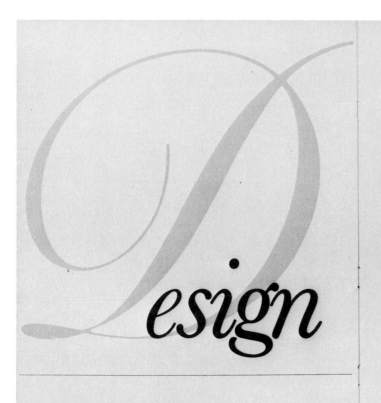

CONSIDERATIONS

Silkscreening: Avoid typefaces with exaggerated thick and thin strokes. Sans serif faces or any types with evenly weighted strokes are preferable for this method of reproduction. Letter-spacing should be normal to open.

It is a good idea to let us know whenever type is to be used for silkscreening. We can advise you of the suitability of the typeface for silkscreening as well as take the process into consideration when setting. If desired, we can provide you with a film positive for the silkscreener (right-reading, emulsion down unless you specify otherwise).

Engraving: When engravings are to be made from phototype, letterspacing should be normal to slightly open. Avoid thin typefaces or typefaces with exaggerated thick and thin strokes. If desired, we can provide a film negative for the engraver (right-reading, emulsion up).

Slides: Provide 300% layouts for 35mm slides, same-size layouts for 8 x 10 overheads or other formats. Use a minimal number of type sizes for continuity. If possible, indicate line breaks. For slides that "build" on the screen, simply type the entire finished slide, then bracket the line or lines that appear in each slide and number each group of lines as they appear on the screen (usually top to bottom). Note at top of copy sheet "build as indicated for a total of X number of slides."

In addition to setting the type, we can provide you with mounted 35mm black and white or color slides. When asked to provide finished slides on any large typesetting jobs, we normally recommend that you approve checking proofs first.

If there is any doubt as to the quantity of each slide required, order extras. Duplicate slides made on the same set-up are cheap insurance against the time and expense involved with shooting another set at a later date, particularly on color work. As a relatively inexpensive precaution, you might consider ordering one or two extra sets "unmounted." This saves the price of mounting if the extra slides are not needed.

TV Titles: Avoid script, calligraphic and similar ornamental faces. Avoid moderns such as Bodoni—the thin horizontal strokes will be obliterated by the lines which form the image on the TV screen. Thin or light faces should not be used for the same reason. Sans serif typefaces in medium to bold weights are ideal.

Leading should be not less than 25% nor more than 100% of the cap height of the type used.

Always advise us when ordering type for TV, since it must be letterspaced fairly "open." For this type of work, we will only touch letter combinations when absolutely necessary, and only if it will not interfere with readability. An "AI" combination can touch and each letter is easily identifiable. If a cap "L" were to touch a cap "I" following it, the viewer would see what would appear to be a cap "U" instead of the "LI" combination. In letterspacing the type, our primary concern is usually opening up all of the vertical combinations for maximum legibility.

Be sure to indicate the kinds of proofs required, and any special positioning of the type on the proof. If desired, we can supply matte reverses for TV supers.

TV TV

Typography/Design	Harold Burch
Typographic Supplier/Client	Aldus Type Studio, Ltd.
Agency	Ken White Design Office, Inc.
Principal Type	Bodoni Book
Dimensions	8½ x 11 in. (22 x 28 cm)

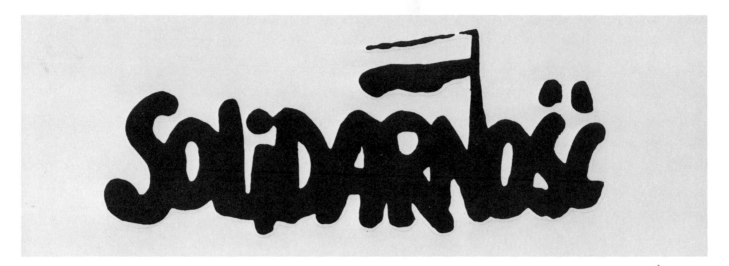

Design/Calligraphy | Anonymous
Client | Committee in Support of Solidarity,
Solidarity Union, Gdansk

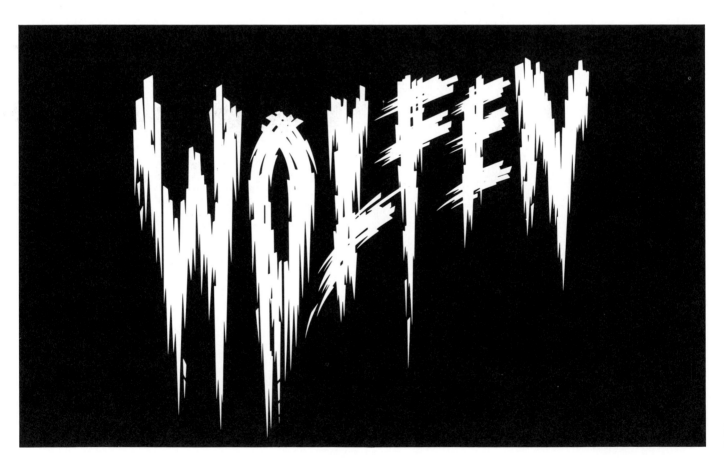

Design | Richard Greenberg
Calligraphy | Michael Doret
Studio | Michael Doret, Inc.
Client | Warner Brothers

16

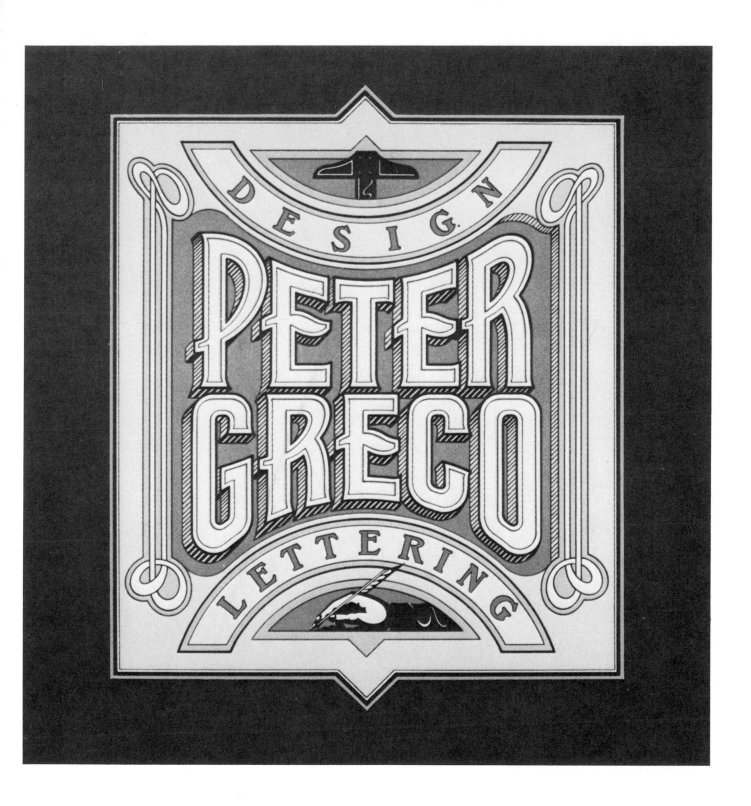

Typography/Design/	
Calligraphy	Peter Greco
Studio/Client	Peter Greco Lettering • Design
Dimensions	3⅞ x 4⅜ in. (10 x 11 cm)

17

Typography/Design	Thom LaPerle
Typographic Supplier	Spartan
Agency	La Perle/Assoc.
Client	California Printing Company
Principal Type	Garamond Book
Dimensions	20 x 15 in. (51 x 38 cm)

18

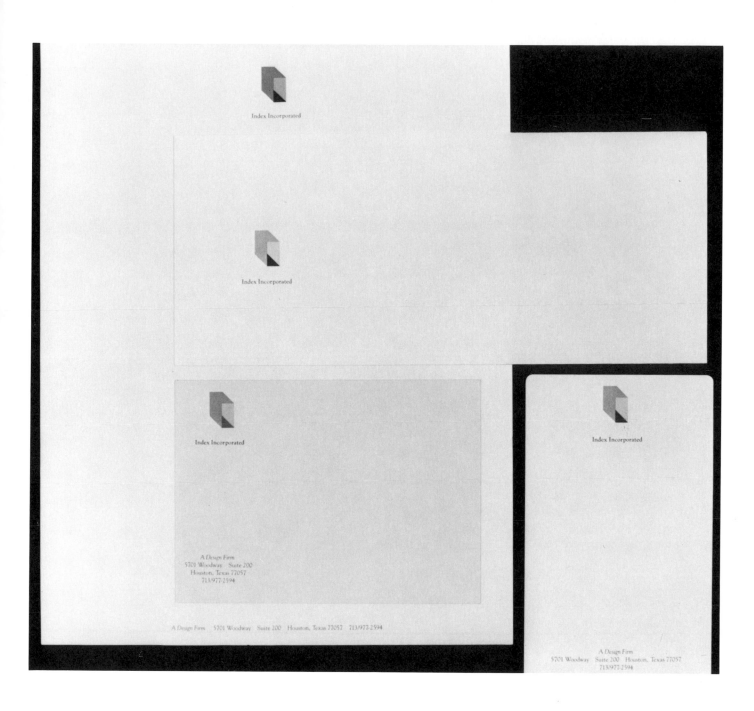

Typography/Design	Warren Moeckel/Glenn Kroepil
Typographic Supplier	Typeworks, Inc. (Houston)
Calligraphy	Glenn Kroepil
Studio	Intergraphic Design Inc.
Client	Index Inc.
Principal Type	Goudy Old Style Italic
Dimensions	8½ x 11 in. (22 x 28 cm)

CBS
REPORTS:
THE
DEFENSE
OF THE
UNITED
STATES
JUNE 14,15,16,17,18,1981
◉CBS NEWS

Typography/Design	David November/ Marie-Christine Lawrence
Studio	CBS Entertainment Promotion
Client	CBS News
Principal Type	Heads: Compacta Bold Body: ITC Cheltenham
Dimensions	8¾ x 10¾ in. (22 x 27 cm)

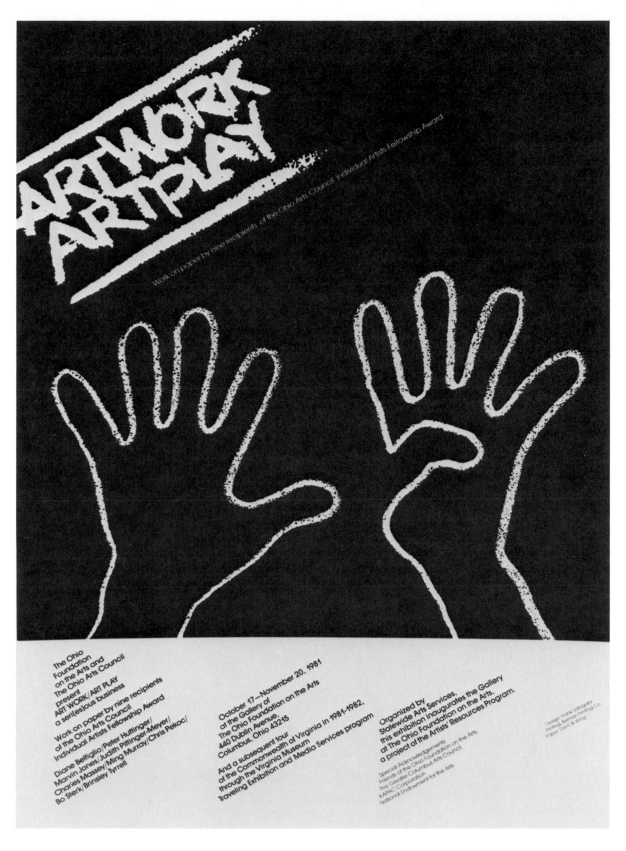

Typography/Design/	
Calligraphy	Frank Satogata
Typographic Supplier	Typoset
Studio	Conceptual Graphics
Client	Ohio Arts Council
Principal Type	Avant Garde
Dimensions	18 x 24 in. (46 x 61 cm)

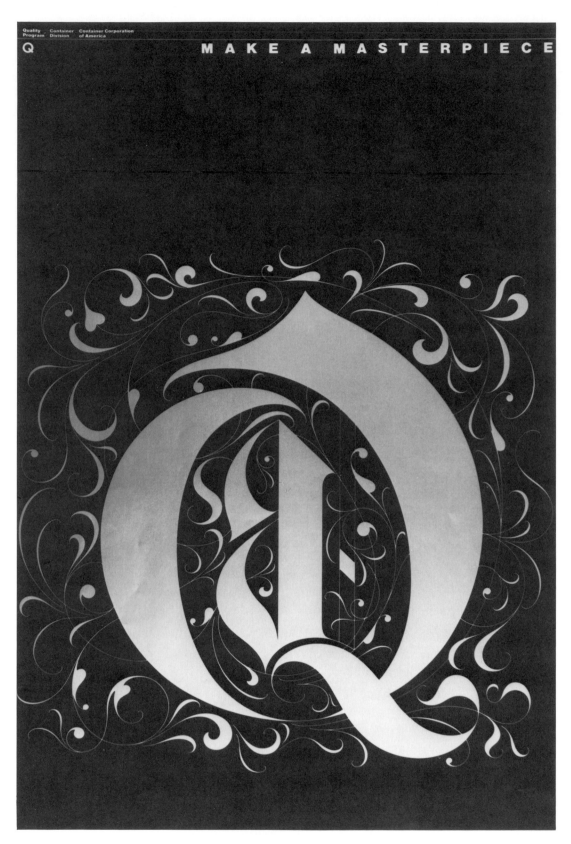

MAKE A MASTERPIECE

Typography/Design	Jeff Barnes
Typographic Supplier	RyderTypes
Calligraphy	Tony DiSpigna
Studio	CCA Communications
Client	CCA Container Division
Principal Type	Helvetica Bold
Dimensions	25 x 38 in. (64 x 97 cm)

22

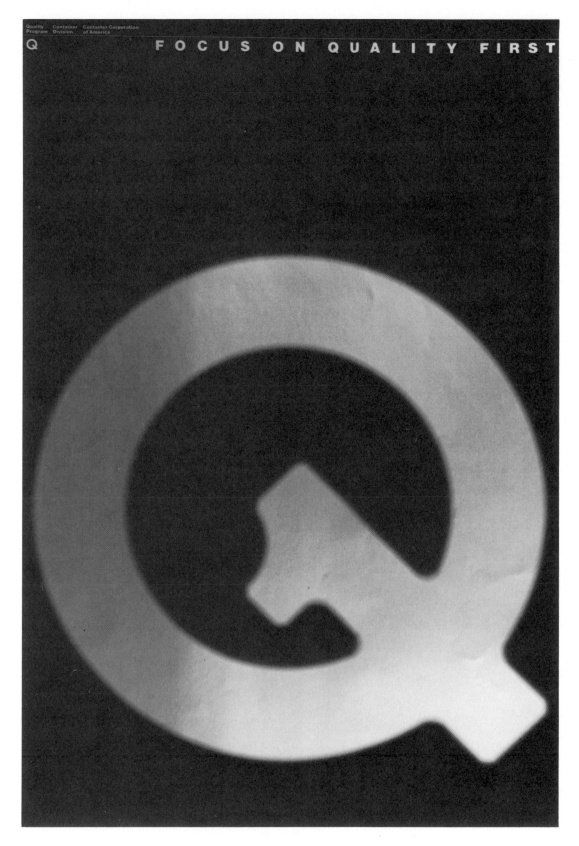

Typography/Design	Jeff Barnes
Typographic Supplier	RyderTypes
Studio	CCA Communications
Client	CCA Container Division
Principal Type	Helvetica Bold
Dimensions	25 x 38 in. (64 x 97 cm)

23

The Boston Globe Magazine

August 23, 1981

Can this man save public housing?

The Boston Housing Authority's Harry Spence

Also
Survivalists: Getting ready for the end

Typography/Design	Ronn Campisi
Typographic Supplier	Headliners/Boston
Client	*The Boston Globe Magazine*
Principal Type	Franklin/Clarendon
Dimensions	10¾ x 12½ in. (27 x 32 cm)

The Boston Globe Magazine

June 21, 1981

WITNESS TO OUR TIME: Alfred Eisenstaedt has photographed Hitler meeting Mussolini, Thomas Mann, Joseph Goebbels, Günter Grass, Hedy Lamarr, Rainer Werner Fassbinder, the Great Depression, Leni Riefenstahl, John F. Kennedy, Sophia Loren, George Bernard Shaw, Igor Stravinsky, Vladimir Horowitz, Joseph Stalin, Hiroshima, Yehudi Menuhin, Bing Crosby, Joan Crawford, Fred Astaire, Marilyn Monroe, Tallulah Bankhead, Katharine Hepburn, Lyndon Baines Johnson, Henry Kissinger, Marlon Brando, Charlie Chaplin, Richard Nixon, Nikita Khrushchev, Winston Churchill, W. H. Auden, Robert Frost, T. S. Eliot, Charles Lindbergh, Harry Truman, Franklin Delano Roosevelt, Ernest Hemingway, Bertrand Russell, Ronald Reagan's ranch, V-J Day, Albert Einstein, Alec Guinness, the eyes of Edward Teller, Sinclair Lewis, James Cagney, General Douglas MacArthur, Jomo Kenyatta, Fidel Castro, Clare Boothe Luce, Harold Macmillan, Mikhail Baryshnikov, the Blue Nile Falls in Ethiopia, Rachel Carson, Salvador Dali, Judy Garland, Judge Learned Hand, Dwight D. Eisenhower, General Hideki Tojo, Shirley Temple, Clement Attlee, Queen Elizabeth II, Thornton Wilder, Nelson Rockefeller, Walt Disney, Josephine Baker, the Graf Zeppelin, General George C. Marshall, Dame Edith Evans, Andrew Wyeth, Paul Dudley White, Edward R. Murrow, Leonard Bernstein, Dag Hammarskjöld, Adlai Stevenson, Arthur Rubinstein ...

Typography/Design	Ronn Campisi
Typographic Supplier	Headliners/Boston
Client	*The Boston Globe Magazine*
Principal Type	Venus Extended/Century
Dimensions	10¼ x 12½ in. (27 x 32 cm)

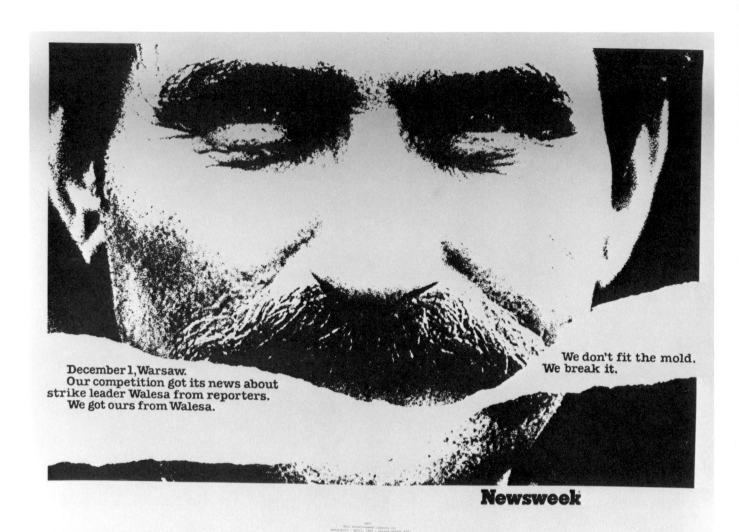

December 1, Warsaw.
Our competition got its news about
strike leader Walesa from reporters.
We got ours from Walesa.

We don't fit the mold.
We break it.

Newsweek

Typography	Julie Silverman
Design	Hector Robledo
Typographic Supplier	Typovision Plus
Agency	Foote Cone & Belding, New York
Client	*Newsweek*
Principal Type	American Typewriter Bold
Dimensions	30¼ x 21¼ in. (77 x 54 cm)

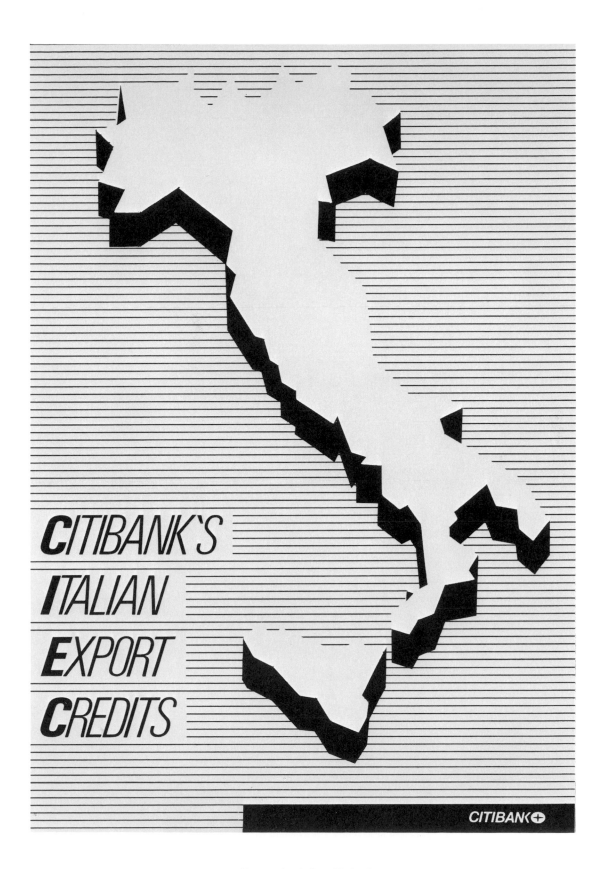

CITIBANK'S
ITALIAN
EXPORT
CREDITS

CITIBANK

Typography	Steve Hodowsky
Design	Jack Odette
Typographic Supplier	Cardinal Type Service
Studios	Citibank/
	Communication Design/LEAG
Client	Citibank Italy,
	Export Credit Unit
Principal Type	Univers
Dimensions	7½ x 11 in. (19 x 28 cm)

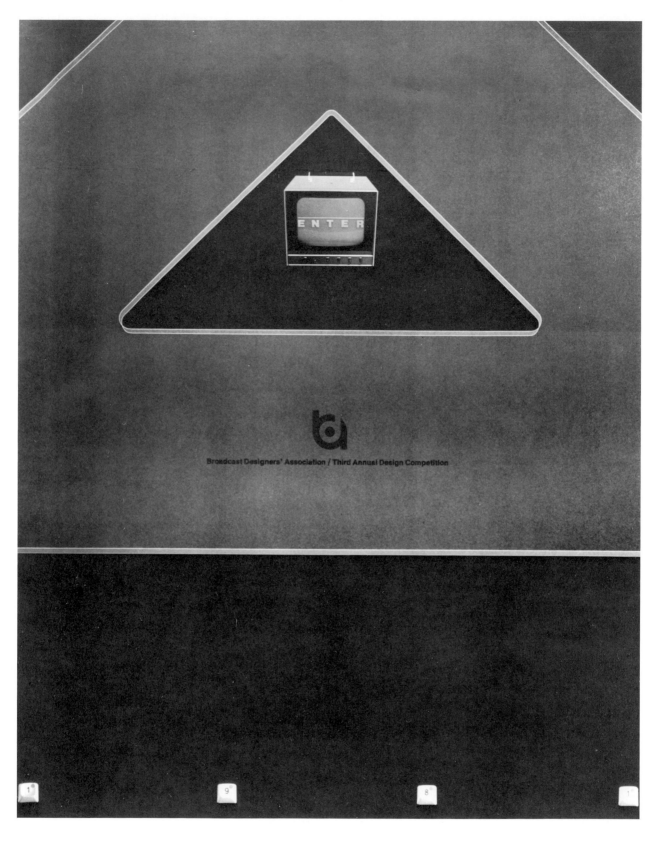

Typography/Design	James A. Houff/Susan Hodgin
Typographic Supplier	WDIV/TV, Detroit
Studio	WDIV/TV, Design Department
Client	Broadcast Designers Association
Principal Type	Helvetica
Dimensions	21 x 27 in. (53 x 69 cm)

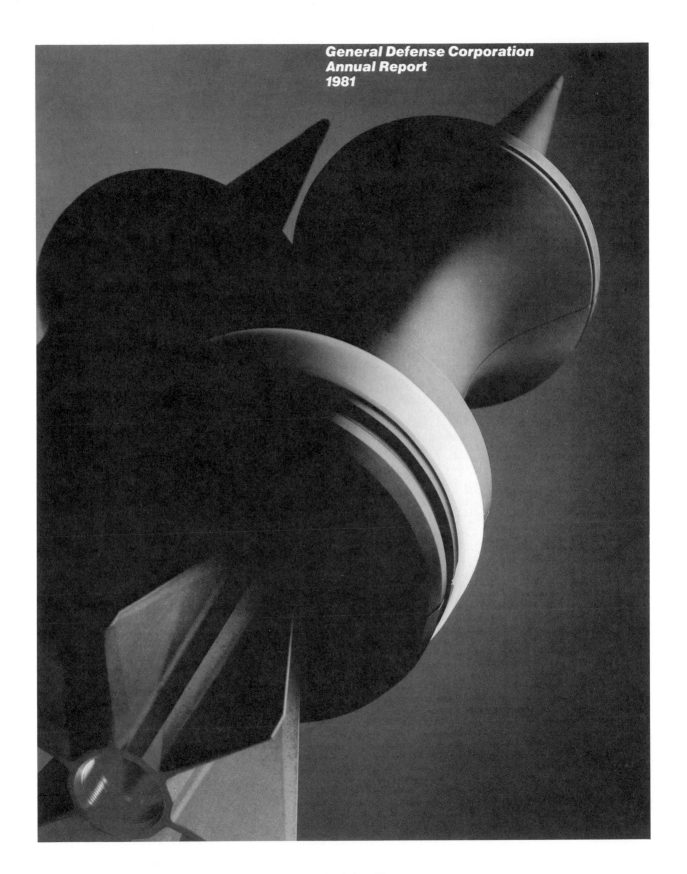

General Defense Corporation
Annual Report
1981

Typography	Russ Tatro
Design	Jack Hough
Typographic Supplier	Lettick Typographic, Inc.
Agency	Jack Hough Associates, Inc.
Client	General Defense Corporation
Principal Type	Helvetica
Dimensions	8½ x 11 in. (22 x 28 cm)

BATH
IRON WORKS

We are an historic shipbuilder,
renowned for turning out ships
under budget and ahead of
schedule. But instead of talking
about ourselves, let's show
you what others have to
say about us.

Typography/Design	Marilyn G. Lurie
Typographic Supplier	Typeworks, Inc., Chicago
Agency	Burson·Marsteller
	Design Group
Client	Bath Iron Works
Principal Type	Caledonia
Dimensions	6¼ x 11¼ in. (16 x 29 cm)

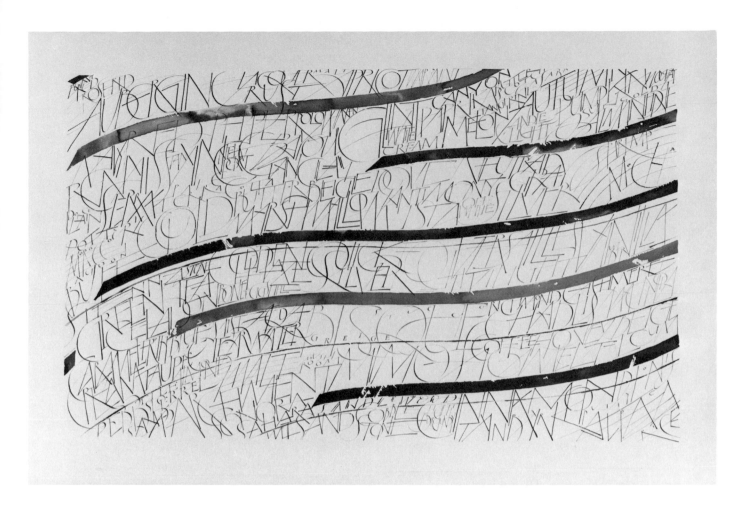

Typography	Russ Hirth
Design/Calligraphy	Tim Girvin
Agency	Carr Liggett
Client	B.F. Goodrich
Dimensions	37 x 24 in. (94 x 61 cm)

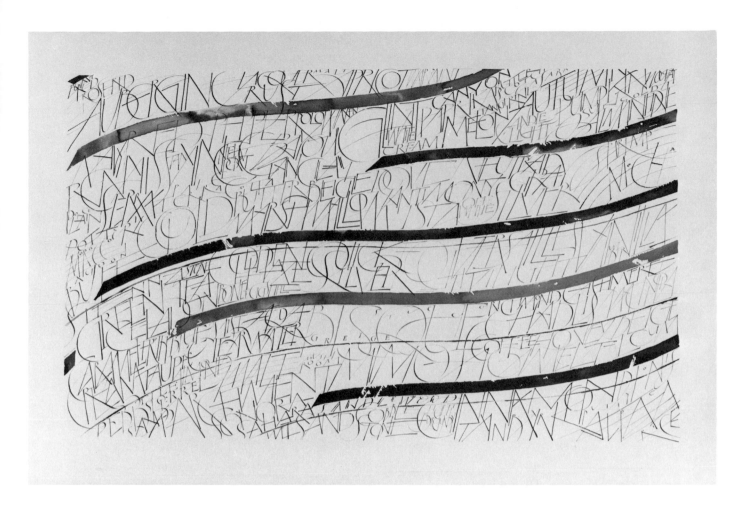

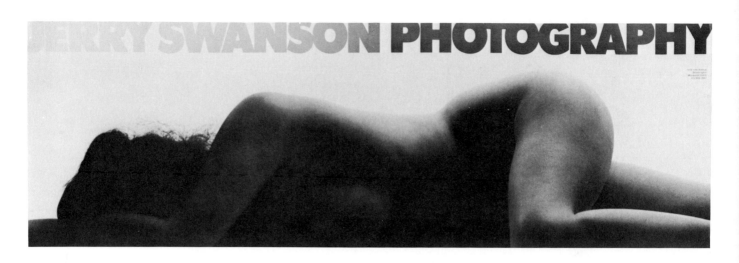

Typography	Sheila Chin
Design	Richard Krogstad
Typographic Supplier	Alphagraphics One
Studio	Gulick & Henry, Inc.
Client	Jerry Swanson Photography
Principal Type	Heads: Futura Extra Bold Body: Helvetica
Dimensions	36 x 12 in. (91 x 31 cm)

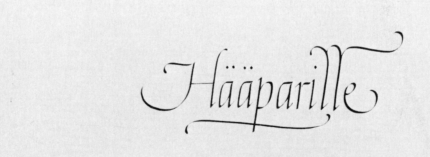

Typography/Design/ Calligraphy	Erkki Ruuhinen
Studio	Anderson & Lembke Oy, Helsinki
Dimensions	11⅝ x 8⅛ in. (29.5 x 21 cm)

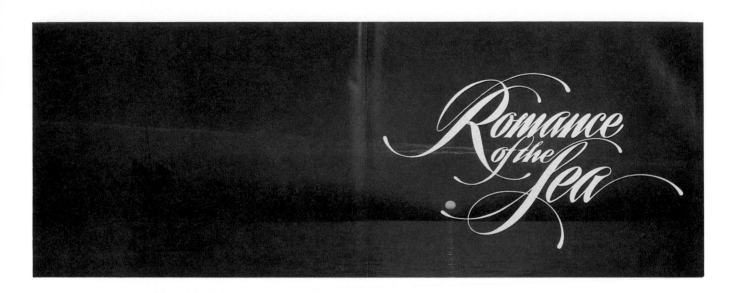

Design | David M. Seager
Typographic Supplier | National Geographic
| Photographic Services
Calligraphy | Terry Dale
Client | National Geographic Society
Principal Type | Garamond
Dimensions | 13¾ x 10½ in. (35 x 27 cm)

Typography/Design	Jacqueline S. Casey
Typographic Supplier	Typographic House
Studio	MIT Design Services
Client	MIT, Committee on the Visual Arts
Principal Type	Helvetica
Dimensions	21½ x 29¾ in. (55 x 76 cm)

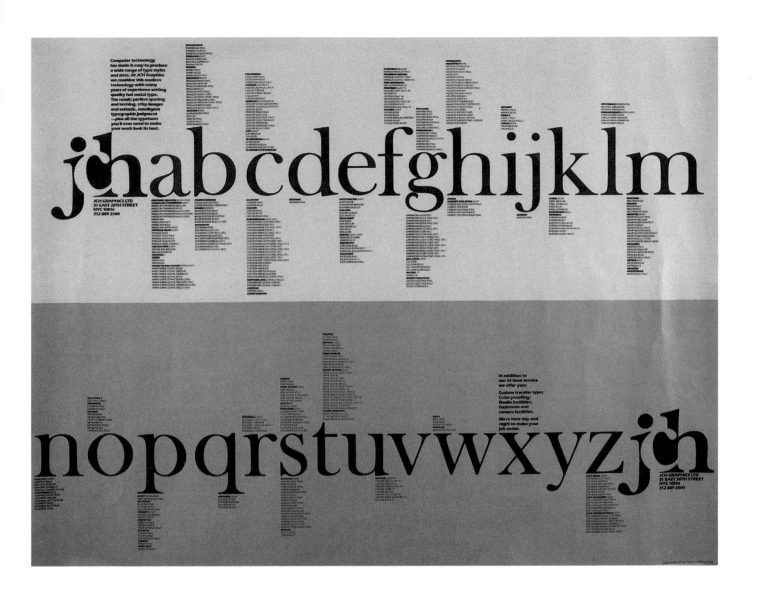

Design	Herbert M Rosenthal
Typographic Supplier/	
Client	JCH Graphics Ltd.
Studio	Your Corporate Look
Principal Type	Heads: Baskerville
	Body: Eras
Dimensions	32½ x 25 in. (83 x 64 cm)

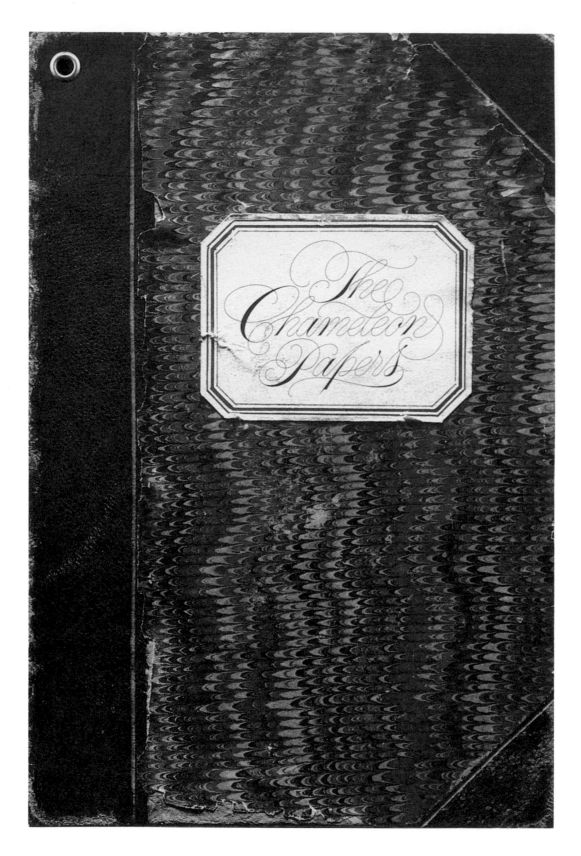

Typography/Design	Bruce McIntosh/
	Robert Cipriani
Typographic Suppliers	Typographic House/
	Stationers Engravers
Calligraphy	Tony DiSpigna
Agency	Robert Cipriani Associates
Client	Monadnock Paper Mills Inc.
Dimensions	6 x 9 in. (15 x 23 cm)

THE COUNTRY MOUSE AND
THE CITY MOUSE

An honest, plain, sensible Country Mouse invited her city friend for a visit. When the City Mouse arrived, the Country Mouse opened her heart and hearth in honor of her old friend. There was not a morsel that she did not bring forth out of her larder—peas and barley, cheese parings and nuts—hoping by quantity to make up for what she feared was wanting in quality, eating nothing herself, lest her guest should not have enough. The City Mouse, condescending to pick a bit here and a bit there, at length exclaimed, "My dear, please let me speak freely to you. How can you endure the dullness of your life here, with nothing but woods and meadows, mountains and brooks about? You can't really prefer these empty fields to streets teeming with carriages and men! Do you not long for the conversation of

Design	Barbara G. Hennessy
Typographic Supplier	A. Colish
Client	Viking Penguin, Inc.
Principal Type	Poliphilus with Blado Italic
Dimensions	8½ x 10½ in. (22 x 27 cm)

Typography/Design	Robert Cipriani
Typographic Supplier	Typographic House
Agency	Robert Cipriani Associates
Client	The Charles Stark Draper Laboratory Inc.
Principal Type	Palatino
Dimensions	9 x 9 in. (23 x 23 cm)

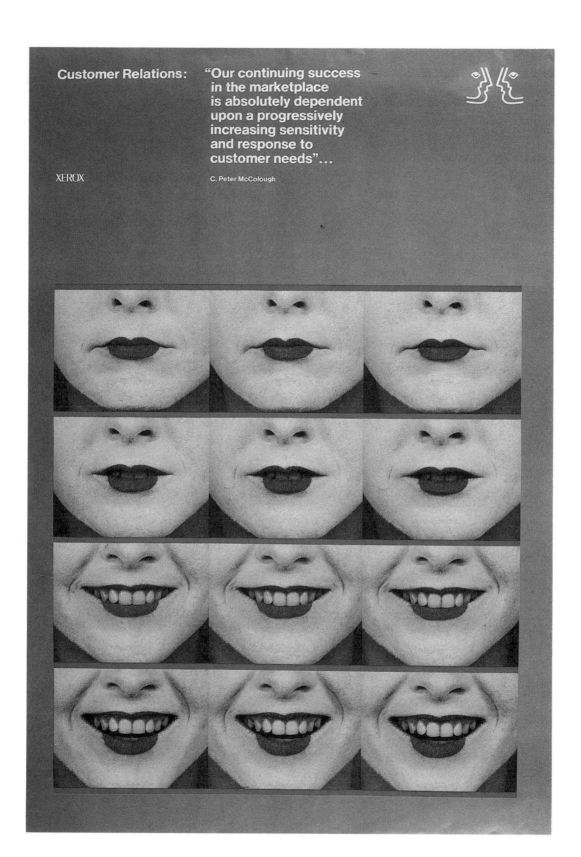

Customer Relations: "Our continuing success in the marketplace is absolutely dependent upon a progressively increasing sensitivity and response to customer needs"...

XEROX

C. Peter McColough

Typography/Design | James L. Selak
Typographic Supplier | Rochester Mono/Headliners
Client | Xerox Corporation
Principal Type | Helvetica Medium
Dimensions | 24 x 36 in. (61 x 91 cm)

Typography/Design	Michael Fountain
Typographic Supplier/Calligraphy	Michael Doret
Agency	Rumrill-Hoyt Inc.
Client	Remington Arms Co.
Dimensions	9½ x 14½ x 10 in. (24 x 37 x 25 cm)

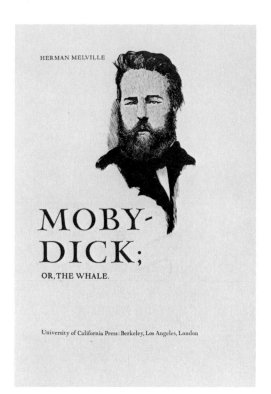

HERMAN MELVILLE

MOBY-DICK;

OR, THE WHALE.

University of California Press: Berkeley, Los Angeles, London

his thoughts. For, d'ye see, rainbows do not visit the clear air; they only irradiate vapor. And so, through all the thick mists of the dim doubts in my mind, divine intuitions now and then shoot, enkindling my fog with a heavenly ray. And for this I thank God; for all have doubts; many deny; but doubts or denials, few along with them, have intuitions. Doubts of all things earthly, and intuitions of some things heavenly; this combination makes neither believer nor infidel, but makes a man who regards them both with equal eye.

CHAPTER 86 THE TAIL

OTHER poets have warbled the praises of the soft eye of the antelope, and the lovely plumage of the bird that never alights; less celestial, I celebrate a tail.
Reckoning the largest sized Sperm Whale's tail to begin at that point of the trunk where it tapers to about the girth of a man, it comprises

Flukes

upon its upper surface alone, an area of at least fifty square feet. The compact round body of its root expands into two broad, firm, flat palms or flukes, gradually shoaling away to less than an inch in thickness. At the crotch or junction, these flukes slightly overlap, then sideways

384

recede from each other like wings, leaving a wide vacancy between. In no living thing are the lines of beauty more exquisitely defined than in the crescentic borders of these flukes. At its utmost expansion in the full grown whale, the tail will considerably exceed twenty feet across.

The entire member seems a dense webbed bed of welded sinews; but cut into it, and you find that three distinct strata compose it:— upper, middle, and lower. The fibres in the upper and lower layers, are long and horizontal; those of the middle one, very short, and running crosswise between the outside layers. This triune structure, as much as anything else, imparts power to the tail. To the student of old Roman walls, the middle layer will furnish a curious parallel to the thin course of tiles always alternating with the stone in those wonderful relics of the antique, and which undoubtedly contribute so much to the great strength of the masonry.

But as if this vast local power in the tendinous tail were not enough, the whole bulk of the leviathan is knit over with a warp and woof of muscular fibres and filaments, which passing on either side the loins and running down into the flukes, insensibly blend with them, and largely contribute to their might; so that in the tail the confluent measureless force of the whole whale seems concentrated to a point. Could annihilation occur to matter, this were the thing to do it.

Nor does this—its amazing strength, at all tend to cripple the graceful flexion of its motions; where infantileness of ease undulates through a Titanism of power. On the contrary, those motions derive their most appalling beauty from it. Real strength never impairs beauty or harmony, but it often bestows it; and in everything imposingly beautiful, strength has much to do with the magic. Take away the tied tendons that all over seem bursting from the marble in the carved Hercules, and its charm would be gone. As devout Eckermann lifted the linen sheet from the naked corpse of Goethe, he was overwhelmed with the massive chest of the man, that seemed as a Roman triumphal arch. When Angelo paints even God the Father in human form, mark what robustness is there. And whatever they may reveal of the divine love in the Son, the soft, curled, hermaphroditical Italian

385

Design	Andrew Hoyem/Steve Renick
Typographic Supplier	Arion Press
Client	University of California Press at Berkeley
Principal Type	Heads: Leviathan Body: Goudy Modern
Dimensions	9 x 13⅜ in. (23 x 34 cm)

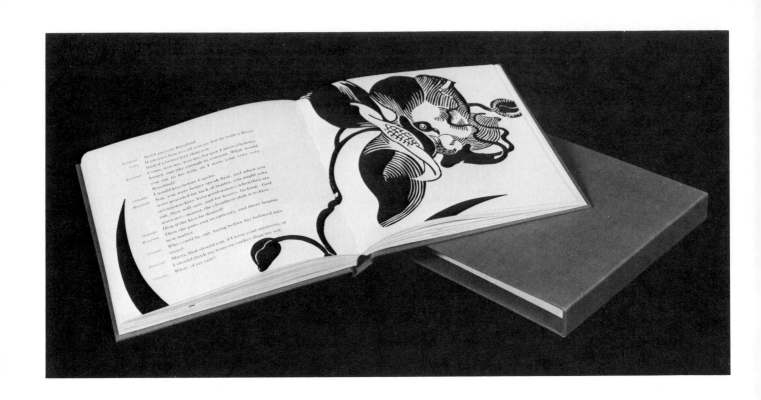

Typography/Design	Daniel Haberman
Typographic Supplier	Royal Composing Room, Inc.
Clients	Royal Composing Room, Inc./
	A. Horowitz & Sons/
	Finch, Pruyn & Company, Inc./
	RAE Publishing Co., Inc./Isadore Seltzer
Principal Type	Binney Old Style
Dimensions	8 x 8 in. (20 x 20 cm)

CARRARA
sheets and pillowcases
comforters
quilted bedspreads
lined draperies
tailored shams
tailored petticoats
duvet covers
shower curtains

COUNTRY CHALET
sheets and pillowcases
comforters
tailored shams
tailored petticoats
shower curtains
towels

ESCAPADE
sheets and pillowcases
comforters
quilted bedspreads
lined draperies
tailored shams
tailored petticoats
duvet covers
shower curtains
towels

CANYONS
sheets and pillowcases
comforters
quilted bedspreads
lined draperies
towels

TRIANON
sheets and pillowcases
comforters
ruffled shams
bedruffles
towels

THE ROSE
sheets and pillowcases
comforters
ruffled shams

JUNGLE SAVAGE
sheets and pillowcases
comforters
quilted bedspreads
lined draperies
quilted tailored shams
quilted tailored petticoats
duvet covers
shower curtains
towels

CRYSTAL DREAMS
sheets and pillowcases
comforters
quilted bedspreads
lined draperies
quilted tailored shams
quilted tailored petticoats
duvet covers
shower curtains
towels
© Mary McFadden

Typography/Design	James Sebastian/ Michael Lauretano
Typographic Supplier	M. J. Baumwell Typographers, Inc.
Studio	Designframe, Incorporated
Client	Martex
Principal Type	Peignot
Dimensions	6⅛ x 11 in. (16 x 28 cm)

43

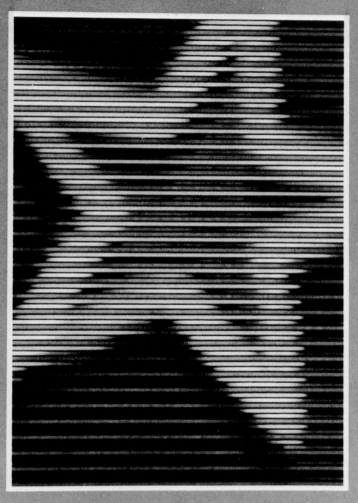

COMSAT®

COMMUNICATIONS SATELLITE CORPORATION MAGAZINE

1981

NUMBER 5

Typography	Joseph M. Essex/
	Wendy Pressley-Jacobs
Design	Robert Petrick/
	Janice Baum
Typographic Supplier	Typeworks, Inc., Chicago
Agency	Burson Marsteller
	Design Group
Client	Communications Satellite
	Corporation
Principal Type	Univers
Dimensions	7 x 11 in. (18 x 28 cm)

"If you can't measure it, you can't improve it." *Alex d'Arbeloff, President*
Teradyne

Quality begins with knowledge. Once you know where you are and where you want to be, the rest is just a matter of commitment.

In electronics, knowing where you are means testing. Not just good-bad testing, but testing that gets inside a device and probes the subtle differences between pretty good and very good.

The subtleties vary from device to device. For high-performance memories, where the issue is usually speed, you need a test system that can set timing edges to within a quarter nanosecond. For precision D to A converters, you need a system that can integrate noise measurements over programmed time intervals. For codecs, you need a system that can measure idle channel noise in the submillivolt region.

Measurements like these are not easy, but they're not impossible. Teradyne test systems have been making tough, critical measurements for years – on digital and linear ICs, discrete semiconductors, hybrid circuits, film resistors, automotive electronic modules, analog LSI devices, and printed circuit boards.

What all this experience gives us is a sense of what really matters in the testing of electronics.

What it gives you is the kind of in-depth measurement you need to improve product quality.

TERADYNE
We measure quality.

Typography/Calligraphy	Tim Girvin
Design	Paula Brown
Agency	Quinn & Johnson/Boston
Client	Teradyne
Dimensions	15¼ x 38½ in (39 x 98 cm)

Typography/Design Oswaldo Miranda (Miran)
Typographic Supplier Digital
Studio Umuarama Publ.
Client Acaiaca Gallery

Principal Type Helvetica Super
Dimensions 9 x 5 in. (23 x 13 cm)

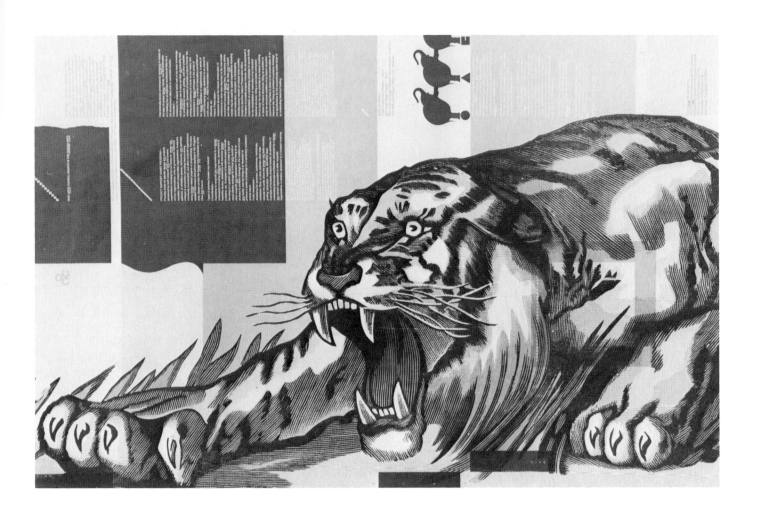

Typography/Design	Gordon Salchow
Typographic Supplier	Dwight Yaeger, Typographer
Studio	G. Salchow Design
Client	Ohio Arts Council
Principal Type	Helvetica
Dimensions	22 x 34 in. (56 x 86 cm)

THE ELEGANT IDEM

BY JOSEPH GRIBBINS

PHOTOGRAPHS BY JIM BROWN

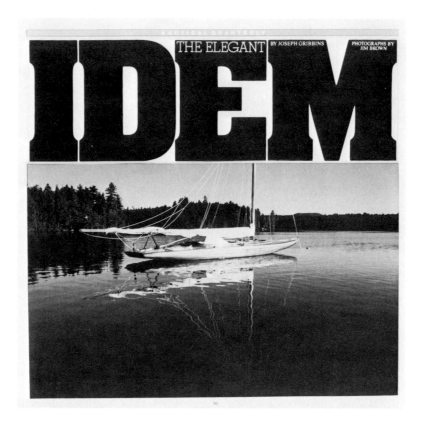

In October of 1899, a circular went out from the St. Regis Yacht Club announcing the Idem at a cost that now seems astonishing: "Members of the Club are hereby notified that an Idem class of jib and mainsail boats will be built for racing during the season of 1900, at a cost of about $750. These boats will be exactly alike and will be raced as a class by themselves without time allowance. The boats will be about 32 feet long, 19 feet water line, and 8 feet beam, with 600 square feet area of sail. A weighted centerboard with a self-bailing cockpit has been decided upon, making the boat non-capsizable."

The Idems were built to Clinton Crane's design and with the dimensions specified, although there proved to be conditions in which they would capsize and spectacularly. When capsized, however, they don't sink altogether. Audrey Bird reports that *Peek-A-Boo*, which leaks a bit after 81 summers, will sink at her mooring if a heavy rain coincides with the absence of a hand or two to bail her out, but she will sink with her decks just under.

The Bird family and other Idem owners enjoy these boats all summer but race them every Tuesday and Saturday in August. The St. Regis Yacht Club also sponsors a Moonlight Race during August, a Handicap Race before Labor Day, and a Labor Day Race in the vicinity of the end-of-the-season weekend. Don-Michael Bird won the Handicap Race among 32 boats in 1978, Michael Bird won the Moonlight Race in the summer of '79, and last season Mrs. Bird and son Michael sailed *Peek-A-Boo* to overall honors in the fleet, including a Labor Day Race with a "hair-raising" thunderstorm that capsized every sailboat on the lake.

The oldest original surviving one-design class in the world is doing very nicely in its 82nd season, a tribute to an elegant boat well-designed for the waters she sails, and to the special people who have owned them for eight decades. They will be around for many more summers, daysailing, racing, moonlight cruising and—as *Peek-A-Boo* will do this year—defending their laurels.

Typography/Design	B. Martin Pedersen
Typographic Suppliers	Empire Cold Type/Latent Lettering
Studio	Jonson Pedersen Hinrichs & Shakery Inc.
Client	Nautical Quarterly Inc.
Principal Type	Heads: Aachen Bold/Stymie Light
	Body: Times Roman
Dimensions	10¼ x 10¼ in. (26 x 26 cm)

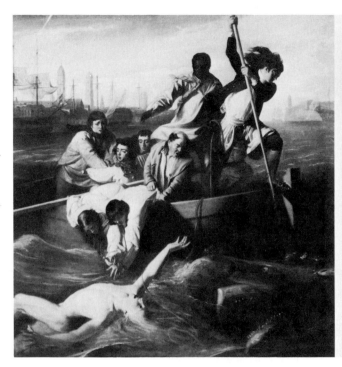

SHARKS

BY RICHARD ELLIS

WHAT WE KNOW, WHAT WE DON'T KNOW, WHAT WE ONLY THINK WE KNOW...

Sharks are indeed efficient predators, and they have been around for a very long time, but the truth about these varied and highly diversified creatures is so fascinating that it requires very little amplification or embellishment. The truth about sharks far surpasses the popular mythology and—as in all scientific pursuits—we are better served by learning the truth than we are by relying on the tales of old fishermen or their wives.

First of all, there is no such thing as "the shark." There is a large class of animals known as Chondrichthyes ("cartilaginous fishes") which includes all sharks, skates and rays. The order Selachii encompasses all the sharks, and is further subdivided into suborders, which are then broken down into families, then genera, and finally into species (from the same root as "specific," meaning "distinctive" or "unique.") A species is that group of individuals not interbreeding with another such group. Sharks range in size from the whale shark, the largest fish in the world at a maximum length of 50', to the 6" Squaliolus laticaudus. There are tropical sharks and polar sharks, surface feeders and bottom dwellers that may never see daylight, sharks that are restricted to a narrow geographical range, and some that are found in nearly all the world's tropical and temperate waters. There are angel sharks, goblin sharks, carpet sharks, swell sharks, nurse sharks, mako sharks, bramble sharks, silky sharks, cow sharks, bull sharks, basking sharks, frilled sharks, catsharks, dogfish, hammerheads, porbeagles and wobbegongs.

Sharks are found in virtually all the oceans of the world, from the tepid waters of the South Pacific and the Caribbean to the icy waters of the Arctic. There are even sharks that spend some part of their lives in fresh water, but these species are now known to be representative of a single species, the bull shark, which has the ability to move from salt to fresh water and back again with no ill effects. The Lake Nicaragua shark, the Zambezi River shark, the Ganges River shark, and others from the Amazon, the Tigris and Euphrates system, and even the Mississippi—a bull shark was found 160 miles up the Atchafalaya River in Louisiana—are now believed to be Carcharinus leucas, the bull shark. (Its affinity for fresh water automatically makes the bull shark a suspect in the 1916 attacks in Matawan Creek, New Jersey, since the great white shark, usually blamed for these attacks, never enters fresh water.)

There may be no such thing as "the shark," but there must be certain characteristics that define the order. There are. All sharks—and there are perhaps 250 species—have a skeleton that is composed completely of cartilage, this means that sharks are totally boneless, and it accounts for the relatively sparse fossil record. Creatures with calcified remains tend to be better preserved. All sharks have multiple gill slits, numbering from five to seven, as opposed to the single opening of the bony fishes. Where the skin of the bony fishes is composed of overlapping scales, sharkskin consists of tiny tooth-shaped plates, known as dermal denticles. The structure of these denticles is similar to that of the teeth. Speaking of teeth, sharks have the ability to replace their teeth regularly throughout their lives, and new teeth are constantly moving up to replace those in the front rows. (This leads to the curious phenomenon of the inner rows being larger than those they will replace; they have to be if the new teeth are to be commensurate with the requirements of the growing shark.) Most sharks have sharp, pointed teeth, but as usual, generalizations do not easily apply. There is a species of shark known as the Port Jackson shark or hornshark, which has teeth in the back of the mouth that are "pavement-like," and are used in crushing the shells of the oysters and other mollusks that make up the diet of this species. Skates and rays, by the way, also fulfill most of these criteria, but their gill slits are located on the underside of their flattened bodies, and they are therefore classified separately.

Most of the larger sharks that feed on sizeable prey have relatively large teeth which are often serrated to facilitate the removal of big bites of flesh from their prey. All sharks, however, do not have triangular, serrated teeth, and some species have some of the most unusual dental arrangements in the world. The teeth of the white, tiger, hammerhead, bull, dusky, blue and whitetip sharks are more-or-less triangular (those of the white are almost perfect triangles, while the teeth of the tiger shark, have been

In 1749, at the tender age of 14 Englishman Brook Watson was attacked by a shark while swimming in Havana harbor. He survived to commission Bostonian John Singleton Copley to paint Watson and the Shark, shown at left, courtesy of the National Gallery of Art, Washington, DC. For this immortality Watson paid a price of more than a pound of his flesh—he lost his foot. Despite this handicap, Watson was a successful merchant, and in 1796 he became Lord Mayor of London. He died at the age of 72.

5

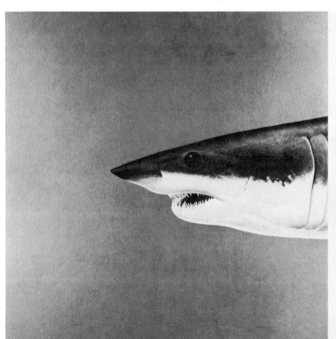

One would assume that the subject of sharks has been virtually exhausted, and that we now know as much as we need to know about these animals. We all know, for example, that sharks are "swimming noses," with an incredibly well-developed sense of smell which permits them to detect a single molecule of blood in the water from great distances; they then home in unerringly on the bleeding victim—whether fish or wounded swimmer—and attack with grisly efficiency. Everyone also knows that sharks have razor-sharp teeth and that they circle their intended victims, dorsal fin knifing through the water, before they attack. Sharks are also totally unpredictable, and they will attack a swimmer one day and ignore a potential meal the next. We also know that there are many species of sharks that are man-eaters, cruising menacingly offshore, just waiting to make a meal of an unwary swimmer. Furthermore, everyone is aware that all sharks need to keep moving to stay alive; that they never stop growing; that they are usually large and voracious creatures, so perfectly attuned and adapted to their environment that they have not changed in 300 million years. All of the foregoing assumptions are incorrect. ◀◀◀◀

Typography/Design	B. Martin Pedersen
Typographic Suppliers	Empire Cold Type/Latent Lettering
Studio	Jonson Pedersen Hinrichs & Shakery Inc.
Client	Nautical Quarterly Inc.
Principal Type	Heads: Aachen Bold/Stymie Light
	Body: Times Roman
Dimensions	10¼ x 10¼ in. (26 x 26 cm)

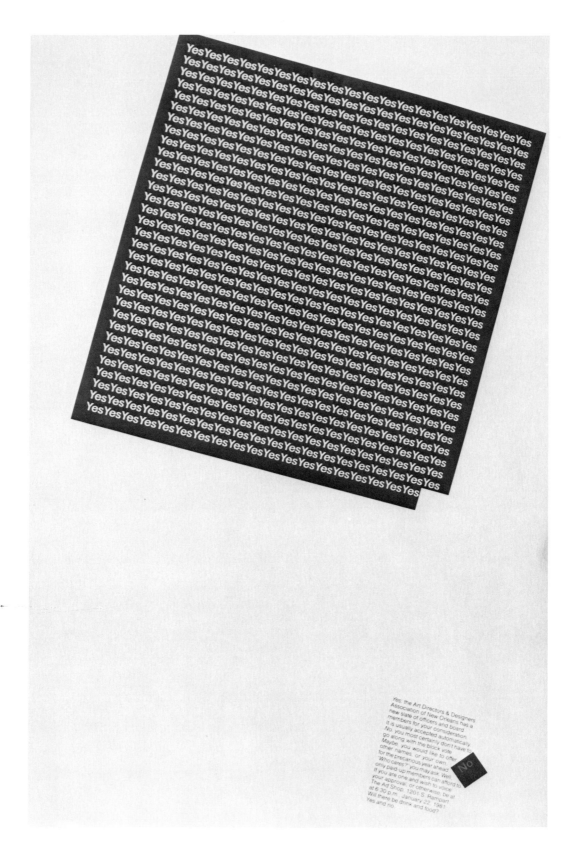

Typography/Design	Tom Varisco
Typographic Supplier	Forstall Typographers
Studio	Tom Varisco Graphic Designs, Inc.
Client	Art Directors & Designers Association of New Orleans
Dimensions	11 x 17 in. (28 x 43 cm)

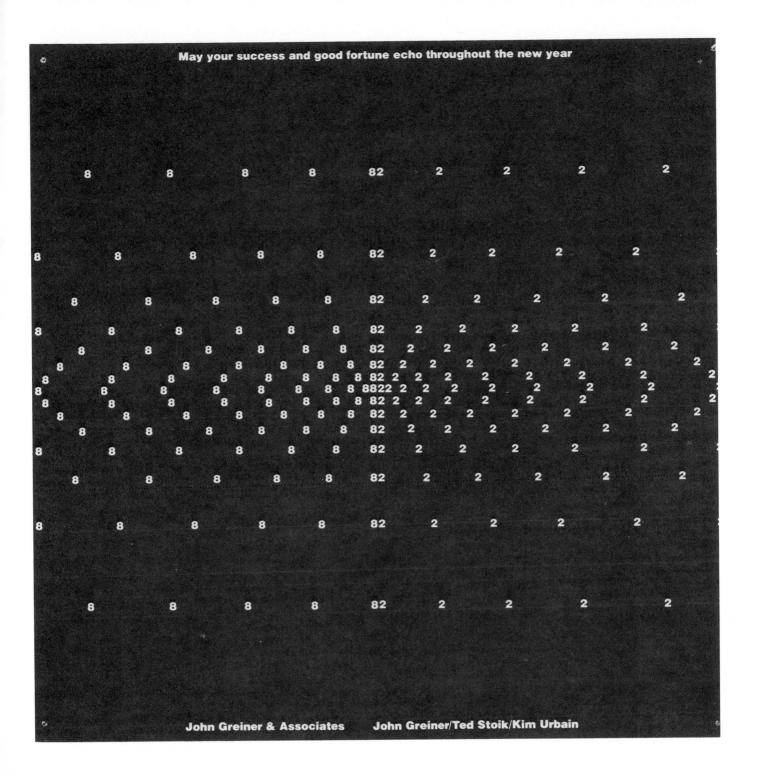

Typography/Design	John Greiner
Typographic Supplier	Lakeshore Typographers
Studio/Client	John Greiner & Associates
Principal Type	Helvetica Bold
Dimensions	8¾ x 8¾ in. (22 x 22 cm)

51

CREATIVITY

It made Mozart, Mozart. It made Picasso, Picasso. It's a rare gift that has been stimulating people since the dawn of civilization. ■ You've either got it or you don't. And if you don't you'll pay the earth just to experience it. To touch it. To see it. To buy it. Or to rent it. ■ It's this hunger for creativity that drives the prices of paintings up to the sky. And sells out theater and concert tickets year after year. ■ Which is why we did what we did. Created a dazzling new cable program service with immediate seating nightly. It's Alpha Repertory Television Service, affectionately known as ARTS. ■ ARTS covers every aspect of the creative scene past and present. With a refreshing new theme every week. ■ Prestigious personalities like Olivia de Havilland, Anne Baxter, and Pierre Salinger guide the viewer through the great cities of the world. To see where famous artists, composers, and writers lived, worked and played. The audience will have a unique opportunity to understand their works and achieve greater insight through their creativity. ■ Every night at 9 PM EST after NICKELODEON, the award-winning entertainment program for young people, completes its day, ARTS is wide awake and ready to bring the world of creativity to family audiences. ■ ARTS and NICKELODEON. A powerful combination of program services uniquely compatible. They work beautifully together to put creativity where it belongs. In the home. ■ ARTS on NICKELODEON 1211 Avenue of the Americas, New York, New York 10036. For more information call Gary Koester at (212) 944-4250.

ARTS

ALPHA REPERTORY TELEVISION SERVICE
ON THE NICKELODEON CHANNEL
1211 AVENUE OF THE AMERICAS, NEW YORK, NEW YORK 10036

Typography/Design	Joel Margulies
Typographic Supplier	Pastore DePamphilis Rampone Inc.
Studio	J.J. Margulies, Inc.
Client	ABC Video Enterprises/Arts
Principal Type	Bodoni
Dimensions	16½ x 11 in. (42 x 28 cm)

ARTSY

THERE'S A BIG DIFFERENCE BETWEEN ARTS AND ARTSY. ■ Art sells. Artsy doesn't. ■ Why? Because people know the difference between a stuffy presentation and one that invigorates by capturing the imagination. ■ And that's why we have created ARTS, the Alpha Repertory Television Service, which will be offered on the NICKELODEON channel, the award winning young people's program service. ■ Premiering April 12, ARTS is a 3-hour nightly cable program service. It's a dazzling panorama of the arts presented the way your audiences want it. ■ Familiar personalities like Olivia DeHavilland, Anne Baxter, and Pierre Salinger on location throughout the world, will guide audiences through particular eras of exciting creative work. Each week ARTS will have a different theme like "Paris: The Dream and the Reality," and "Vienna: The Home of Genius." ■ Viewers will see where artists, writers and composers like Debussy and Degas lived and worked. They'll see what they saw, meet who they knew and even feel what they felt. ARTS brings this special world of art to viewers the way they've never seen it before. Without the "Y." ■ Every night at 9 PM EST, when NICKELODEON signs off, ARTS signs on. ■ ARTS and NICKELODEON are a powerful combination of program services which are uniquely compatible. Subscribers will find this new viewing opportunity irresistible. For more information about ARTS on the NICKELODEON channel call Gary Koester at (212) 944-4250.

ARTS
ALPHA REPERTORY TELEVISION SERVICE
ON THE NICKELODEON CHANNEL
1211 AVENUE OF THE AMERICAS, NEW YORK, NEW YORK 10036

Typography/Design	Joel Margulies
Typographic Supplier	Pastore DePamphilis Rampone Inc.
Studio	J.J. Margulies, Inc.
Client	ABC Video Enterprises/Arts
Principal Type	Heads: Goudy
	Body: Bodoni
Dimensions	16½ x 11 in. (42 x 28 cm)

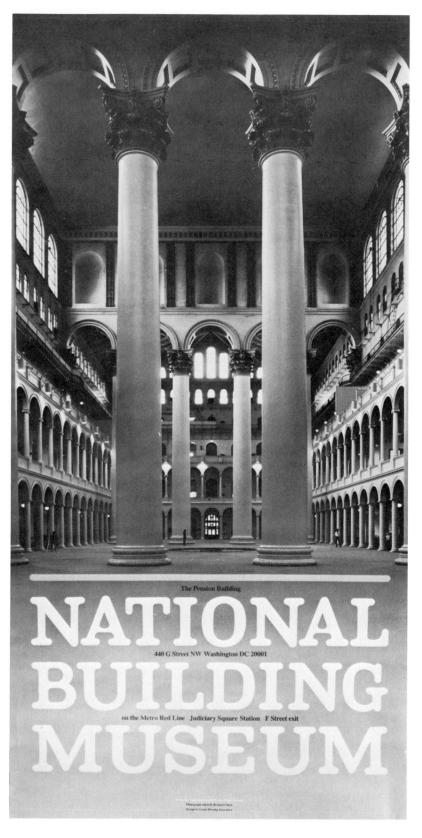

Typography/Design/Calligraphy	Bernard H. Wissing
Typographic Supplier	Typesetting Service
Studio	Grear/Wissing Associates
Client	National Building Museum
Principal Type	Times Roman Bold
Dimensions	24½ x 49 in. (62 x 125 cm)

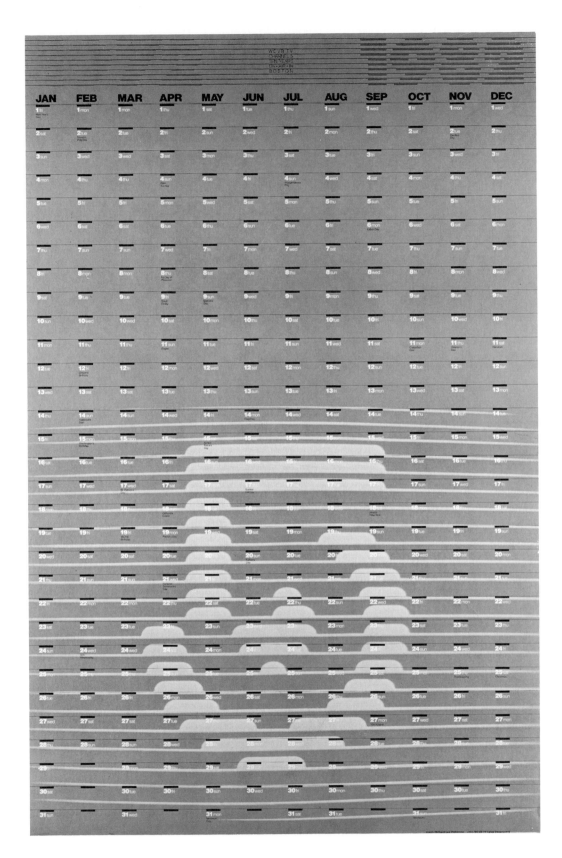

Design | Richard Lee Dickinson
Typographic Supplier | Wrightson Typographers
Studio | WCVB TV Graphics
Client | WCVB TV5 Boston

Principal Type | Helvetica
Dimensions | 22 x 34 in. (56 x 86 cm)

P I N E Y

P O I N T

Typography/Design | Warren Moeckel
Typographic Supplier | Typeworks, Inc. (Houston)
Calligraphy | Marilyn Van Cleave
Studio | Intergraphic Design Inc.
Client | Kirksey Development

Principal Type | Goudy Italic
Dimensions | 8½ x 11 in. (22 x 28 cm)

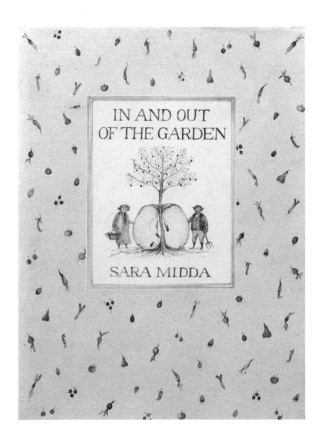

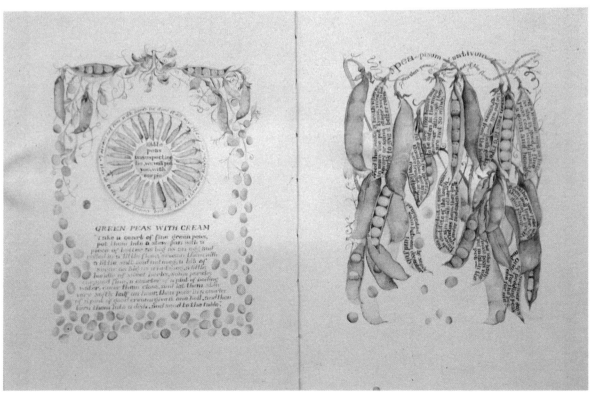

Design | Paul Hanson
Calligrapher | Sara Midda
Client | Workman Publishing

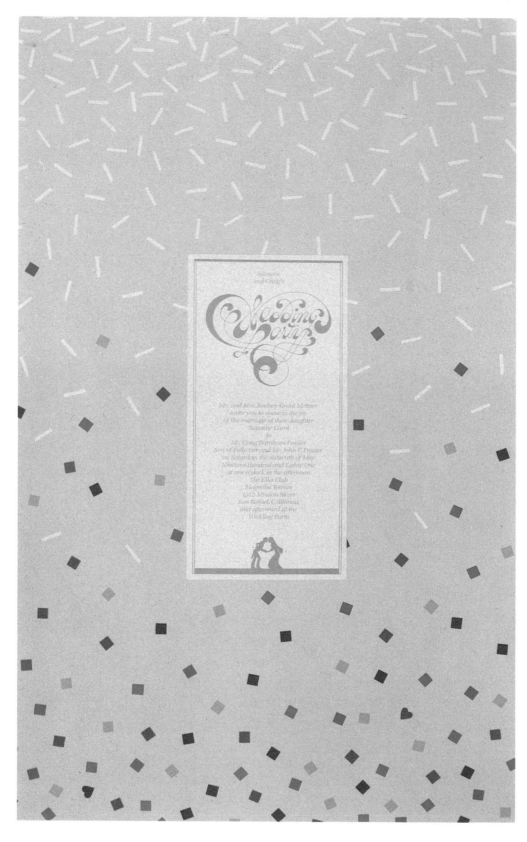

Typography/Design/Calligraphy	Craig Frazier
Typographic Supplier	Drager & Mount
Studio	Jorgensen/Frazier
Client	The Fraziers
Principal Type	Zapf International Italic
Dimensions	10½ x 17 in. (27 x 43 cm)

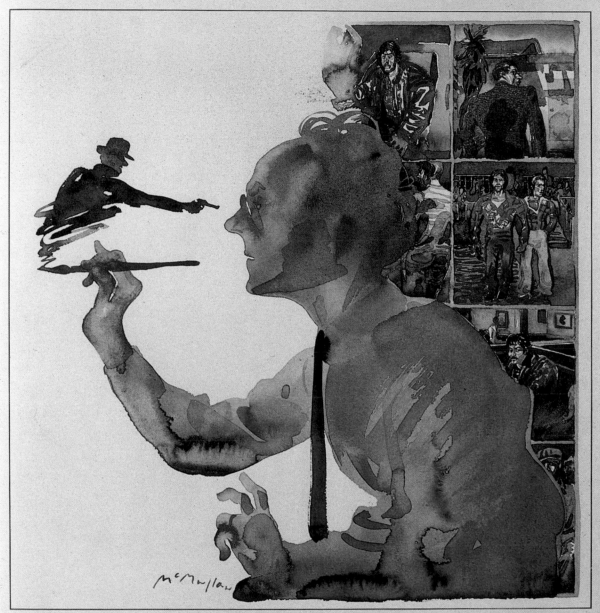

McMullan
REVEALING ILLUSTRATIONS

The Art of James McMullan
INTRODUCTORY INTERVIEW BY MILTON GLASER

Design	James McMullan
Typographic Suppliers	Publishers Graphics Inc.
	JCH Graphics Ltd.
	Latent Lettering Company, Inc.
Studio	Visible Studio Inc.
Client	Watson-Guptill Publications
Principal Type	Text: Times Roman
	Heads: Franklin Gothic
Dimensions	9 x 12 in. (23 x 30 cm)

59

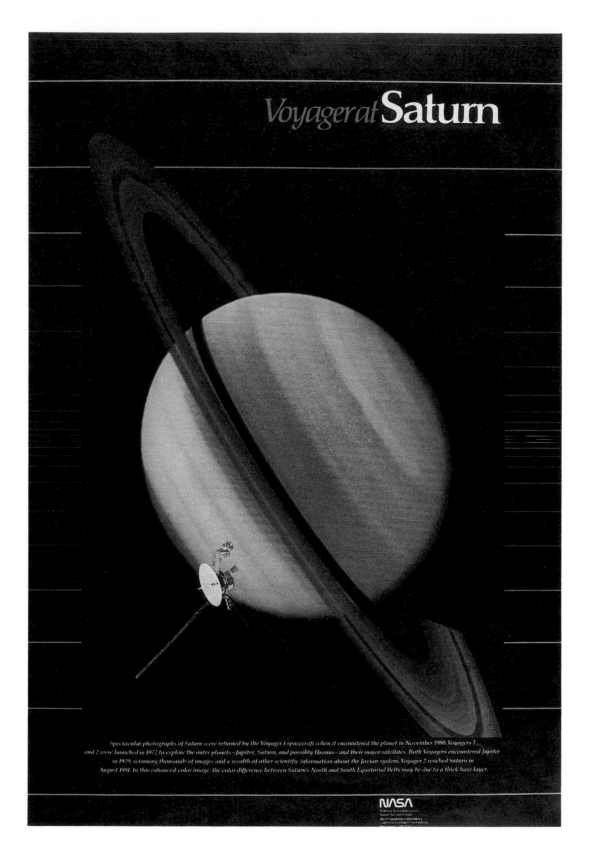

Voyager at **Saturn**

Spectacular photographs of Saturn were returned by the Voyager I spacecraft when it encountered the planet in November 1980. Voyagers 1 and 2 were launched in 1977 to explore the outer planets—Jupiter, Saturn, and possibly Uranus—and their major satellites. Both Voyagers encountered Jupiter in 1979, returning thousands of images and a wealth of other scientific information about the Jovian system. Voyager 2 reached Saturn in August 1981. In this enhanced-color image, the color difference between Saturn's North and South Equatorial Belts may be due to a thick haze layer.

NASA
National Aeronautics and
Space Administration
Jet Propulsion Laboratory
California Institute of Technology
Pasadena, California

Typography/Design	Ken White/
	Tak Kiriyama
Typographic Supplier	R & S Typographics
Agency	Ken White Design Office, Inc.
Client	NASA/JPL
Principal Type	Palatino
Dimensions	24 x 36 in. (61 x 91 cm)

Reinsurance deals with the further distribution of liability assumed by underwriters and is concerned with sharing risk and spreading catastrophic losses.

Marsh & McLennan Companies provides reinsurance services under the names Guy Carpenter & Company, Inc. and C. T. Bowring & Co. (Insurance) Ltd., with each firm conducting its business independently of the other.

Although separate, Carpenter and Bowring enjoy a long-standing business relationship. Their association began in 1920, when Mr. Guy Carpenter approached Bowring to learn whether a London market existed for his innovative reinsurance idea, which could substitute for the old form of treaty reinsurance and furnish automatic protection for all losses in excess of an agreed retention. In time, the concept became known throughout the world reinsurance industry as the Carpenter Plan.

Carpenter and Bowring serve major insurance and reinsurance companies of the world, providing advice and services and placing reinsurance in the best markets at the best possible terms. Bowring also serves Lloyd's underwriters and provides other brokers throughout the world with specialty expertise and access to Lloyd's and the London market.

Typography/Design	Karen Kutner Katinas
Typographic Supplier	Haber Typographers, Inc.
Studio	Karen Katinas
Client	Marsh & McLennan Companies, Inc.
Principal Type	Helvetica
Dimensions	8½ x 11 in. (22 x 28 cm)

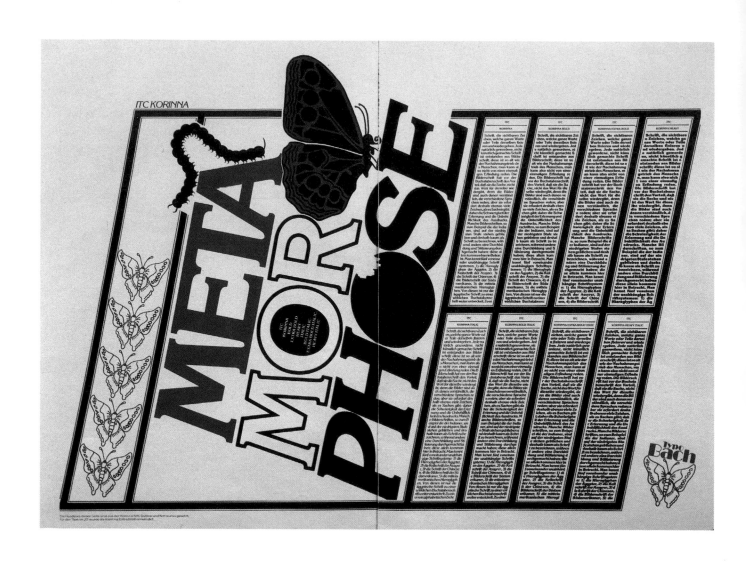

Typography/Design	Erwin Roeth
Typographic Supplier/Studio	Atelier Erwin Roeth
Client	Typo Bach GmbH
Dimensions	12 x 17 in. (29 x 42 cm)

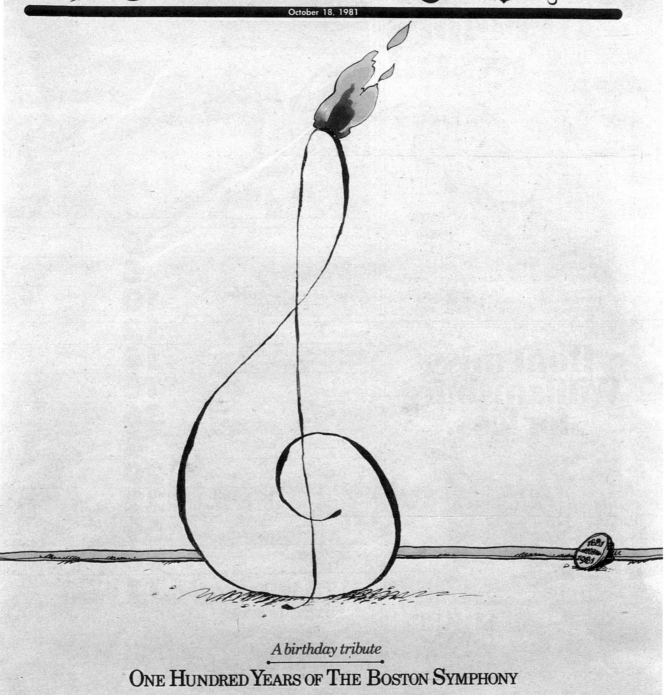

Typography/Design	Ronn Campisi
Typographic Supplier	Headliners/Boston
Client	*The Boston Globe Magazine*
Principal Type	Century
Dimensions	10¾ x 12½ in. (27 x 32 cm)

EPISCOPAL

Eagle

Episcopal School

Newsletter

Name

School

7¾ IN × 12¼ IN 12 SHEETS

Typography/Design/Calligraphy	Brian Boyd
Typographic Supplier	Typographics
Studio	Richards, Sullivan, Brock & Associates
Client	Episcopal School of Dallas
Principal Type	Vermont/Snell Roundhand/ Helvetica
Dimensions	7¾ x 12¼ in. (20 x 32 cm)

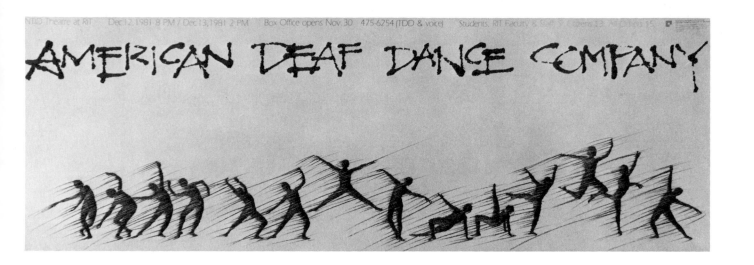

Typography/Calligraphy/Design | Louise Hutchison
Typographic Supplier | Sarah J. Perkins
Studio | National Technical Institute
for the Deaf,
Rochester Institute of Technology,
Media Production Department
Client | NTID Theatre at RIT,
Division of Performing Arts
Principal Type | Eras
Dimensions | 34 x 12 in. (86 x 31 cm)

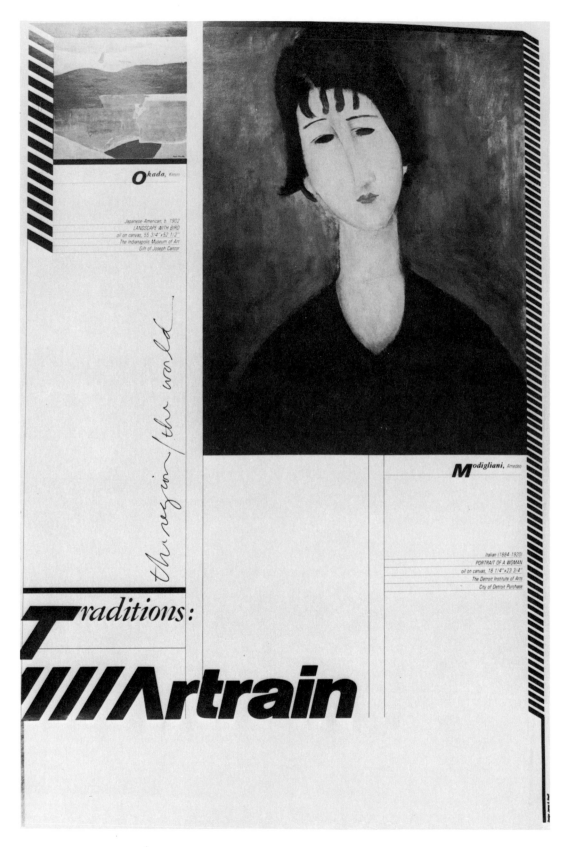

Traditions: ////Artrain

the region/the world

Okada, Kenzo

Japanese American, b. 1902
LANDSCAPE WITH BIRD
oil on canvas, 55 3/4" x 52 1/2"
The Indianapolis Museum of Art
Gift of Joseph Cantor

Modigliani, Amedeo

Italian (1884-1920)
PORTRAIT OF A WOMAN
oil on canvas, 18 1/4" x 23 3/4"
The Detroit Institute of Arts
City of Detroit Purchase

Typography/Design/ Calligraphy/Studio	James A. Houff
Typographic Supplier	Lettergraphics/Detroit, Inc.
Client	Artrain, Inc.
Principal Type	Heads: Garamond Extra Bold Italic Body: Univers 48
Dimensions	13 x 20 in. (33 x 51 cm)

66

1 9 8 1

//////Artrain

316 Fisher Building
Detroit, MI 48202
313 871 2910

Design:
James A. Houff
Typesetting:
Lettergraphics/Detroit, Inc.
Printing:
The Typocraft Company

*T*raditions:

the region/the world

Photo: Courtesy of the artist

*L*arkin, *Alan, Indiana*

PREMONITIONS
color lithograph, 22" x 30"
Lent by the artist. Represented by Arts Development

Typography/Design/Calligraphy/Studio	James A. Houff
Typographic Supplier	Lettergraphics/Detroit, Inc.
Client	Artrain Inc.
Principal Type	Heads: Garamond Extra Bold Italic
	Body: Univers 48
Dimensions	8½ x 10 in. (22 x 25 cm)

THE WHOLE EGG
CATALOG

YOUNG & RUBICAM INC.

Design	Hau Chee Chung/
	Richard Hsiung/
	Muts Yasumura
Typographic Supplier	Scarlett Letters Inc.
Studio	Yasumura & Associates
Client	Young & Rubicam Inc.
Principal Type	Heads: Avant Garde Extra Light
	Body: ITC Clearface Condensed
Dimensions	7⅞ x 12 in. (20 x 31 cm)

DESIGNERS

Simplicity and quality are integral parts of Herman Miller's design heritage. No less important than those ideals are the individuals who, with our design philosophy in mind, create honest designs.

BURDICK

CHADWICK

EAMES

MÜLLER-DEISIG

NELSON

PROPST

PROTZMANN

RASMUSSEN

STUMPF

WILKES

The above-mentioned individuals are recognized for the design of product which is currently produced. There are numerous other designers, however, who have made substantial contributions to Herman Miller. Among them: William Baldauf, Frieda Diamond, Alexander Girard, Alan Gould, Fritz Haller, Peter Hvedt, Poul Kjaerholm, Paul Laszlo, O.M.Nielsen, Isamu Noguchi, Verner Panton, Gilbert Rohde, and Jan Ruhtenberg.
©1981 Herman Miller, Inc., Corporate Communications Design and Development.

Typography/Design	Linda Powell
Typographic Supplier	Typehouse
Studio	Herman Miller, Inc.,
	Corporate Communications
	Design & Development
Client	Herman Miller, Inc.
Principal Type	Helvetica Light
Dimensions	24 x 36 in. (61 x 91 cm)

69

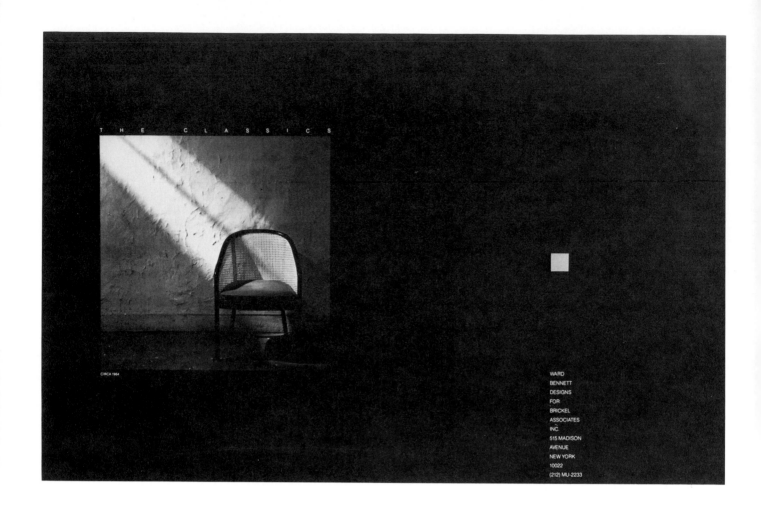

THE CLASSICS

CIRCA 1964

WARD
BENNETT
DESIGNS
FOR
BRICKEL
ASSOCIATES
INC.
515 MADISON
AVENUE
NEW YORK
10022
(212) MU-2233

Typography/Design	Michael Donovan
Typographic Supplier	Concept
Agency/Studio	Donovan and Green, Inc.
Client	Brickel Associates Inc.
Principal Type	Helvetica Light
Dimensions	17 x 11 in. (43 x 28 cm)

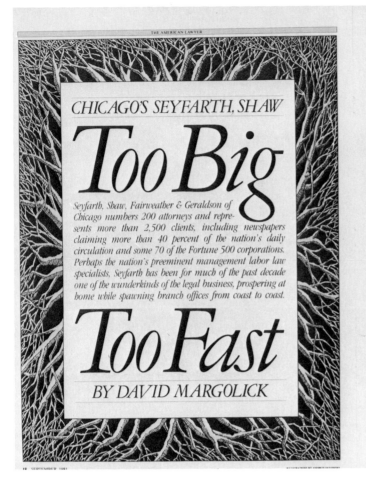
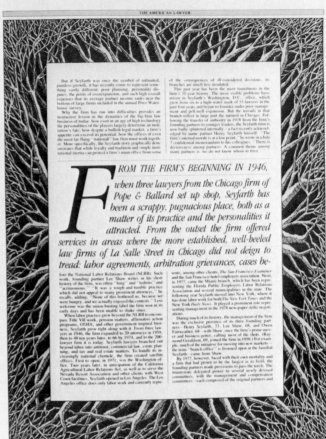

CHICAGO'S SEYFARTH, SHAW

Too Big

Seyfarth, Shaw, Fairweather & Geraldson of Chicago numbers 200 attorneys and represents more than 2,500 clients, including newspapers claiming more than 40 percent of the nation's daily circulation and some 70 of the Fortune 500 corporations. Perhaps the nation's preeminent management labor law specialists, Seyfarth has been for much of the past decade one of the wunderkinds of the legal business, prospering at home while spawning branch offices from coast to coast.

Too Fast

BY DAVID MARGOLICK

But if Seyfarth was once the symbol of unlimited, painless growth, it has recently come to represent something vastly different: poor planning, personality disputes, the perils of overexpansion, and such high overall expenses that its average partner income ranks near the bottom of large firms included in the annual Price Waterhouse survey.

Why the firm has run into difficulties provides an instructive lesson in the dynamics of the big firm law business of today: how even in an age of high technology the personalities of the players largely determine an institution's fate; how despite a bullish legal market, a firm's appetite can exceed its potential; how the offices of even the most far-flung "national" law firm must work together. More specifically, the Seyfarth story graphically demonstrates that while loyalty and tradition and simple institutional inertia can protect a firm's main office from some of the consequences of ill-considered decisions, its branches are much less insulated.

This past year has been the most tumultuous in the firm's 35-year history. The most visible problems have arisen in Seyfarth's Washington, D.C., office, which grew from six to a high-water mark of 53 lawyers in the past four years and began to founder under poor management and pell-mell expansion. But the travails in that branch reflect in large part the turmoil in Chicago. Following the transfer of authority in 1978 from the firm's founding partners to younger leaders, the Seyfarth firm is now badly splintered internally—a fact recently acknowledged by name partner Henry Seyfarth himself. "The firm's internal morale is at a low point," he wrote in a July 7 confidential memorandum to his colleagues. "There is divisiveness among partners. A common theme among many partners is 'we do not know whom to trust.'"

FROM THE FIRM'S BEGINNING IN 1946,

when three lawyers from the Chicago firm of Pope & Ballard set up shop, Seyfarth has been a scrappy, pugnacious place, both as a matter of its practice and the personalities it attracted. From the outset the firm offered services in areas where the more established, well-heeled law firms of La Salle Street in Chicago did not deign to tread: labor agreements, arbitration grievances, cases before the National Labor Relations Board (NLRB). Such work, founding partner Lee Shaw writes in his short history of the firm, was often "long" and "tedious" and "acrimonious." "It was a rough and tumble practice which did not appeal to many prominent attorneys," he recalls, adding, "None of this bothered us, because we were hungry, and we actually enjoyed the contests. "Less welcome was the union-busting label the firm won in its early days and has been unable to shake since.

When labor practice grew beyond the NLRB to encompass Title VII work, pension matters, affirmative action programs, OSHA, and other government-inspired business, Seyfarth grew right along with it. From three lawyers in 1946, the firm expanded to 20 attorneys in 1959, then to 48 ten years later, to 66 by 1974, and to the 200-lawyer firm it is today. Seyfarth lawyers branched out beyond labor into antitrust, commercial law, estate planning, and tax and real estate matters. To handle its increasingly national clientele, the firm created satellite offices. First to open, in 1971, was the Washington office. Two years later, in anticipation of the California Agricultural Labor Relations Act, as well as to serve the Nevada Resort Association and other clients with West Coast facilities, Seyfarth opened in Los Angeles. The Los Angeles office does only labor work and currently represents, among other clients, The San Francisco Examiner and the San Francisco hotel employers association. Next, in 1977, came the Miami branch, which has been representing the Florida Public Employers Labor Relations Association and several municipalities in the state. The following year Seyfarth moved into New York, where it has done labor work for both The New York Times and the New York Daily News. It played a prominent role representing management in the 1978 newspaper strike negotiations.

During much of its history, the management of the firm was the exclusive province of its three founding partners—Henry Seyfarth, 73, Lee Shaw, 68, and Owen Fairweather, 68—with Shaw, once the firm's prime mover and business-getter, calling most of the shots. (Raymond Geraldson, 69, joined the firm in 1950.) For example, much of the initiative for moving into new markets—the term "branch office" is frowned upon at the familial Seyfarth—came from Shaw.

By 1977, however, faced with their own mortality and a firm that had grown to be the largest in its field, the founding partners made provisions to pass the torch. The triumvirate delegated power to several newly devised committees, with the management and compensation committees—each composed of the original partners and

Typography/Design Joe Dizney/Pegi Goodman
Typographic Suppliers Lettering Directions/
Daystar Graphics Ltd.
Client The American Lawyer
Principal Type Heads: Garamond Old Style Italic/
Garamond #3
Body: Times Roman/Garamond #3 Italic
Dimensions 21¼ x 14⅜ in. (54 x 37 cm)

71

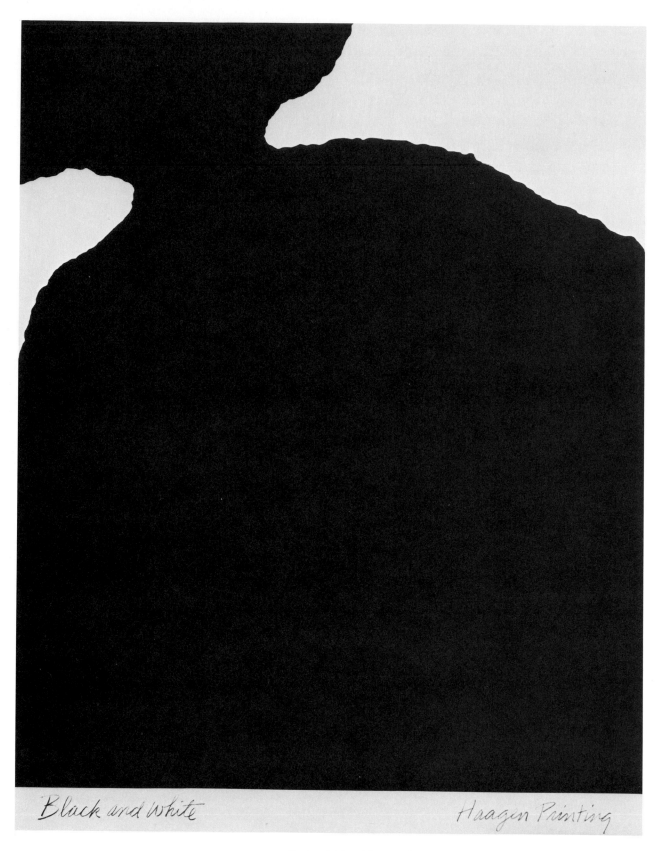

Black and white

Haagen Printing

Design	Marty Neumeier/Byron Glaser
Calligraphy	Marty Neumeier
Studio	Neumeier Design Team
Client	Haagen Printing
Dimensions	18 x 24 in. (46 x 61 cm)

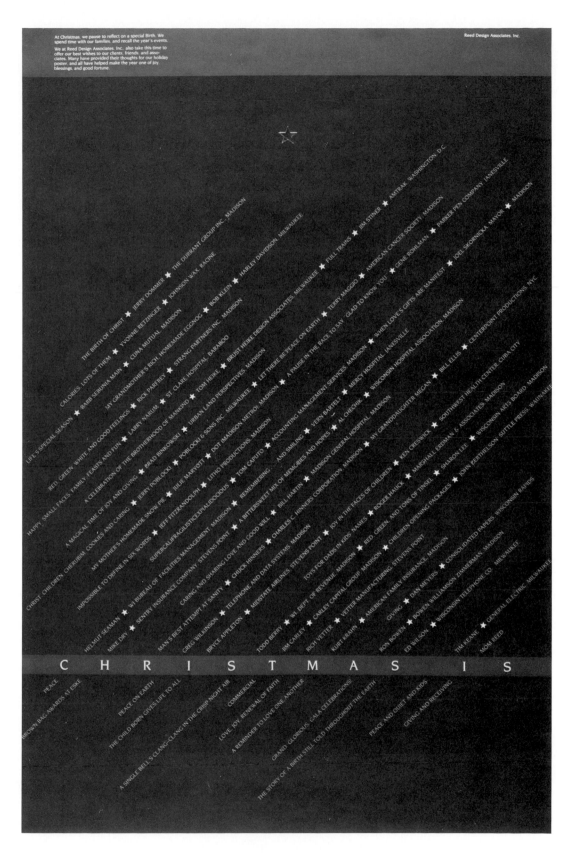

Typography Dan Donovan
Design Stan Reed
Typographic Supplier Landmann Associates, Inc.
Studio/Client Reed Design Associates, Inc.
Principal Type ITC Novarese
Dimensions 17 x 25½ in. (43 x 65 cm)

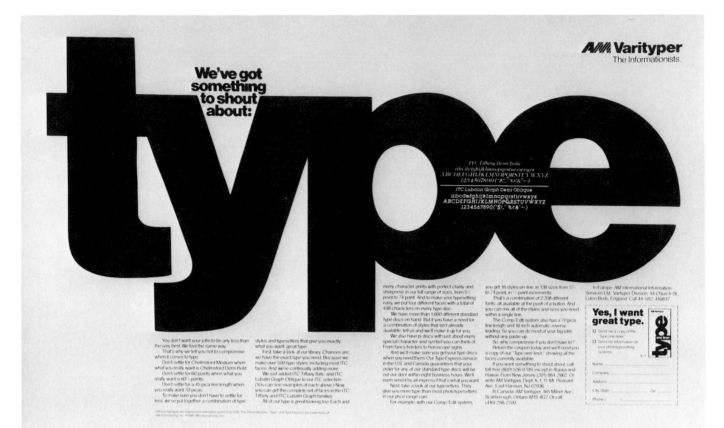

You don't want your jobs to be any less than the very best. We feel the same way.

That's why we tell you not to compromise when it comes to type.

Don't settle for Chelmsford Medium when what you really want is Chelmsford Demi Bold.

Don't settle for 60 points when what you really want is 60½ points.

Don't settle for a 45 pica line length when you really want 70 picas.

To make sure you don't have to settle for less, we've put together a combination of type styles and typesetters that give you exactly what you want: great type.

First, take a look at our library. Chances are we have the exact type you need. Because we make over 500 type styles, including most ITC faces. And we're continually adding more.

We just added ITC Tiffany Italic and ITC Lubalin Graph Oblique to our ITC selection. (You can see examples of each above.) Now you can get the complete set of faces in the ITC Tiffany and ITC Lubalin Graph families.

All of our type is great looking, too. Each and every character prints with perfect clarity and sharpness in our full range of sizes, from 5½ point to 74 point. And to make your typesetting easy, we put four different faces with a total of 448 characters on every type disc.

We have more than 1,000 different standard type discs on hand. But if you have a need for a combination of styles that isn't already available, tell us and we'll make it up for you.

We also have pi discs with just about every special character and symbol you can think of. From fancy borders to horoscope signs.

And we'll make sure you get your type discs when you need them. Our Type Express service in the U.S. and Canada guarantees that your order for any of our standard type discs will be out our door within eight business hours. We'll even send it by air express if that's what you want.

Next, take a look at our typesetters. They give you more type than most phototypesetters in our price range can.

For example, with our Comp/Edit system, you get 16 styles on-line, in 138 sizes from 5½ to 74 point, in ½-point increments.

That's a combination of 2,208 different fonts, all available at the push of a button. And you can mix all of the styles and sizes you need within a single line.

The Comp/Edit system also has a 70 pica line length and 16 inch automatic reverse leading. So you can do most of your big jobs without any paste-up.

So, why compromise if you don't have to?

Return the coupon today and we'll send you a copy of our "Type one-liner," showing all the faces currently available.

If you want something to shout about, call toll-free (800) 526-0709, except in Alaska and Hawaii. From New Jersey (201) 884-2662. Or write AM Varityper, Dept. K-1, 11 Mt. Pleasant Ave., East Hanover, NJ 07936.

In Canada, AM Varityper, 165 Milner Ave., Scarborough, Ontario M1S 4G7. Or call (416) 298-2700.

In Europe, AM International Information Services Ltd., Varityper Division, 44 Church St., Luton Beds, England. Call 44-582-416837.

Yes, I want great type.
☐ Send me a copy of the Type one-liner.
☐ Send me information on your phototypesetting systems.

Name
Company
Address
City, State Zip
Phone ()

Typography	Paul Armand
Design	Tony Cappiello
Typographic Supplier/Agency	Cappiello & Chabrowe, Inc.
Client	AM Varityper
Principal Type	Helvetica
Dimensions	21½ x 14⅝ in. (55 x 37 cm)

The Designer's Guide to
TEXT TYPE

Leaded showings of fifty-one popular text typefaces in 6 point through 12 point plus 14 point.

12/12

The main purpose of letters is the practical one o f making thoughts visible. Ruskin says that all le tters are frightful things and to be endured only on occasion, that is to say, in places where the se nse of the inscription is of more importance than external ornament. This is a sweeping statemen t, from which we need not suffer unduly; yet it i s doubtful whether there is art in individual lette rs. Letters in combination may be satisfying and in a well composed page even beautiful as a wh ole, but art in letters consists rather in the art of a rranging and composing them in a pleasing and appropriate manner. The main purpose of letter *The main purpose of letters is the practical one of maki ng thoughts visible. Ruskin says that all letters are fri* **The main purpose of letters is the practical one of making thoughts visible. Ruskin says that al**

12/13

The main purpose of letters is the practical one o f making thoughts visible. Ruskin says that all le tters are frightful things and to be endured only on occasion, that is to say, in places where the se nse of the inscription is of more importance than external ornament. This is a sweeping statemen t, from which we need not suffer unduly; yet it i s doubtful whether there is art in individual lette rs. Letters in combination may be satisfying and in a well composed page even beautiful as a wh ole, but art in letters consists rather in the art of a rranging and composing them in a pleasing and *The main purpose of letters is the practical one of maki ng thoughts visible. Ruskin says that all letters are fri* **The main purpose of letters is the practical one of making thoughts visible. Ruskin says that al**

12/14

The main purpose of letters is the practical one o f making thoughts visible. Ruskin says that all le tters are frightful things and to be endured only on occasion, that is to say, in places where the se nse of the inscription is of more importance than external ornament. This is a sweeping statemen t, from which we need not suffer unduly; yet it i s doubtful whether there is art in individual lette rs. Letters in combination may be satisfying and in a well composed page even beautiful as a wh ole, but art in letters consists rather in the art of a rranging and composing them in a pleasing and *The main purpose of letters is the practical one of maki ng thoughts visible. Ruskin says that all letters are fri* **The main purpose of letters is the practical one of making thoughts visible. Ruskin says that al**

12/15

The main purpose of letters is the practical one o f making thoughts visible. Ruskin says that all le tters are frightful things and to be endured only on occasion, that is to say, in places where the se nse of the inscription is of more importance than external ornament. This is a sweeping statemen t, from which we need not suffer unduly; yet it i s doubtful whether there is art in individual lette rs. Letters in combination may be satisfying and in a well composed page even beautiful as a wh ole, but art in letters consists rather in the art of a *The main purpose of letters is the practical one of maki ng thoughts visible. Ruskin says that all letters are fri* **The main purpose of letters is the practical one of making thoughts visible. Ruskin says that al**

Jean Callan King and Tony Esposito

Typography/Design/Client | Tony Esposito/Jean Callan King
Dimensions | 9 x 12 in. (23 x 31 cm)

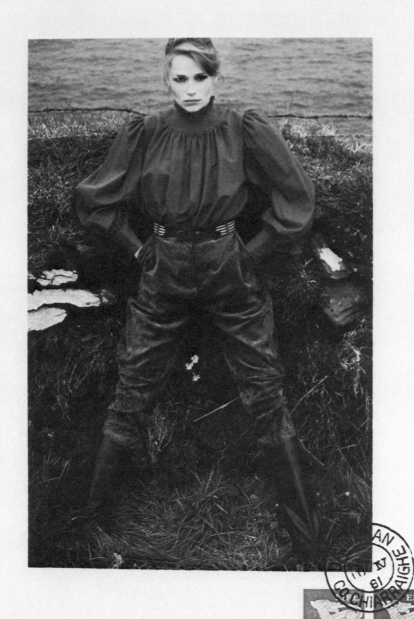

AnnTaylor.

Fall 1981

Typography/Design	Tyler Smith
Typographic Supplier	Typesetting Service
Studio	Tyler Smith
	Art Direction Inc.
Client	Ann Taylor
Principal Type	Gill Sans Light
Dimensions	9⅛ x 11¼ in. (23 x 29 cm)

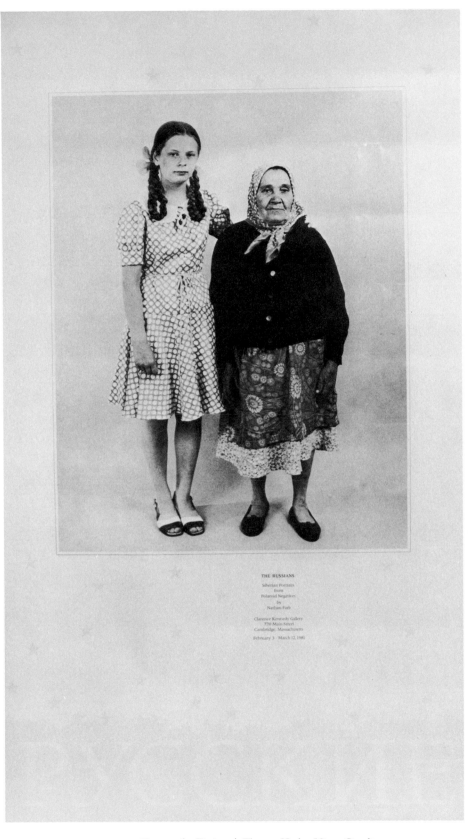

THE RUSSIANS

Siberian Portraits
from
Polaroid Negatives
by
Nathan Farb

Clarence Kennedy Gallery
770 Main Street
Cambridge, Massachusetts

February 3 – March 12, 1981

Typography/Design	Thomas Hughes/Victor Cevoli
Typographic Supplier	Wrightson Typographers
Studios	Polaroid Design/Premier Design
Client	Polaroid Corporation
Principal Type	Meridien
Dimensions	20 x 35 in. (51 x 89 cm)

Typography/Design/Calligraphy	Arnold Goodwin
Typographic Supplier	Design Typographers
Studio	Arnold Goodwin Graphic Communications
Client	Surrey Court Venture Partnership
Principal Type	Heads: Baskerville Body: ITC Cheltenham Book
Dimensions	7¾ x 12 in. (20 x 31 cm)

C·H·R·I·S·T·M·A·S

THE SEASON OF SEASONS

ASSOCIATE ARTISTS

STEVEN CHIN · JEFF LOUGHEED · ARTHUR BROWNE

16/70

Typography/ **Typographic Supplier/** **Calligraphy**	Arthur Browne
Design	Steve Chinn/Jeff Lougheed
Studio/Client	Associate Artists
Principal Type	Palatino
Dimensions	11 x 15 in. (27.9 x 38.1 cm)

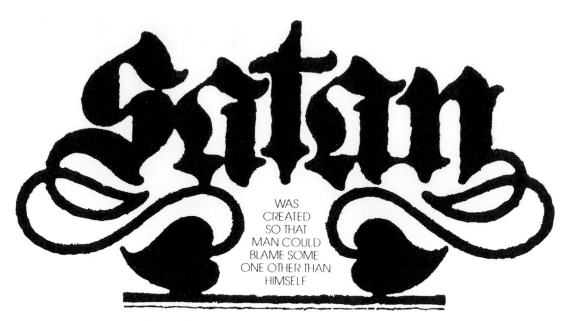

WAS
CREATED
SO THAT
MAN COULD
BLAME SOME
ONE OTHER THAN
HIMSELF

THE OLD SAGE

Typography/Design/Calligraphy	Tony Forster
Typographic Supplier	The Quick Brown Fox Company Limited
Studio	Royle Murgatroyd & Forster
Client	Enchantment Unlimited
Principal Type	ITC Avant Garde

Ligature

THE TYPOGRAPHIC COMMUNICATION JOURNAL PUBLISHED BY WORLD TYPEFACE CENTER INC. VOLUME ONE NUMBER ONE MAR 1978

Typography/Design	Tom Carnase/Jason Calfo
Typographic Suppliers	Carnase Typography/ Pastore DePamphilis Rampone Inc.
Studio	Carnase, Inc.
Client	World Typeface Center, Inc.
Principal Type	WTC Goudy
Dimensions	10 x 2¼ in. (25 x 6 cm)

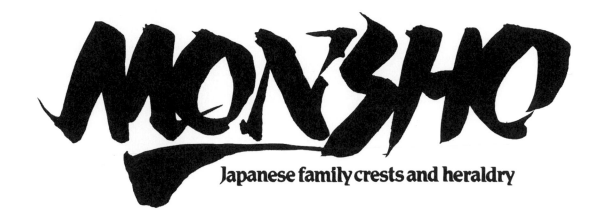

MONSHO

Japanese family crests and heraldry

Typography/Design/ Calligraphy	Frank Satogata
Studio	Conceptual Graphics
Client	Syracuse University
Principal Type	Romic Bold
Dimensions	12 x 9 in. (31 x 23 cm)

PushpinLubalinPeckolick

Typography/Design	Alan Peckolick/ Seymour Chwast
Calligraphy	Tony DiSpigna
Studio/Client	Pushpin Lubalin Peckolick

MARTEX

THREE HOUSES

Typography/Design	James Sebastian/ Michael Lauretano
Typographic Supplier	Haber Typographers, Inc.
Studio	Designframe, Incorporated
Client	Martex
Principal Type	Univers 48
Dimensions	8¾ x 8¾ in. (22 x 22 cm)

Typography/Design	R.D. Scudellari
Calligraphy	John Gruen
Studio	E.J. Krebs
Client	Alfred A. Knopf, Inc.
Dimensions	13¼ x 12 in. (34 x 31 cm)

46% of the companies in the U.S. employing more than 1,000 people offer fitness programs.

A well-designed fitness program is definitely cost-effective.

The Canadian government is so convinced of the cost effectiveness that it offers incentive plans to get companies involved in corporate fitness. The province of Ontario will pay up to $10,000 in matching funds for companies developing fitness programs.

The U.S. Public Health Service has recommended that all branches and departments of the federal government provide employees with exercise facilities.

Large companies in the U.S., including leading Northwest businesses, also have found it worthwhile. Forty-six percent of the companies in the U.S. employing more than 1,000 people offer fitness programs (see list on this page of major U.S. firms offering fitness facilities).

Smaller companies also have been responding. Thirteen percent of U.S. companies employing between 50 and 99 people now offer fitness programs. Corporate fitness is simply an investment in a major asset—employees. In fact, corporate fitness is one of the best investments a company can make.

Sampling of private firms now committed to physical fitness programs:

American Can Company
ARCO
Bankers Life and Casualty
Boeing
Chase Manhattan
Dun and Bradstreet
Equitable Life
Exxon
Firestone
Forbes Magazine
General Foods
General Motors
General Telephone
Goodyear
Gulf Oil
Kimberley-Clark
Kodak
3M
McGraw-Hill

Merrill Lynch
Metropolitan Life
Mobil
National Cash Register
Northern Natural Gas
Occidental Life
PACCAR
Pepsico
Phillips Petroleum
Prudential Life
Rockwell International
Sentry Life
Sperry Rand
Texaco
Time
Western Electric
Weyerhaeuser
Xerox

Typography/Design	Doug Fast
Typographic Supplier	The Type Gallery
Agency	Jay Rockey Public Relations
Client	Washington Conditioning Club
Principal Type	Century Old Style Bold
Dimensions	8½ x 11 in. (22 x 28 cm)

84

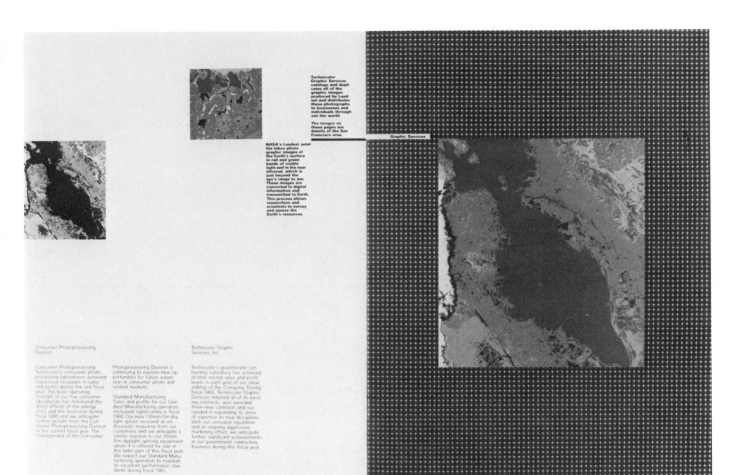

Technicolor Graphic Services catalogs and duplicates all of the graphic images produced by Landsat and distributes these photographs to businesses and individuals throughout the world.

The images on these pages are details of the San Francisco area.

Graphic Services

NASA's Landsat satellite takes photographic images of the Earth's surface in red and green bands of visible light and in the near infrared, which is just beyond the eye's range to see. These images are converted to digital information and transmitted to Earth. This process allows researchers and scientists to survey and assess the Earth's resources.

Consumer Photoprocessing Division

Consumer Photoprocessing Technicolor's consumer photoprocessing laboratories achieved impressive increases in sales and profits during the last fiscal year. The basic operating strength of our five consumer laboratories has minimized the direct effects of the energy crisis and the recession during fiscal 1980 and we anticipate further growth from the Consumer Photoprocessing Division in the current fiscal year. The management of the Consumer

Photoprocessing Division is continuing to explore new opportunities for future expansion in consumer photo and related markets.

Standard Manufacturing Sales and profits for our Standard Manufacturing operation increased significantly in fiscal 1980. Our new 110mm film day light splicer received an enthusiastic response from our customers and we anticipate a similar reaction to our 35mm film daylight splicing equipment when it is offered for sale in the latter part of this fiscal year. We expect our Standard Manufacturing operation to maintain its excellent performance standards during fiscal 1981.

Technicolor Graphic Services, Inc.

Technicolor's government contracting subsidiary has achieved all-time record sales and profit levels in each year of our stewardship of the Company. During fiscal 1980, Technicolor Graphic Services retained all of its existing contracts, was awarded three new contracts, and succeeded in expanding its areas of expertise to new disciplines. With our unrivaled reputation and an ongoing aggressive marketing effort, we anticipate further significant achievements in our government contracting business during this fiscal year.

Typography/Design	Jim Berte
Typographic Supplier	Composition Type
Studio	Robert Miles Runyan & Associates
Client	Technicolor, Inc.
Principal Type	Helvetica
Dimensions	8¾ x 11¾ in. (22 x 30 cm)

85

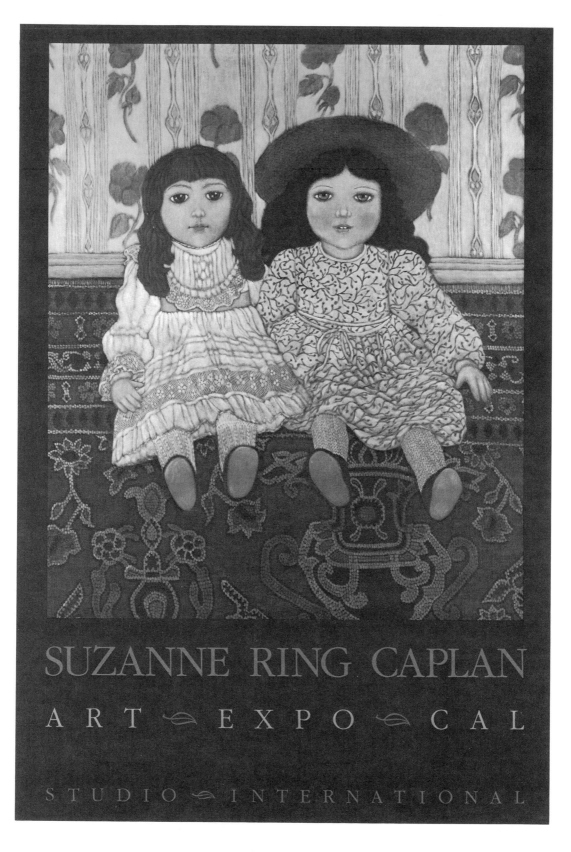

Typography/Design	Don Weller
Typographic Supplier	Alphagraphix
Studio	The Weller Institute
	for the Cure of Design, Inc.
Client	Studio International
Principal Type	ITC Garamond
Dimensions	24 x 36 in. (61 x 91 cm)

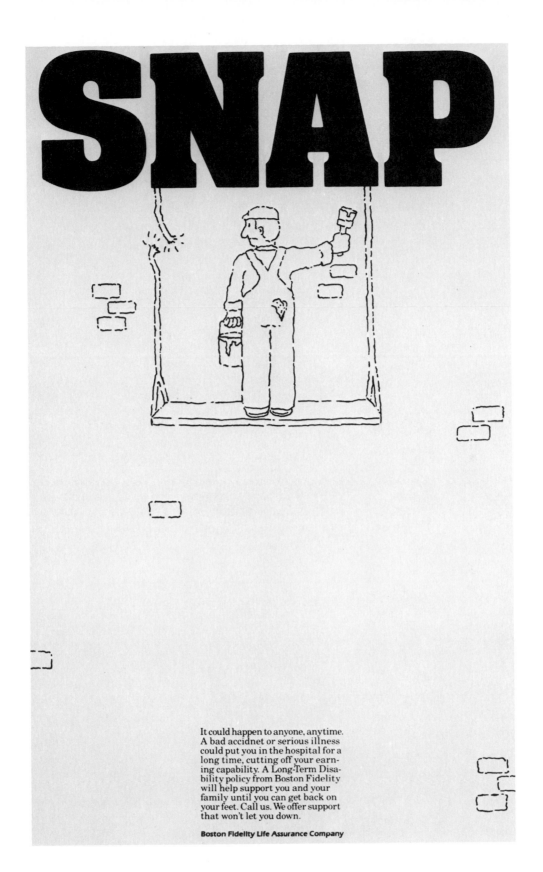

It could happen to anyone, anytime. A bad accidnet or serious illness could put you in the hospital for a long time, cutting off your earning capability. A Long-Term Disability policy from Boston Fidelity will help support you and your family until you can get back on your feet. Call us. We offer support that won't let you down.

Boston Fidelity Life Assurance Company

Typography/Design	David Wright
Typographic Supplier	Swift Tom Type Shop
Studio	Form & Function
Client	Sandi Smith/
	Boston Fidelity Assurance

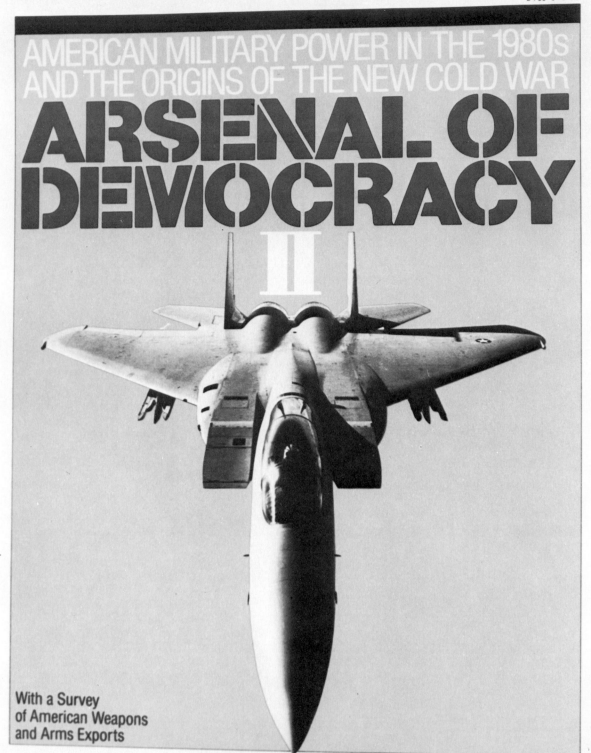

E-760 $10.95

AMERICAN MILITARY POWER IN THE 1980s
AND THE ORIGINS OF THE NEW COLD WAR

ARSENAL OF DEMOCRACY

II

With a Survey
of American Weapons
and Arms Exports

BY TOM GERVASI

Typography/Design	Neil Shakery
Typographic Suppliers	Zimmering & Zinn/
	U.S. Lithograph Inc.
Studio	Jonson Pedersen Hinrichs
	& Shakery
Client	Grove Press
Principal Type	Helvetica
Dimensions	8½ x 11 in. (22 x 28 cm)

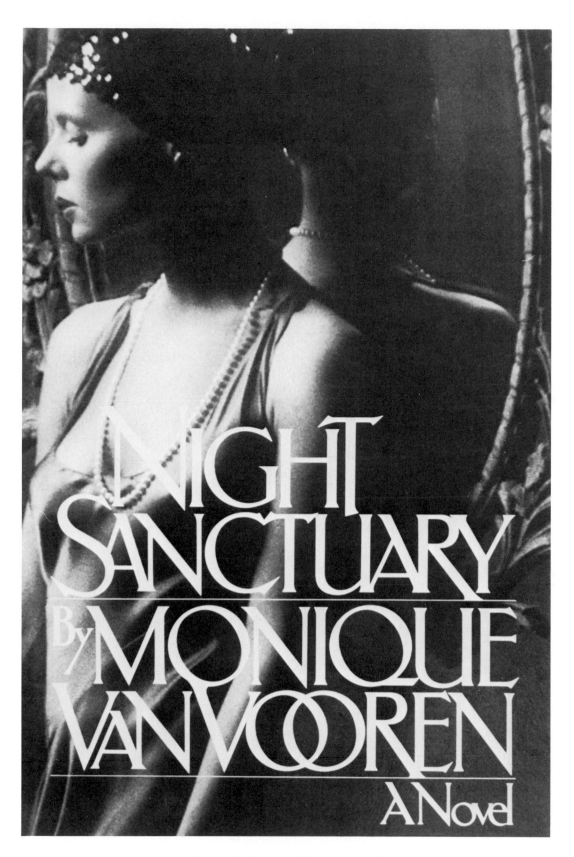

Typography/Design	Robert Anthony
Calligraphy	Vladimir Yevtikhiev
Studio	Robert Anthony, Inc.
Client	Simon & Schuster (Summit Books)
Dimensions	6¼ x 9½ in. (16 x 24 cm)

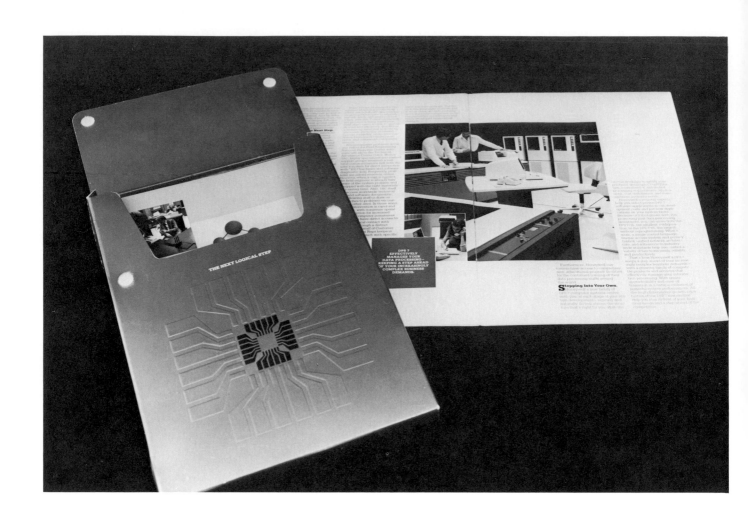

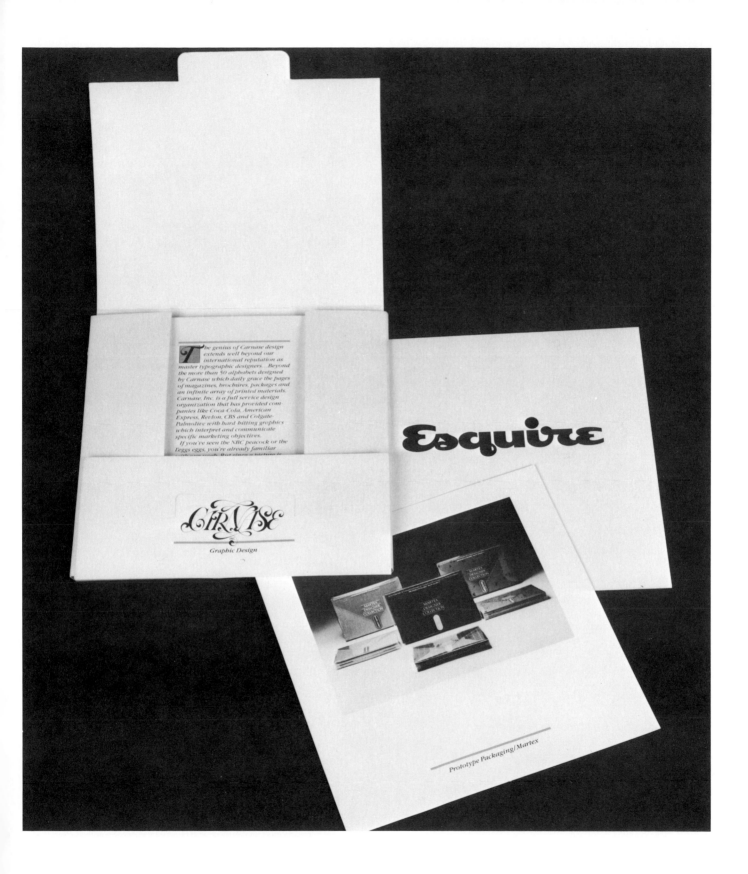

Typography	Tom Carnase
Design	Joe Feigenbaum/
	Doug May/Jason Calfo
Typographic Supplier	Carnase Typography
Studio/Client	Carnase, Inc.
Principal Type	Garamond
Dimensions	6⅛ x 6⅛ in. (16 x 16 cm)

91

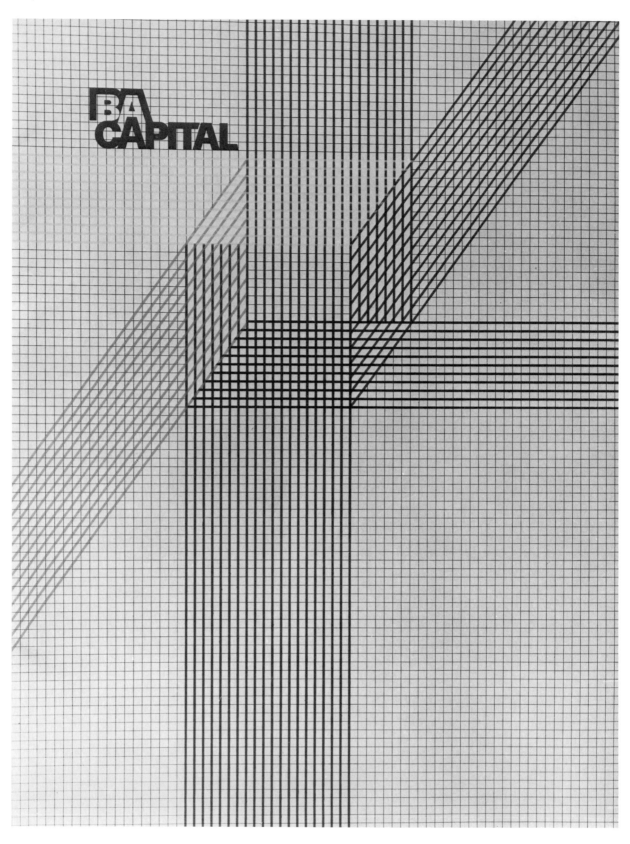

Typography/Design	Jeffrey Moriber
Typographic Supplier	Characters
Agency	Hill and Knowlton, Inc.
Client	BA Capital Corporation
Principal Type	Heads: Helvetica Bold
	Body: Trade Gothic
Dimensions	20 x 50 picas

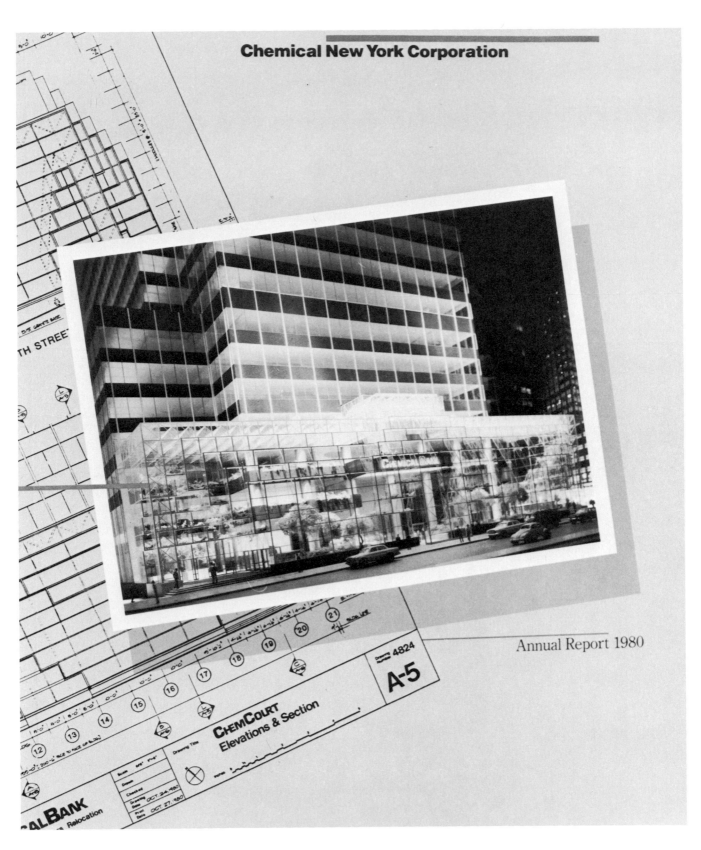

Annual Report 1980

Typography	Robert V. Prestyly, Jr.
Design	Richard J. Whelan
Typographic Supplier	Pastore DePamphilis Rampone Inc.
Studio	The Whelan Design Office Inc.
Client	Chemical New York Corporation
Principal Type	Heads: Helvetica Bold
	Body: Century Old Style
Dimensions	9 x 11 in. (23 x 28 cm)

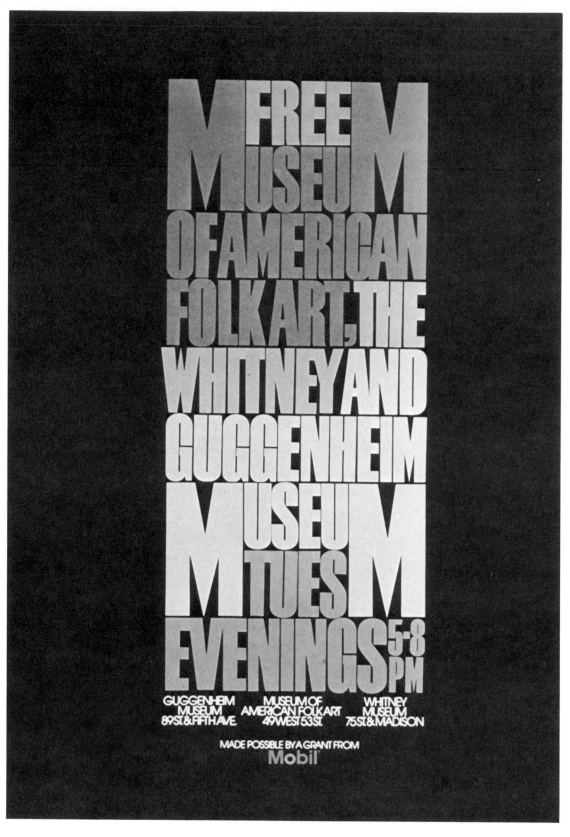

Typography/Design | Alan Peckolick
Typographic Supplier/Studio | Lubalin, Peckolick
| Associates Inc.
Client | Mobil Oil
Principal Type | Lettera Fat
Dimensions | 47½ x 68½ in. (121 x 174 cm)

We have entered a new age.
The age of corporate clutter.
Page after page of every
business publication is devoted
to the paid corporate message.
Yet, because of the sheer number
of them, few retain their power
and importance.
Analysts may wade through
them. Decision makers may sift
through them. But for most of the
business and non-business publics,
the nearly one billion dollars
of corporate advertising is blending
into one amorphous logo.
Which is why the corporate
advertiser must look beyond the
traditional business publications
to a medium that allows his
message to stand out.
And which is why these times
demand The Times. Its environ–
ment of integrity surrounds your
message; framing it, elevating it,
separating it from the crowd.
With an immediacy that brings
with it additional power.
Here, the importance of
your ad cannot be denied. You
are in The New York Times.
You have entered a new arena,
but not as a spectator. As a player.

These times demand more of a corporate advertiser.
These times demand The Times.

The New York Times

Typography	Bonnie Hazelton
Design	Ira Madris/Bruce Nelson
Typographic Supplier	Photo-Lettering Inc.
Agency	McCann-Erickson
Client	*The New York Times*
Principal Type	ITC Garamond
Dimensions	14⅞ x 21⁷⁄₁₆ in. (38 x 54 cm)

213 467-4681

Typography/Design	Ken White
Typographic Supplier	Aldus Type Studio, Inc.
Agency/Client	Ken White Design Office, Inc.
Principal Type	Jansen
Dimensions	34¼ x 9⅝ in. (87 x 25 cm)

Typography/Design	Lou Dorfsman/
	Marie-Christine Lawrence/
	David November
Typographic Supplier	TypoGraphics Communications, Inc.
Studio	Lou Dorfsman
Client	The Charles H. Shaw Company
Principal Type	Heads: Caslon 471
	Body: Trade Gothic Light/
	News Gothic Bold
Dimensions	4⅝ x 12¼ in. (12 x 31 cm)

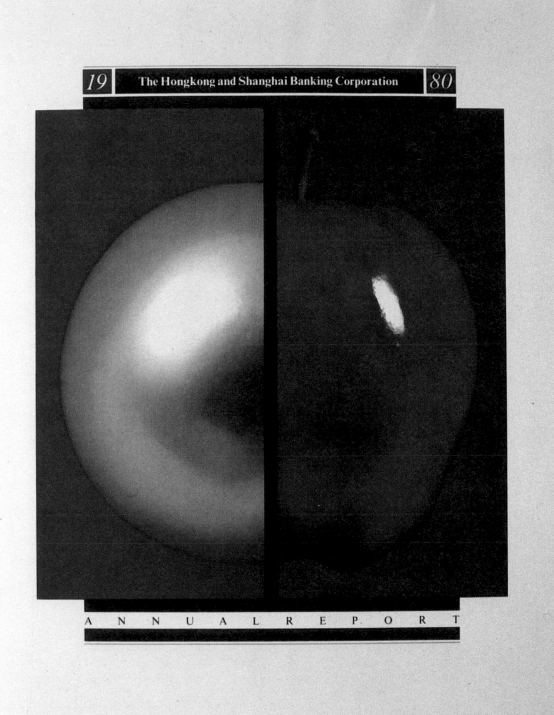

ANNUAL REPORT

Design	Henry Steiner
Typographic Supplier	Asco Trade Typesetting Ltd.
Studio	Graphic Communication Limited, Hong Kong
Client	The Hong Kong and Shanghai Banking Corporation
Principal Type	Heads: Times Bold Body: Times Roman
Dimensions	8 x 11 in. (21 x 28 cm)

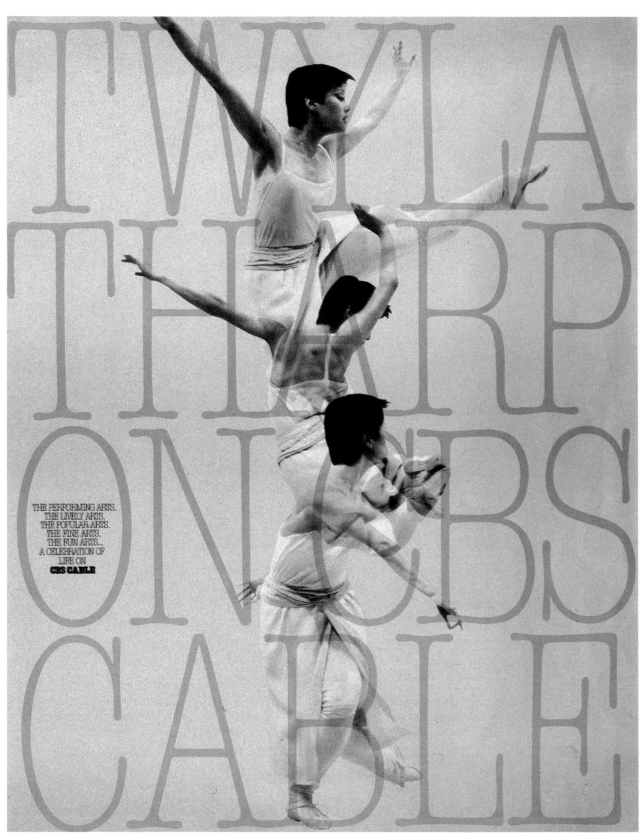

THE PERFORMING ARTS.
THE LIVELY ARTS.
THE POPULAR ARTS.
THE FINE ARTS.
THE FUN ARTS...
A CELEBRATION OF
LIFE ON
CBS CABLE

Typography/Design	Ira Teichberg
Typographic Supplier	TypoGraphics Communications, Inc.
Studio	CBS Advertising & Design
Client	CBS Cable
Principal Type	ITC American Typewriter
Dimensions	24 x 31 in. (61 x 79 cm)

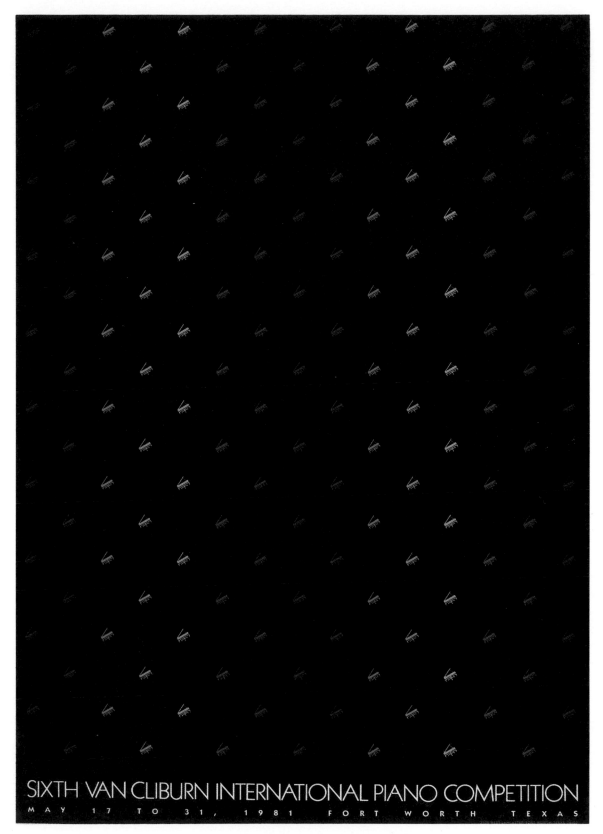

SIXTH VAN CLIBURN INTERNATIONAL PIANO COMPETITION
MAY 17 TO 31, 1981 FORT WORTH TEXAS

Design	Warren Wilkins/
	Tommer Peterson
Typographic Supplier	The Type Gallery
Studio	Wilkins & Peterson
Client	The Van Cliburn Foundation
Principal Type	Kabel
Dimensions	15½ x 21¾ in. (39 x 55 cm)

Typography/Design	Klaus Winterhager
Typographic Supplier	Type Service Leyhausen
Client	Zanders Feinpapiere AG
Principal Type	Heads: Times
	Body: Times/Garamond/Akzidenzgrotesk
Dimensions	22 x 27½ in. (56 x 70 cm)

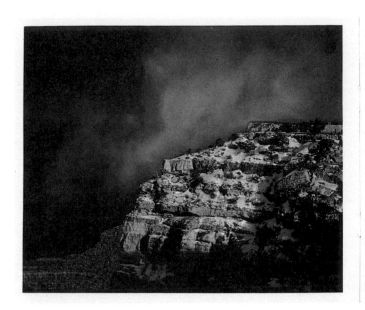

ALONG THE RIM

A ROAD GUIDE TO THE SOUTH RIM OF GRAND CANYON

By Nancy J. Loving
Photography by Tom Bean

Typography/Design/Studio	Don McQuiston & Daughter
Typographic Supplier	Bayer & Brass
Client	Grand Canyon
	Natural History Association
Principal Type	Heads: Michelangelo
	Body: Times Roman
Dimensions	9¼ x 7¼ in. (23.5 x 18.4 cm)

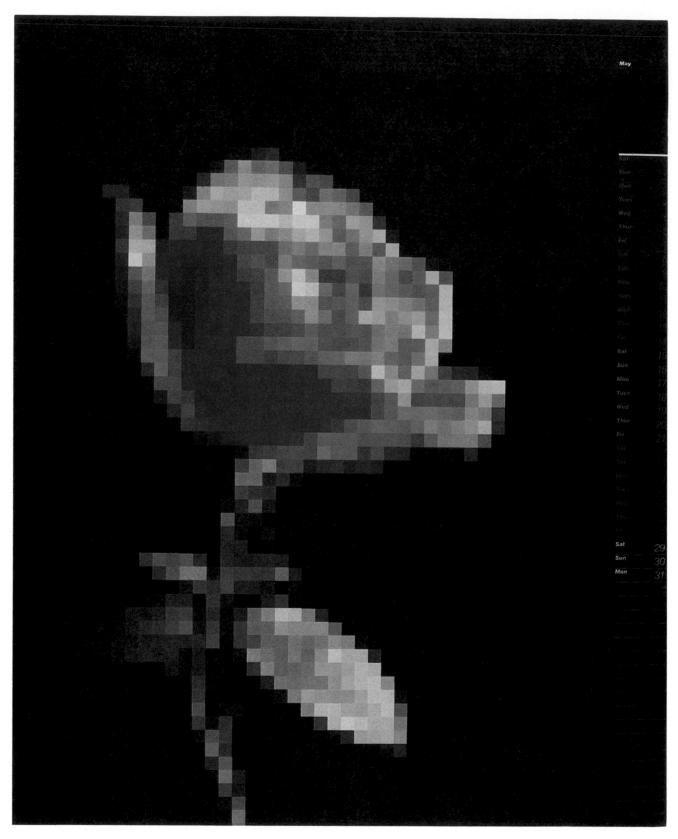

Typography/Design	Joan Dugan
Typographic Supplier	Set-to-Fit
Client	Herlin Press
Principal Type	Helvetica
Dimensions	18 x 22½ in. (46 x 57 cm)

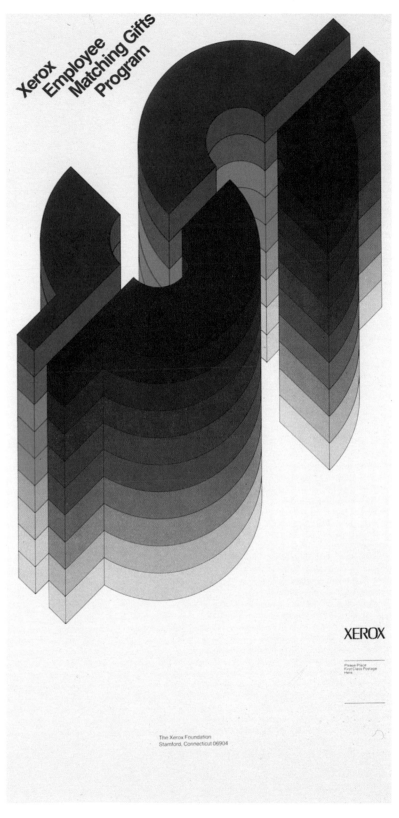

Typography/Design	Stephen D. Chapman/
	Gene Mayer
Typographic Supplier	Set-to-Fit
Agency	Jack Hough Associates, Inc.
Client	Xerox Corporation
Principal Type	Helvetica
Dimensions	9 x 18½ in. (23 x 47 cm)

A TRIBUTE
Humanity has been enriched by their existence

Anwar Sadat: He was a man of great, great personal warmth. If he liked a person, he let them know it; he gathered them into his arms almost. He was a great philosopher; he was a dreamer.... His courage was known to everyone. But personal bravery, beyond political courage, was also a hallmark of Anwar Sadat. The nation, the world, lost a statesman, but it also lost a man. [Walter Cronkite, "CBS Evening News with Dan Rather," October 6, 1981] Roy Wilkins: No fight meant more to Roy Wilkins and no victory was sweeter than Brown versus the Topeka Board of Education. The 1954 Supreme Court decision declaring separate but equal schools inherently unequal, and thus unconstitutional, was the most significant victory for black people since the Emancipation Proclamation. All his life, Roy Wilkins fought for equality and never abandoned his dream of a fully integrated America. [Randy Daniels, "CBS News Special Report: Roy Wilkins—The Man and the Movement," September 9, 1981] Lowell Thomas: He just loved the face of the earth. I suppose he would have agreed with Macaulay,

who wrote somewhere that there are two things that endure through the ages. One is the great features of nature and the other is the human heart. And Lowell loved the seas and the deserts and the mountains and he loved stories about people, and that's almost a kind of journalism that's gone. We're all too damn serious. [Eric Sevareid, "CBS News Special Report: Remembering Lowell Thomas," August 31, 1981] Omar Bradley: During World War II, Bradley commanded the largest American force ever assembled, more than a million soldiers. Bradley cared about his troups, and the GI's knew it, and they nicknamed him "the GI's general." So all the pomp and circumstance was not for the five stars so much as for the man who wore them. [Richard Threlkeld reporting, "Morning with Charles Kuralt," April 14, 1981] Robert Moses: He did more than anybody else, probably, to shape American cities. And to the extent that they are choked with cars, he probably deserves more blame than anybody else. He built, and nobody could stop him. "If the end doesn't justify the means," Robert Moses said, "what does?" [Charles Kuralt, "Morning with Charles Kuralt," July 30, 1981]

Typography/Design	David November/ Marie-Christine Lawrence
Studio	CBS Entertainment Promotion
Client	CBS Television Network
Principal Type	Heads: Goudy Bold/Franklin Gothic Body: Goudy Bold
Dimensions	8¾ x 8½ in. (22.2 x 21.6 cm)

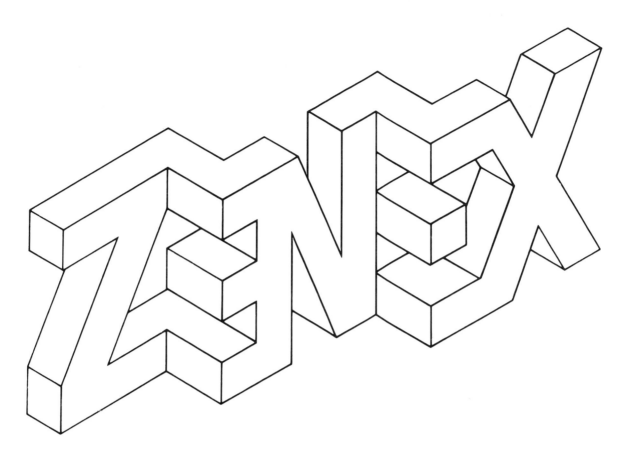

Typography/Design/Calligraphy | Tony Forster
Studio | Royle Murgatroyd & Forster
Client | Zenex Partnership Limited

Typography/Design | Joseph M. Essex
Calligraphy | Joseph M. Essex/
| Marilyn Lurie
Agency | Burson • Marsteller
Client | Spiegel Corporation

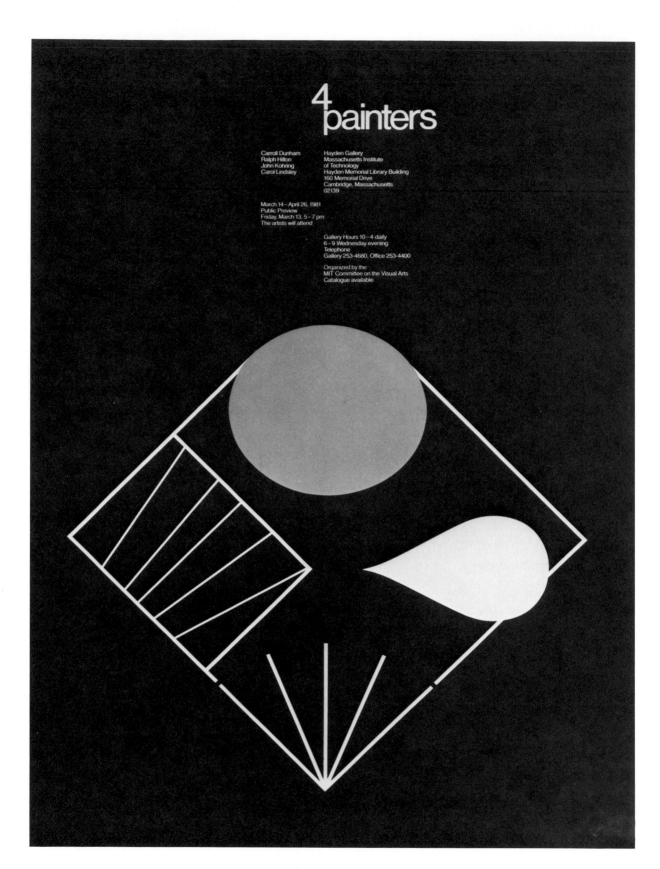

4 painters

Carroll Dunham
Ralph Hilton
John Kohring
Carol Lindsley

Hayden Gallery
Massachusetts Institute
of Technology
Hayden Memorial Library Building
160 Memorial Drive
Cambridge, Massachusetts
02139

March 14 – April 26, 1981
Public Preview
Friday, March 13, 5 – 7 pm
The artists will attend

Gallery Hours 10 – 4 daily
6 – 9 Wednesday evening
Telephone
Gallery 253-4680, Office 253-4400

Organized by the
MIT Committee on the Visual Arts
Catalogue available

Typography/Design	Jacqueline S. Casey
Typographic Supplier	Typographic House
Studio	MIT Design Services
Client	MIT, Committee on the Visual Arts
Principal Type	Helvetica
Dimensions	22 x 29 in. (56 x 74 cm)

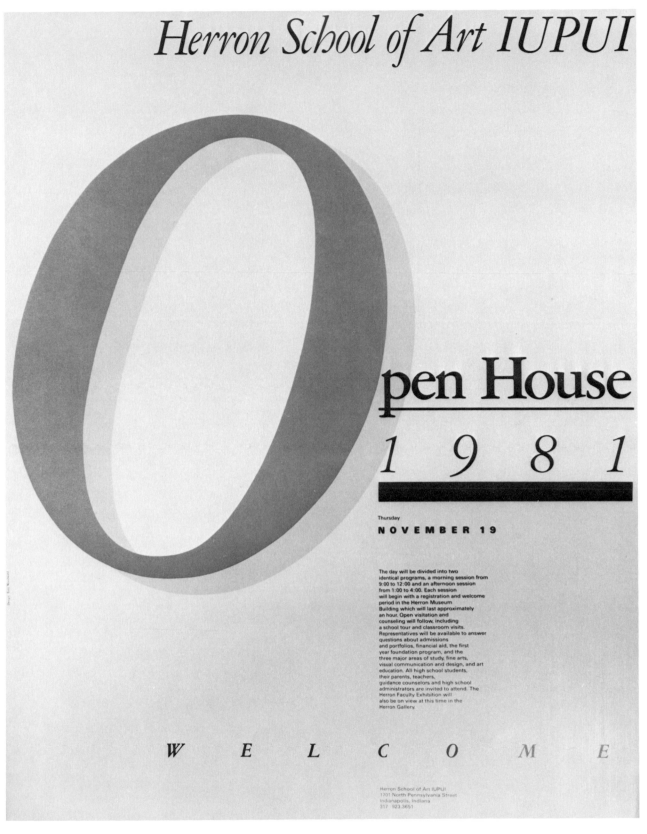

Typography/Design	Tony Woodward
Typographic Supplier	Weimer Typesetting Co., Inc.
Client	Herron School of Art
Principal Type	Heads: Garamond Body: Univers
Dimensions	17 x 22 in. (43 x 56 cm)

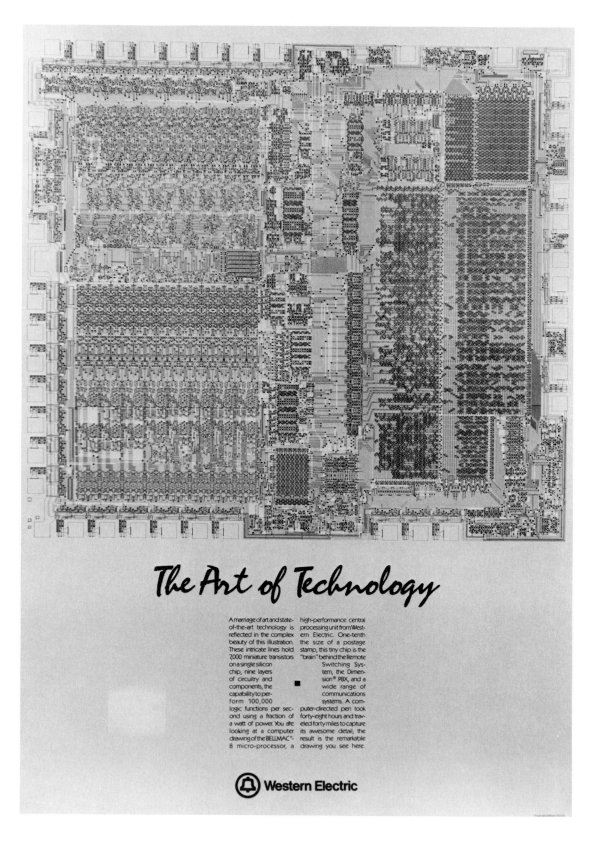

The Art of Technology

A marriage of art and state-of-the-art technology is reflected in the complex beauty of this illustration. These intricate lines hold 7,000 miniature transistors on a single silicon chip, nine layers of circuitry and components, the capability to perform 100,000 logic functions per second using a fraction of a watt of power. You are looking at a computer drawing of the BELLMAC®-8 micro-processor, a high-performance central processing unit from Western Electric. One-tenth the size of a postage stamp, this tiny chip is the "brain" behind the Remote Switching System, the Dimension® PBX, and a wide range of communications systems. A computer-directed pen took forty-eight hours and traveled forty miles to capture its awesome detail; the result is the remarkable drawing you see here.

Ⓐ Western Electric

Typography/Design	Ronald Ridgeway
Typographic Suppliers	Typographic Innovations/ Pastore DePamphilis Rampone Inc.
Studio	Design Four
Client	Western Electric
Principal Type	Heads: Mistral Body: Kabel
Dimensions	26 x 38 in. (66 x 97 cm)

108

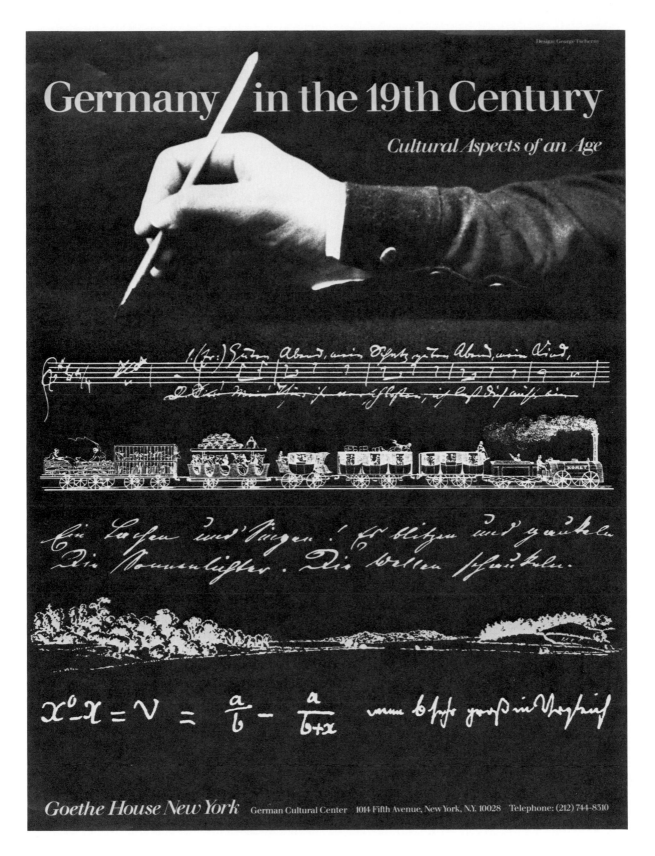

Typography/Design	George Tscherny
Typographic Supplier	Pastore DePamphilis Rampone Inc.
Studio	George Tscherny, Inc.
Client	Goethe House, New York
Principal Type	Walbaum
Dimensions	22 x 29 in. (56 x 74 cm)

The Elephant Man

"Sometimes I think my head is so big because it is so full of dreams."

An Auspicious Debut For ABC Theatre On Broadway

Typography/Design	Carolyn Lamont
Typographic Supplier	Volk & Huxley
Client	ABC Sales Development
Principal Type	Belwe
Dimensions	7¼ x 11 in. (18 x 28 cm)

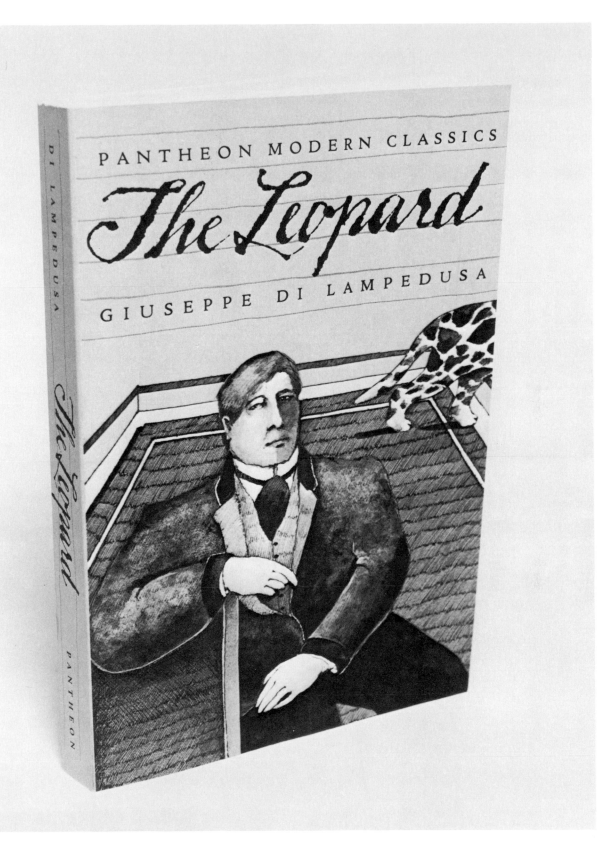

Typography/Design/Calligraphy	Louise Fili
Typographic Supplier	Haber Typographers, Inc.
Client	Pantheon Books
Principal Type	Cloister
Dimensions	5½ x 8¼ in. (14 x 21 cm)

The
Chimera
Broadsides

It falls onto my page like rain
the morning here
and the ink-marks run
to a smoke and stain, a vine-cord, hair:

this script that untangles itself
out of wind, briars, stars unseen,
keeps telling me what I mean
is theirs, not mine:

I try to become all ear
to contain their story:
it goes on arriving from everywhere:
it overflows me

and then:
a bird's veering
into sudden sun
finds me for a pen

a feather on grass,
a blade tempered newly
and oiled to a gloss
dewless among dew:

save for a single
quicksilver drop—
one from a constellation
pearling its tip

Charles Tomlinson

26

Typography/Design	Kathleen Walkup
Typographic Supplier	Mackenzie-Harris
Calligraphy	Janice Mae Schopfer/
	Georgianna Greenwood
Studio	Matrix Press
Client	Chimera Books
Principal Type	Spectrum
Dimensions	11 x 14 in. (28 x 36 cm)

The American Institute of Architects 1735 New York Avenue, N.W. Washington, D.C. 20006

Typography/Design	Lynda Maudlin
Typographic Supplier	Composition Systems Inc.
Calligraphy	Penny Saiki
Client	American Institute of Architects
Principal Type	Palatino
Dimensions	7 x 5 in. (18 x 13 cm)

113

create standardized goods and then to locate and persuade large numbers of consumers to buy those goods after they were made.

Now let's see how this change actually took place. Eli Terry was a Connecticut custom-clock maker. He decided that by following a new standardized process he could make clocks with interchangeable parts. Using a primitive assembly-line technique (borrowed from his Connecticut neighbor Eli Whitney, who in 1798 was busy mass-producing guns for the U.S. Government), Terry first made four identical clocks. These he packed in

Patent Clocks,
MADE AND SOLD AT PLYMOUTH, CONNECTICUT
BY
ELI TERRY,
INVENTOR AND PATENTEE.
WARRANTED, IF WELL USED.

his horse's saddlebags–one in front, one behind and one on each side. So laden, he set off across the wintry hills of the Connecticut River Valley on a sales trip, seeking buyers among the farmers.

Terry struck a unique bargain with these doubting farmers. He would leave the clock, and if it gave good service, he would collect payment on his next trip along that route; if the clock proved faulty, the customer would owe him nothing. It was an irresistible offer, and even the most skeptical were hard put to find a flaw in it. Thus Terry became the first American

Typography	Roy Zucca
Design	Laura Kerner
Typographic Supplier	Pastore DePamphilis Rampone Inc.
Agency/Client	Young & Rubicam Inc.
Principal Type	Heads: Avant Garde Gothic Book Condensed Body: Glypha Light 45
Dimensions	8 x 8 in. (20 x 20 cm)

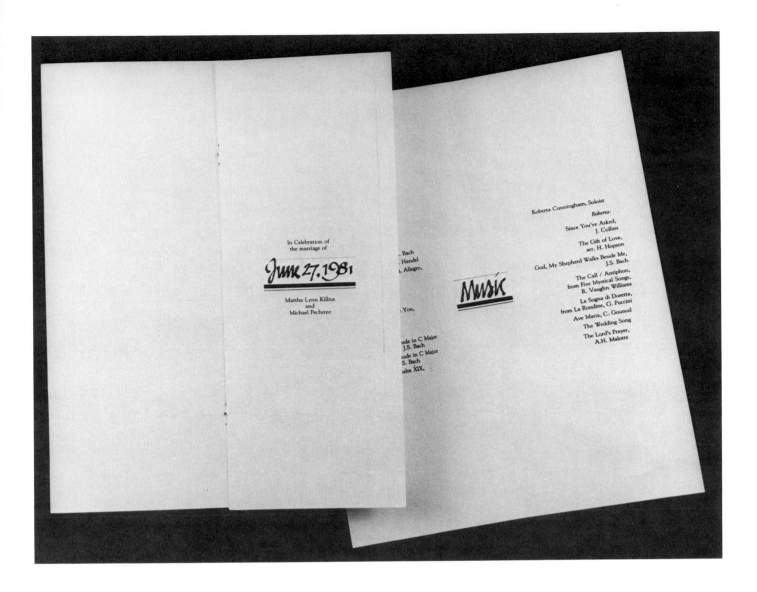

Typography/Design/Calligraphy	Louise Hutchison
Typographic Supplier	Sarah J. Perkins
Clients	Martha Killius/
	Michael Pechnyo
Principal Type	Goudy Old Style
Dimensions	4¼ x 11 in. (11 x 28 cm)

**Japanese
Experimental
Film
1960-1980**

Design	Steven Schoenfelder
Typographic Supplier	Photogenic Graphics, Inc.
Studio	Steven Schoenfelder Design
Client	The American Federation of Arts
Principal Type	Helvetica
Dimensions	9 x 10 in. (23 x 25 cm)

1982 Calendar

Photographs by
Fredrich Cantor

PARIS

© 1981 by Fredrich Cantor Designed by Willi Kunz

Typography/Design	Willi Kunz
Typographic Supplier	Typogram
Studio	Willi Kunz Associates Inc.
Client	Fredrich Cantor
Principal Type	Univers
Dimensions	9⅛ x 12 in. (23 x 30.5 cm)

Typography/Design	David November/
	Marie-Christine Lawrence
Studio	CBS Entertainment Promotion
Client	CBS Television Network
Principal Type	Goudy/ITC Cheltenham
Dimensions	10¾ x 9 in. (27 x 23 cm)

THE ART OF LEO & DIANE DILLON

BYRON PREISS, EDITOR
BALLANTINE BOOKS NEW YORK

Typography/Design/Calligraphy	Alex Jay
Typographic Supplier	Typographic Images
Studio	Studio J
Client	Byron Preiss Visual Publications
Principal Type	Eras Book
Dimensions	8¾ x 11¾ in. (22 x 30 cm)

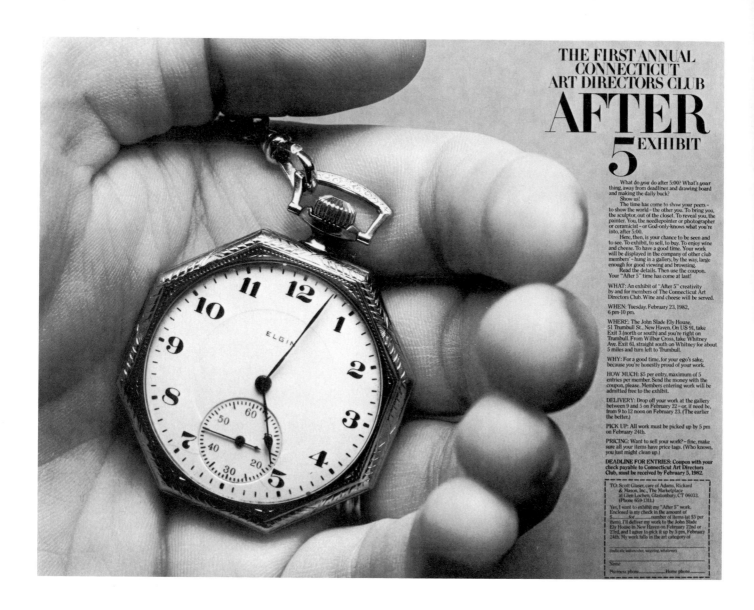

Typography/Design	Scott A. Glaser
Typographic Supplier	Typographic House
Agency	Adams, Rickard & Mason, Inc.
Client	The Connecticut
	Art Directors Club
Principal Type	Heads: Didi
	Body: Clearface Roman
Dimensions	19¼ x 15⅞ in. (49 x 40 cm)

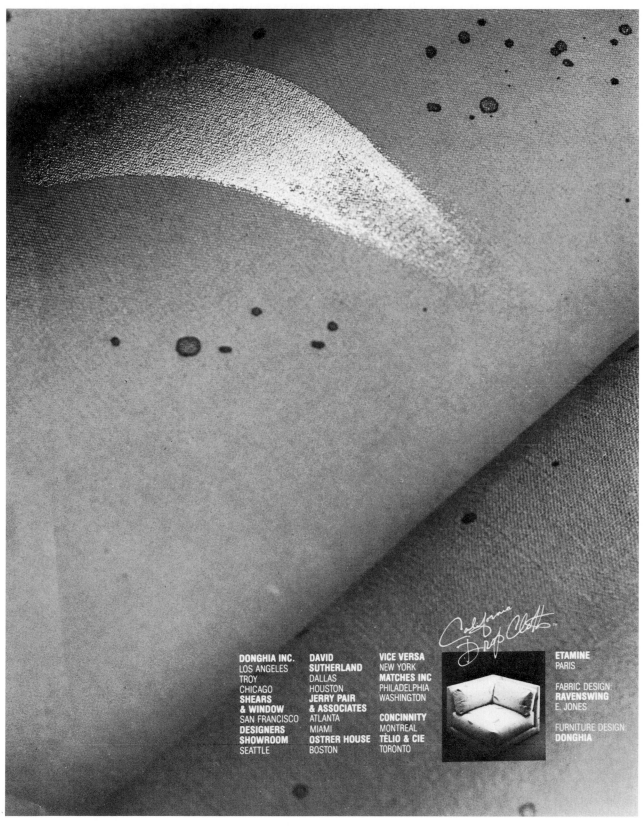

DONGHIA INC.
LOS ANGELES
TROY
CHICAGO
SHEARS
& WINDOW
SAN FRANCISCO
DESIGNERS
SHOWROOM
SEATTLE

DAVID
SUTHERLAND
DALLAS
HOUSTON
JERRY PAIR
& ASSOCIATES
ATLANTA
MIAMI
OSTRER HOUSE
BOSTON

VICE VERSA
NEW YORK
MATCHES INC
PHILADELPHIA
WASHINGTON

CONCINNITY
MONTREAL
TÊLIO & CIE
TORONTO

ETAMINE
PARIS

FABRIC DESIGN:
RAVENSWING
E. JONES

FURNITURE DESIGN:
DONGHIA

Typography/Design	Joe Feigenbaum/ Takaaki Matsumoto
Typographic Supplier	Concept Typographers, Inc.
Studio	T & J Design
Client	California Drop Cloth, Inc.
Principal Type	Univers 57
Dimensions	8½ x 11 in. (22 x 28 cm)

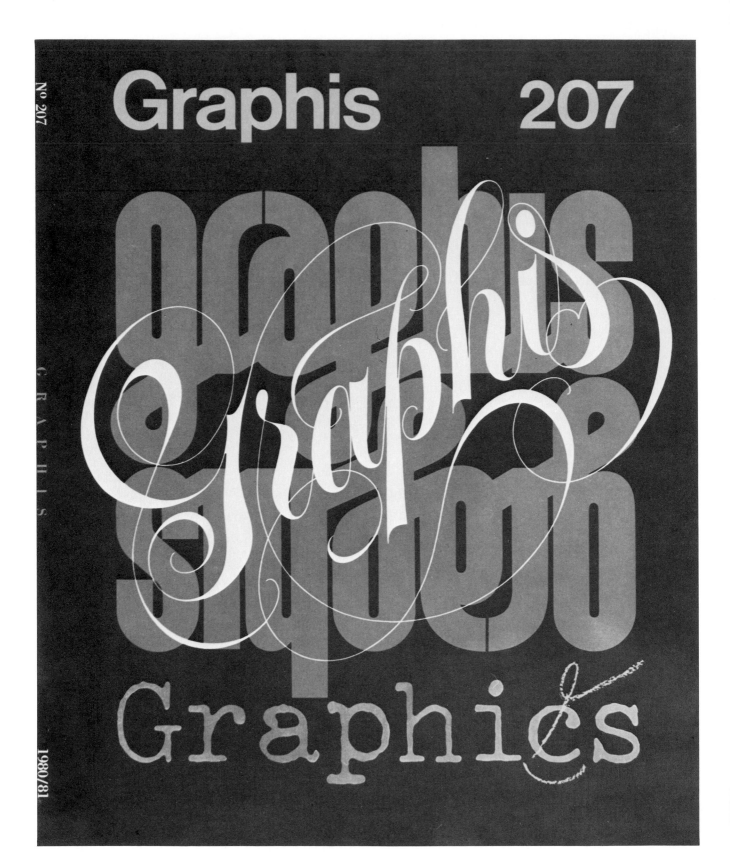

Typography/Design	Alan Peckolick/Ernie Smith/
	Tony DiSpigna
Calligraphy	Tony DiSpigna
Studio	Lubalin, Peckolick
	Associates Inc.
Client	Graphis Press

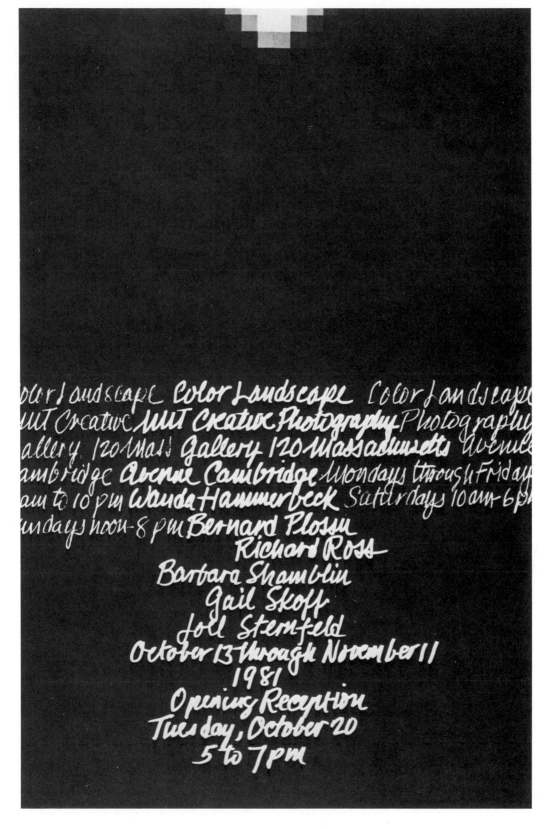

Typography/Design/Calligraphy	Ralph Coburn
Typographic Supplier/Studio	MIT Design Services
Client	MIT, Creative Photography
	Laboratory
Dimensions	11 x 17 in. (28 x 43 cm)

123

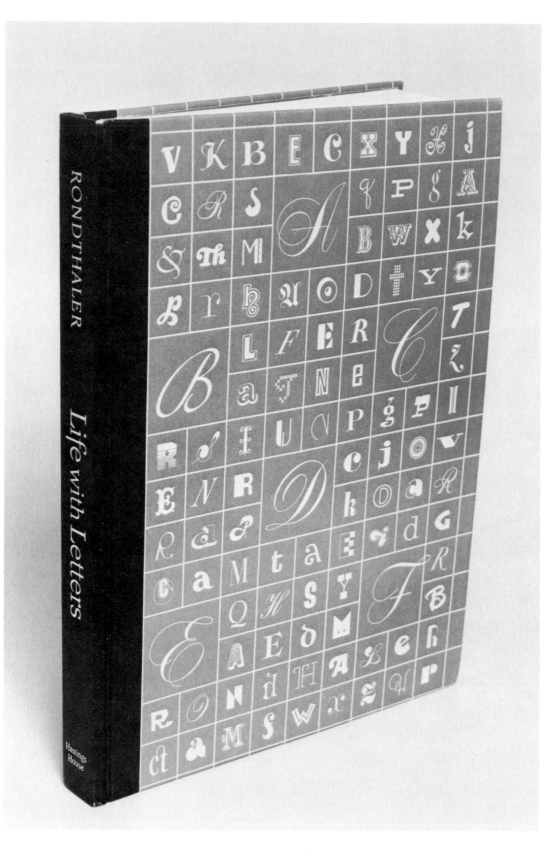

Typography/Design	Edward Rondthaler
Typographic Supplier	Photo-Lettering, Inc.
Client	Hastings House, Publishers
Principal Type	Narrator
Dimensions	7 x 10 in. (18 x 25 cm)

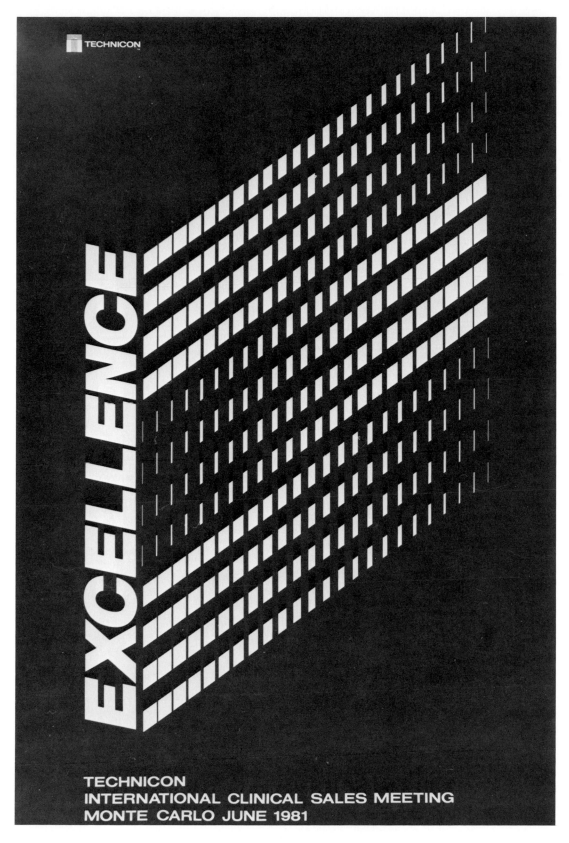

Typography/Design	Rick Stubbins/James Kwolyk
Typographic Supplier	Letraset
Studio	Technicon Marketing Communications Group
Client	Technicon International Division
Principal Type	Helvetica
Dimensions	24 x 36 in. (61 x 91 cm)

125

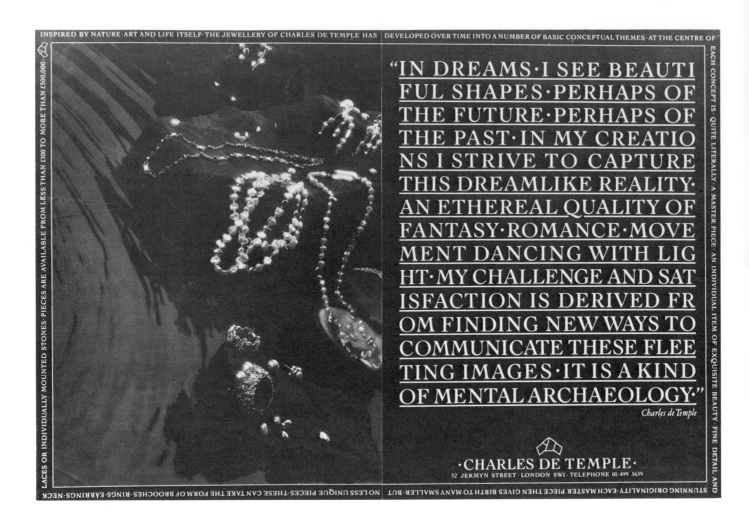

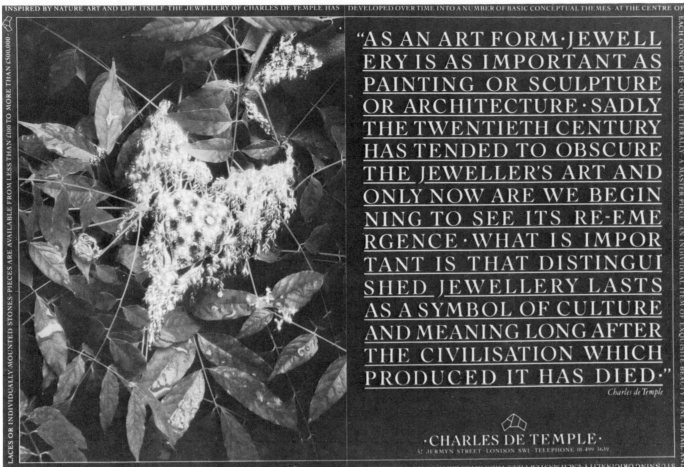

127

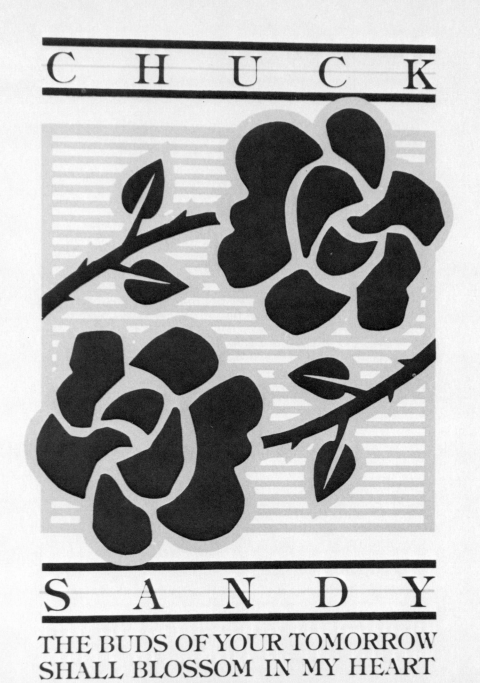

CHUCK

SANDY

THE BUDS OF YOUR TOMORROW
SHALL BLOSSOM IN MY HEART

Typography/Design	Charles S. Anderson
Typographic Supplier	Seitz Yamamoto & Moss Inc.
Client	Charles & Sandy Anderson
Principal Type	Tiffany
Dimensions	4½ x 6 in. (12 x 15 cm)

128

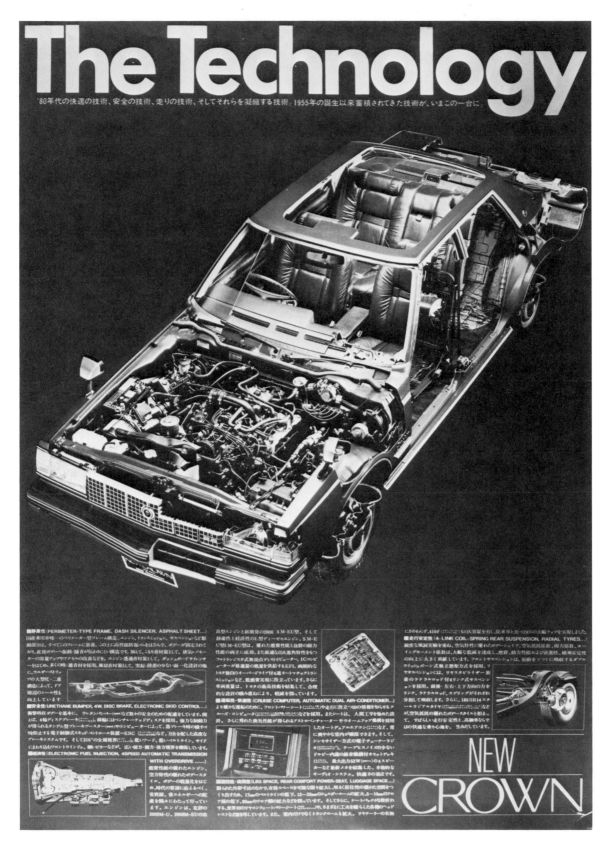

The Technology

'80年代の快適の技術、安全の技術、走りの技術、そしてそれらを凝縮する技術。1955年の誕生以来蓄積されてきた技術が、いまこの一台に。

NEW CROWN

Typography/Design	Toshio Hakuta
Typographic Supplier	Toshin Co., Ltd.
Studio	Nippon Design Center
Client	Toyota Motor Sales Co., Ltd.
Principal Type	Heads: Futura Demibold
	Body: Mincho (Reader)
Dimensions	28¾ x 40½ in. (73 x 103 cm)

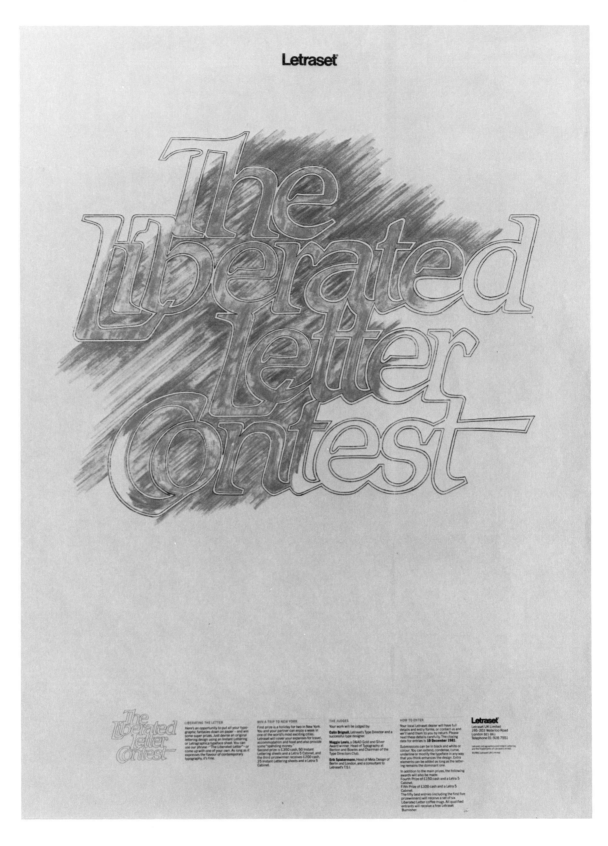

Typography	Michael O'Reilly, MSTD
Design	Paul Butler
Typographic Supplier	Apex Photosetting
Calligraphy	Colin Brignall
Agency	Butler Cornfield Dedman Limited
Client	Letraset UK Limited
Principal Type	Trade Gothic
Dimensions	23⅛ x 33⅛ in. (59 x 84 cm)

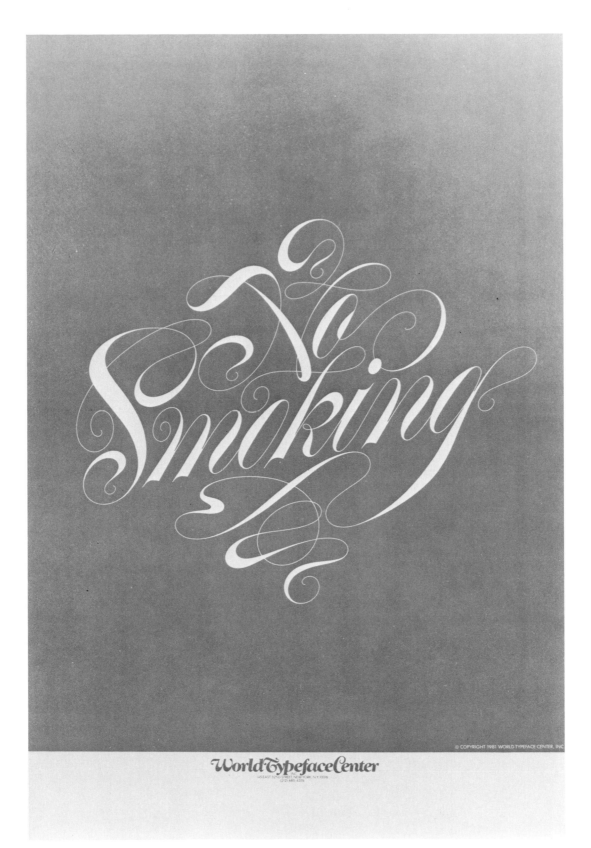

Typography/Design	Tom Carnase
Studio	Carnase, Inc.
Client	World Typeface Center, Inc.
Principal Type	Heads: Script
	Body: WTC Goudy
Dimensions	12 x 18 in. (31 x 46 cm)

131

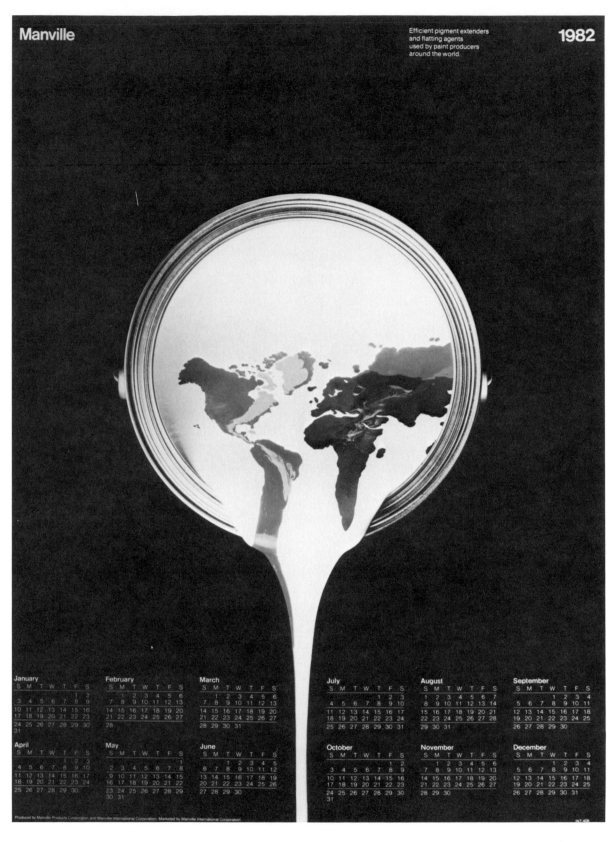

Design | Robert W. Taylor
Typographic Supplier | The Board Room
Studio | Robert W. Taylor Design, Inc.
Client | Manville International Corporation

Principal Type | Helvetica
Dimensions | 15 x 20 in. (38.1 x 50.8 cm)

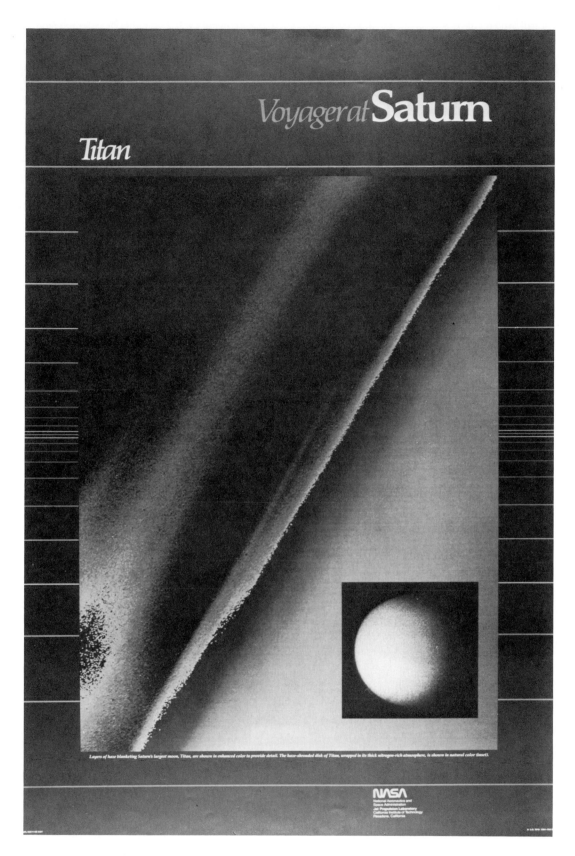

Typography/Design	Ken White/ Tak Kiriyama
Typographic Supplier	R & S Typographics
Agency	Ken White Design Office, Inc.
Client	NASA/JPl
Principal Type	Palatino
Dimensions	24 x 36 in. (61 x 91 cm)

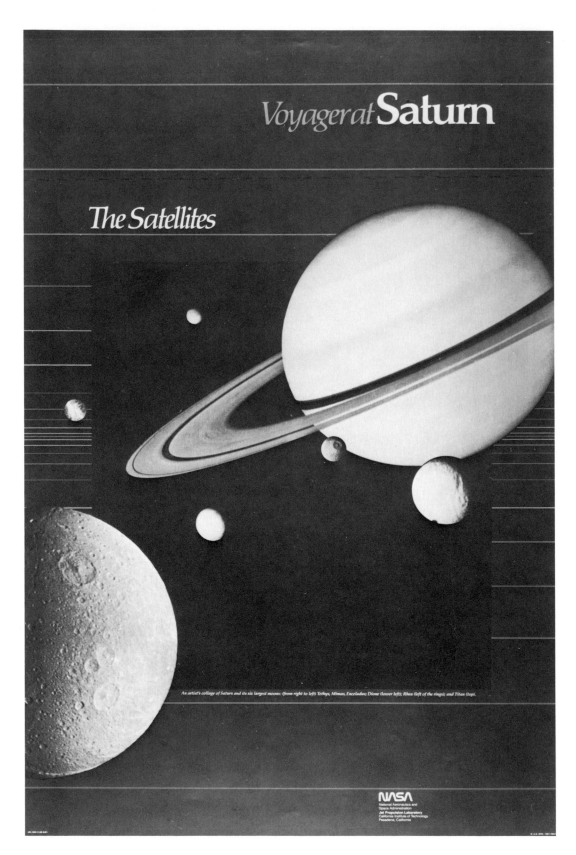

An artist's collage of Saturn and its six largest moons: (from right to left) Tethys, Mimas, Enceladus; Dione (lower left); Rhea (left of the rings); and Titan (top).

Typography/Design	Ken White/
	Tak Kiriyama
Typographic Supplier	R & S Typographics
Agency	Ken White Design Office, Inc.
Client	NASA/JPL
Principal Type	Palatino
Dimensions	24 x 36 in. (61 x 91 cm)

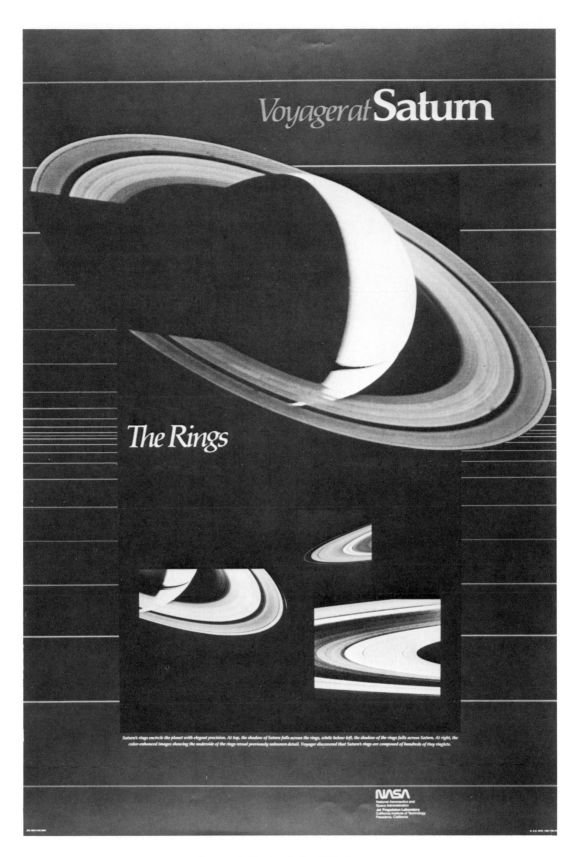

Typography/Design	Ken White/
	Tak Kiriyama
Typographic Supplier	R & S Typographics
Agency	Ken White Design Office, Inc.
Client	NASA/JPL
Principal Type	Palatino
Dimensions	24 x 36 in. (61 x 91 cm)

Typography/Design/
Calligraphy Lars Jonsson
Studio Jonsson & Essen
Creative Graphic Design Group
Client Swedish Psychology,
Ove Nilsson, Stockholm

Design Marty Neumeier
Studio Neumeier Design Team
Client Arntz Cobra

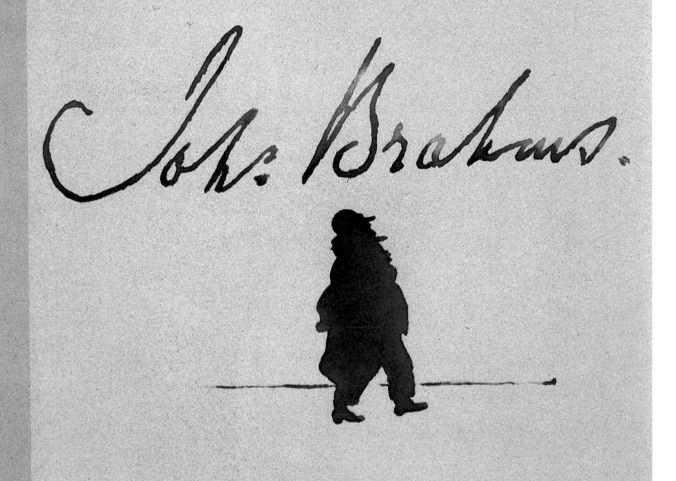

BRAHMS
The Complete Sonatas for Violin and Piano
TOSHIYA ETO, Violin
WILLIAM MASSELOS, Piano

Typography/Calligraphy	Norm Ung
Design	Ron Coro
Typographic Supplier	Andresen Type
Studio	Elektra/Asylum Records
Client	Elektra/Asylum/Nonesuch Records
Principal Type	Futura

Schrift, Musiknoten, Handzeichnungen, sondern auch an Bilder mit malerischem Charakter. Dies läßt sich aus den Farbversuchen ableiten, die der Erfinder selbst unternahm. Bereits in seinem Antrag, der ihm 1799 das Privilegium exclusivum des Bayerischen Kurfürsten einbrachte, und in seiner Londoner Spezifikation von 1801 spricht er vom Farbdruck. In seinem »Musterbuch« führt er unter dem Titel »Erhobene Manier« auch den »colorierten und illuminierten Abdruck«, beide mit mehreren Platten« an. Senefelder teilt mit, er habe im Farbdruck solche Fortschritte gemacht, »daß ich außer den Farben illuminierten Bildern auch noch den Ölgemälden ganz ähnliche Abdrücke liefern kann«. Diese Nachricht kann mit einem Blatt in mehreren Farben zu Feyerbach-Gönners »Allgemeinem Bürgerlichen Gesetzbuch für Bayern« aus dem Jahre 1808 belegt werden. 1809 entstanden zum Teil colorierte Karten. Während der bereits 1807

praktizierte Tondruck von zwei Platten vervollkommnet wurde, bereitete jedoch der Farbdruck von mehreren Platten ziemliche Schwierigkeiten. Erst 1817 lassen sich mit Silber und Gold bedruckte Lithographien nach dem »Turnierbuch Herzogs Wilhelm IV. von Bayern von 1510/45« nachweisen, die Theobald und Clemens Senefelder auf den Stein gezeichnet haben. In seinem »Lehrbuch« (1818) stellt Senefelder die Frage, wie die Lithographie »einer Malerei oder einem in Farben gedruckten Kupferstich ähnlich werden kann, oder ob sie einem illuminierten Kupferstich ähnlich sein soll«. An anderer Stelle heißt es: »Der Druck mit mehreren Farben ist eine Manier, die dem Stein vorzüglich eigen ist, daß man mit der Zeit wahre Gemälde dadurch verfertigen wird.« Im Anhang seines »Lehrbuches« erläutert Senefelder außerdem den »Druck mit Wasser- und Ölfarbe zugleich«. Dabei nimmt er sich den »englischen oder französischen Farbendruck der Kupferstiche« zum Vorbild.

Vielen ist die Tatsache unbekannt, daß J. A. Barth in Breslau bereits 1818 sein farbig illustriertes Werk mit den »Hauptszenen des Friedensvertrages von 1815« im Fünf- und Sechsfarbendruck herausbrachte. 1818/19 legte Joseph Lanzedelly in Wien vorzügliche Farblithographien vor, die als die besten jener Zeit überhaupt gelten dürfen. In München beschäftigte sich Franz Weishaupt intensiv mit dem Farbendruck. 1823 erschienen seine ersten farbigen Blätter zu »Reise in Brasilien« (fortgesetzt 1828 und 1831), 1833 druckte die lithographische Anstalt von C. Hildebrandt die Farbfolge »Ornamente aller klassischen Kunstepochen«, 1835 erschienen bei Charles Hullmandel in London Faksimiledrucke nach Malereien in einem ägyptischen Grab, 1836 die Farblithographien von Owen Jones, welche die Alhambra darstellen.

Alle diese Farblithographien sind Beweise dafür, zu welchen technischen Leistungen der lithographische Steindruck fähig geworden war. Hinsichtlich ihrer malerischen Qualitäten blieben sie jedoch hinter der Malerei zurück, während die Schwarzweißlithographien der späten Zwanziger- und frühen Dreißiger Jahre eigenständigen malerischen Bildcharakter gewonnen hatten. Eine Wende brachte der Dreifarbendruck, den Godefroy Engelmann erfand. Im Dezember legte er seine ersten Abzüge, 1837 sein Album »Chromolithographie« vor. Kurz vorher hatte sein Verfahren noch »Lithocolore« genannt. Im Vorwort seines Albums schreibt

Engelmann: »Lithographie in Farben« – ist das nicht eine Vollkommenheit, die aller Forschung wert war! Die Farblithographie hat nun einen solchen Grad der Perfektion erreicht, daß ich glaube, sie ist endlich am Ziel ihres ersten Entwicklungsstadiums angekommen. Eine neue Ära beginnt.« Wie recht Engelmann hatte, beweisen vor allem die 1839 bei Charles Hullmandel gedruckten Farblithographien »Picturesque Architecture« von Thomas Shotter-Boys, die ohne jede Retouche entstanden, Ihr besonderer Wert liegt darin, daß sie Originale, nicht mehr farbige Nachbildungen sind.

Bevor dann gegen Ende des 19. Jahrhunderts die künstlerische Farblithographie aufs neue dazu beitrug, daß auch Originalgraphik Maßstäbe für hohe Kunst setzte, wirkte sie auch auf die Entwicklung der Plakate ein. Das schwarz-weiße Informationsblatt hat es schon in der Frühgeschichte der Lithographie gegeben. Die Buch- und Zeitungsverlage in Frankreich entwickelten die »affiches intérieures« und die »affiches extérieures«. Es erschienen die »réclames de magasins«. Vor allem in England setzte sich das lithographierte Plakat durch. Auf der Weltausstellung in London im Jahre 1851 standen die papiernen Wetterfahnen der wirtschaftlichen Konjunktur im Blickpunkt. Jules Chéret brachte das farbige Plakat nach Paris mit. Eugène Grasset und Toulouse-Lautrec gaben ihm eine künstlerische Note. Die Plakat-Kunst hat der Lithographie viel zu verdanken. Was Godefroy Engelmann schon 1837 vorhergesagt hatte, verwirklichte

Typography/Design	Fritz Hofrichter/Olaf Leu
Typographic Supplier	Gruetzmacher GmbH, Frankfurt/Main
Calligraphy/Studio	Olaf Leu Design & Partner
Client	Internationale Senefelder-Stiftung
Principal Type	Bodoni Antiqua
Dimensions	11 x 14½ in. (28 x 37 cm)

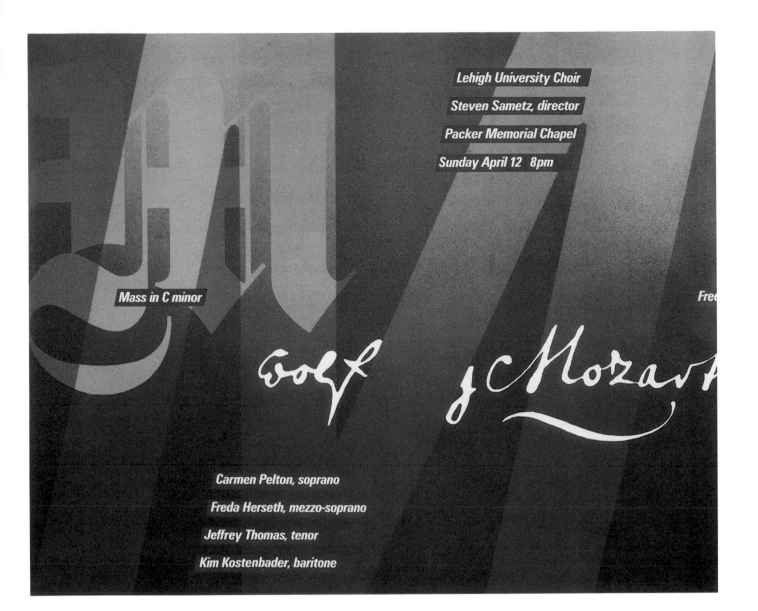

Lehigh University Choir

Steven Sametz, director

Packer Memorial Chapel

Sunday April 12 8pm

Mass in C minor

Free

Carmen Pelton, soprano

Freda Herseth, mezzo-soprano

Jeffrey Thomas, tenor

Kim Kostenbader, baritone

Typography	Roger Sametz
Design	John Kane
Typographic Supplier	Monotype Composition Company, Boston
Calligraphy	Stuart Darsch/Stephen Mignogna
Studio	Sametz Blackstone Associates, Inc.
Client	Lehigh University Choir
Principal Type	Univers

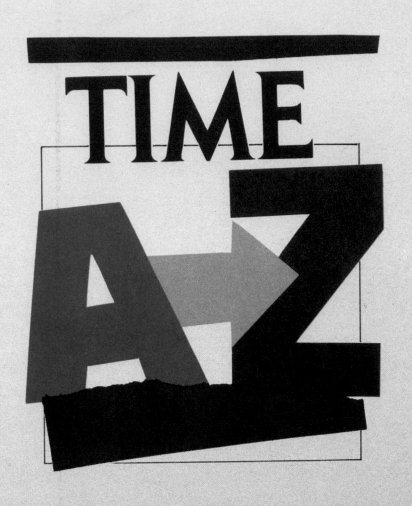

Typography/Design/
Calligraphy Holley Flagg
Typographic Supplier Nassau Typographers
Client Time, Inc.

Principal Type American Typewriter Medium
Dimensions 9 x 9 in. (23 x 23 cm)

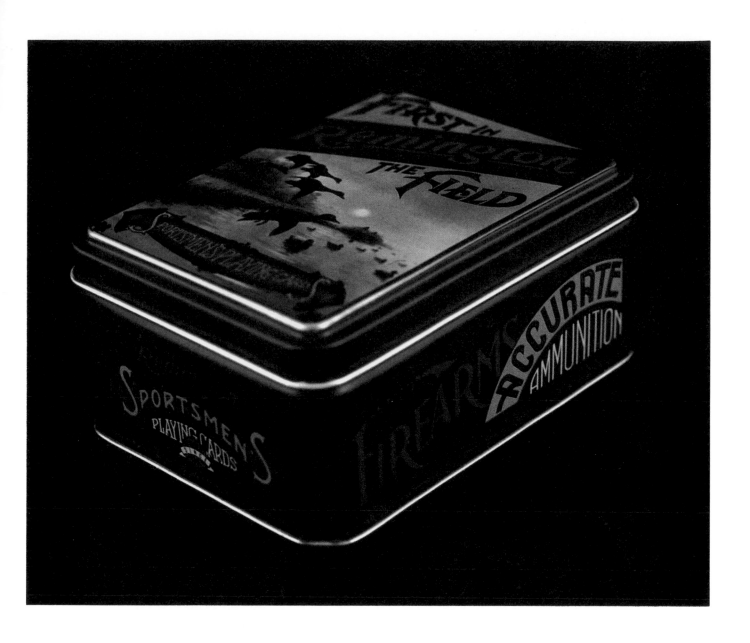

Typography/Design	Michael Fountain
Typographic Supplier/Calligraphy	Michael Doret
Agency	Rumrill-Hoyt Inc.
Client	Remington Arms Co.
Dimensions	3 x 5 x 1¾ in. (8 x 13 x 4 cm)

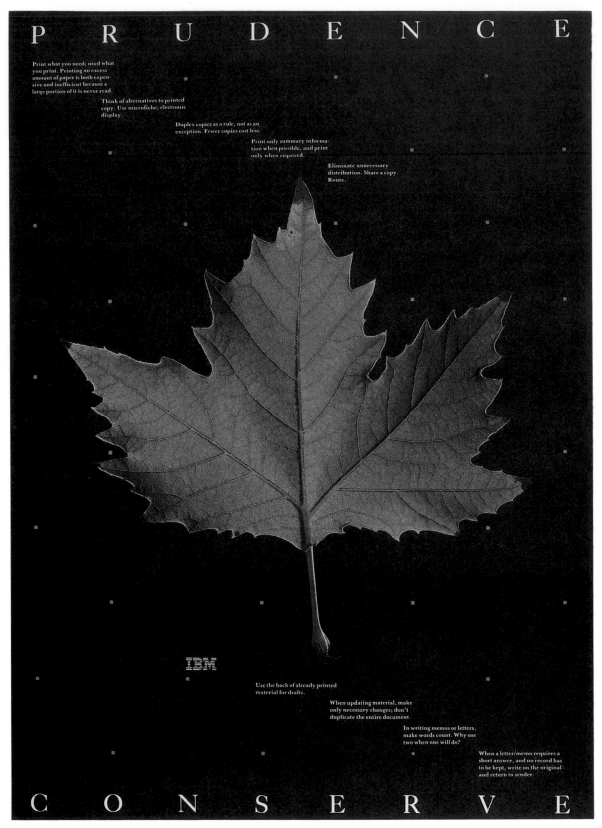

P R U D E N C E

Print what you need; need what
you print. Printing an excess
amount of paper is both expen-
sive and inefficient because a
large portion of it is never read.

Think of alternatives to printed
copy. Use microfiche; electronic
display.

Duplex copies as a rule, not as an
exception. Fewer copies cost less.

Print only summary informa-
tion when possible, and print
only when required.

Eliminate unnecessary
distribution. Share a copy.
Route.

IBM

Use the back of already printed
material for drafts.

When updating material, make
only necessary changes; don't
duplicate the entire document.

In writing memos or letters,
make words count. Why use
two when one will do?

When a letter/memo requires a
short answer, and no record has
to be kept, write on the original
and return to sender.

C O N S E R V E

Design	Kurt W. Gibson
Typographic Supplier	Tucson Type
Studio	IBM Tucson Design Center
Client	IBM Tucson
Principal Type	Baskerville Bold
Dimensions	15 x 21 in. (38 x 53 cm)

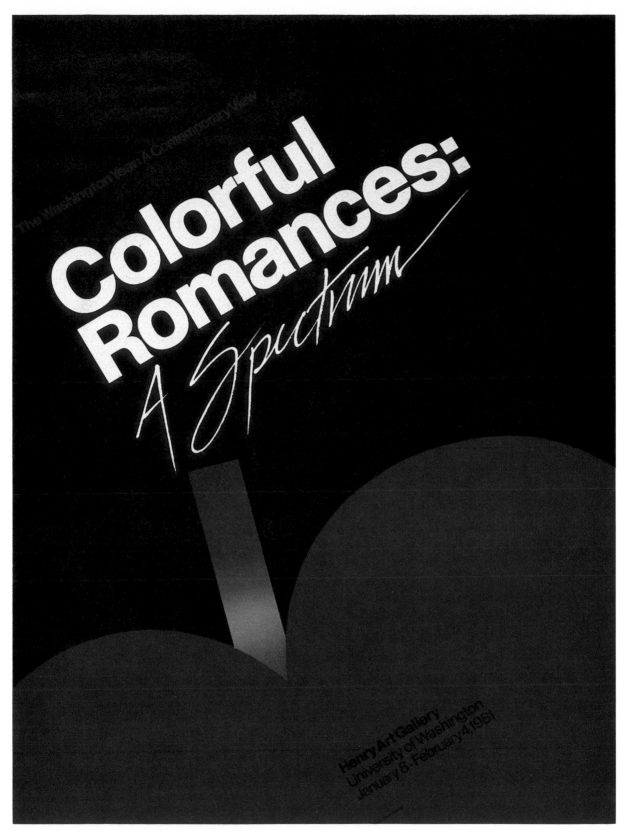

Typography/Design/Calligraphy	Rick Eiber
Typographic Supplier	The Type Gallery
Studio	Rick Eiber Design (RED)
Client	Henry Art Gallery
Principal Type	Header Neo Helvetica Demi
	Body: Helvetica
Dimensions	18 x 24 in. (46 x 61 cm)

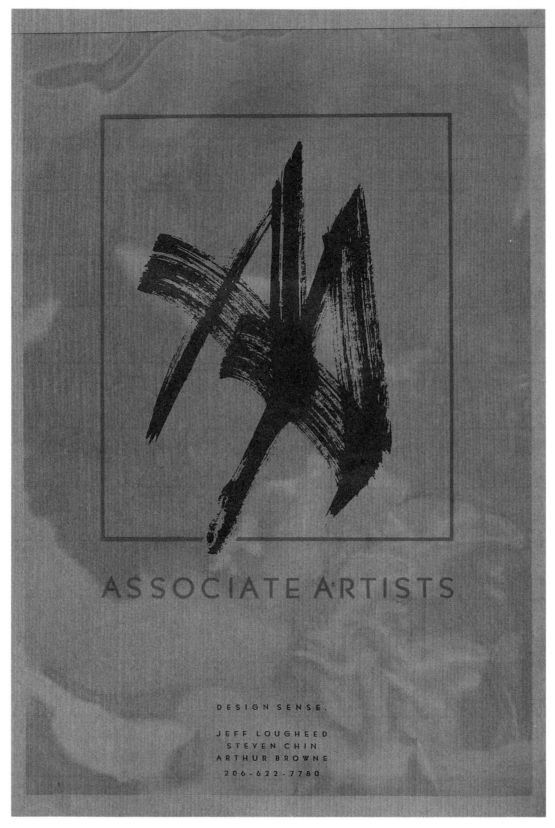

ASSOCIATE ARTISTS

DESIGN SENSE.

JEFF LOUGHEED
STEVEN CHIN
ARTHUR BROWNE
206-622-7780

Typography/ Typographic Supplier	Arthur Browne
Design	Jeff Lougheed/Steve Chinn
Calligraphy	Jeff Lougheed
Studio/Client	Associate Artists
Principal Type	Bernhard Gothic Medium
Dimensions	15 x 22½ in. (38 x 57 cm)

144

Typography/Design | Jeff Barnes
Typographic Supplier | Typographic Arts Inc.
Studio | CCA Communications
Client | CCA Container Division
Principal Type | Helvetica Light
Dimensions | 3½ x 5½ in. (9 x 14 cm)

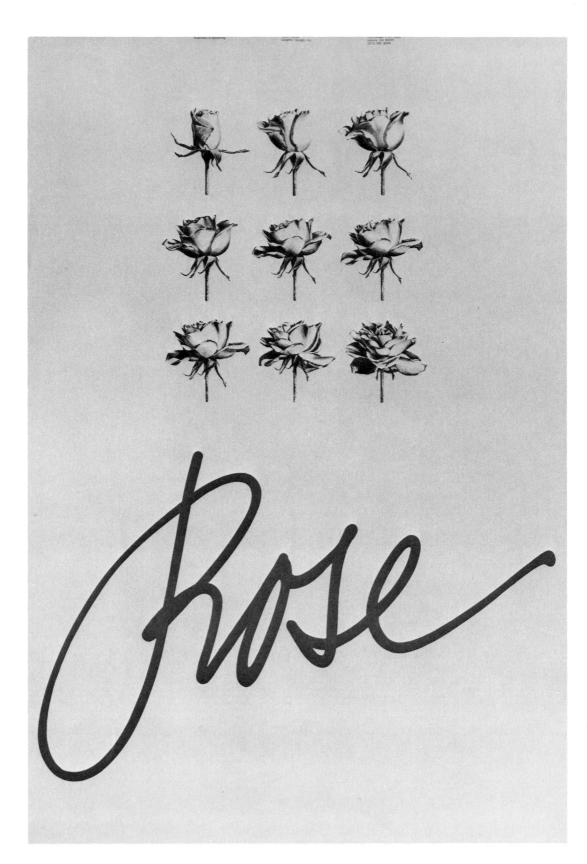

Typography	Rose Farber
Design/Calligraphy	Barry Anderson
Typographic Supplier	Burns Typographers
Studio/Client	Rose Farber
	Graphic Design, Inc.
Principal Type	Helvetica Light
Dimensions	23 x 35 in. (58 x 89 cm)

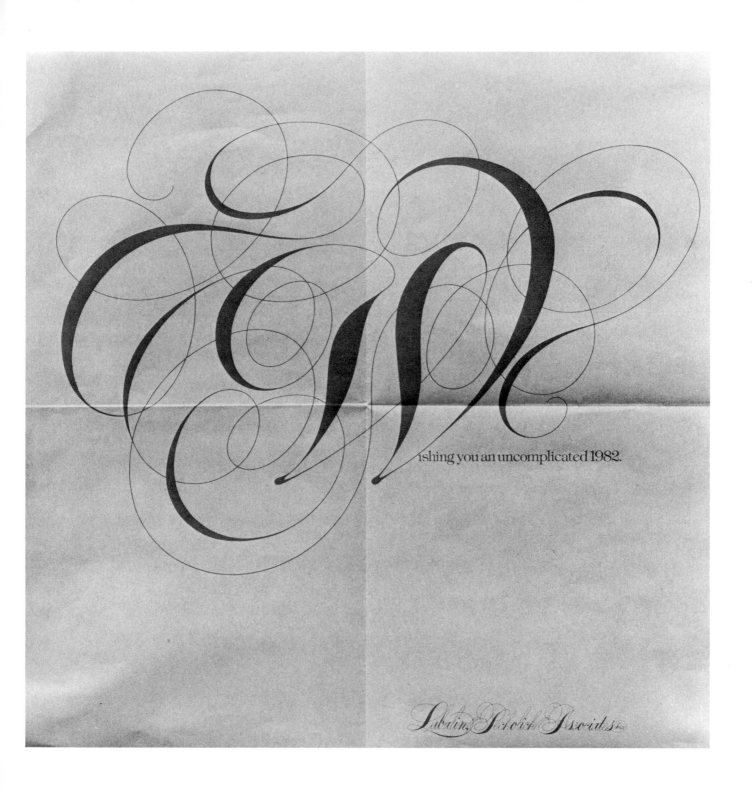

ishing you an uncomplicated 1982.

Typography/Design	Alan Peckolick
Typographic Supplier	M. J. Baumwell
Calligraphy	Tony DiSpigna
Studio/Client	Lubalin, Peckolick Associates Inc.
Principal Type	ITC Garamond Light
Dimensions	12½ x 12½ in. (32 x 32 cm)

147

Charrette Pressure Graphics Catalog, Volume 2

Design	Johanna Bohoy/ Mary Lou Supple
Studio/Client	Charrette
Principal Type	Helvetica Light
Dimensions	8⅛ x 10³⁄₁₆ in. (21 x 26 cm)

WE ARE HAPPY TO INVITE YOU

אנו שמחים להזמין אתכם

TO THE BAR MITZVAH CELEBRATION OF

להשתתף בחגיגת הבר מצוה של

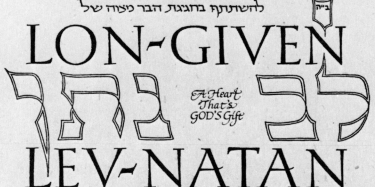

LON~GIVEN

לב נתן

A Heart That's GOD'S Gift

LEV~NATAN

IT WILL TAKE PLACE ON SHABBAT PARAH · TORAH PORTION SHEMINI (RED HEIFER)

שותתקים אי"ה בשבת, פרשת שמיני

22 ADAR 2·5741 · MARCH 28 · 1981 · AT NINE O'CLOCK IN THE MORNING

כ"ב אדר ב' תשמ"א, בשעה תשע בבוקר

AT THE HOUSE OF WORSHIP · TEMPLE ISRAEL · 475 GROVE STREET · RIDGEWOOD · NEW JERSEY

בבית הכנס טעמפל ישראל 475 רחוב גרוב, רידווד, ניו ג'רדי

KIDDUSH FOLLOWING THE PRAYERS

קידוש אחרי התפילה

PLEASE COME

נא לבוא

AVIGAYIL (ABIGAIL) · HIS MOTHER & YEHUDAH (JEROME) CHAPMAN · HIS FATHER

אביגיל, אמו, ויהודה שפמן, אבו

SHAUL LEVINE (SETH LANCE) · HIS BROTHER & HANNAH RACHEL (AMY ROANNE) · HIS SISTER

שאול לוין, אחיו, וחנה רחל, אחותו

RIFKAH (REBECCA) LEVINE CHAPMAN & CIPORAH (PAULINE) BRILL DIAMOND · HIS GRANDMOTHERS

רבכה לוין שפמן וצפורה בריל דיימנד, הסבתא

ISRAEL (WILLIAM) CHAPMAN & SHMUAL YOSEF (SAMUEL JOSEPH) DIAMOND · HIS GRANDFATHERS

ישראל שפמן ושמואל יוסף דיימנד, הסבא

Typography	Leonard Seastone
Design/Calligraphy	Abigail Diamond Chapman
Studio	Merser Company
Client	Mr. and Mrs. Jerome Chapman
Dimensions	11¾ x 13¾ in. (30 x 34 cm)

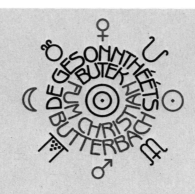

Typography/Design	Christof Gassner
Typographic Supplier	Typo Bach GmbH
Studio	Christof Gassner
	Grafik-Design
Client	Christian Butterbach
Principal Type	Benguiat Gothic Medium
Dimensions	8⅛ x 11⅝ in. (21 x 29.7 cm)

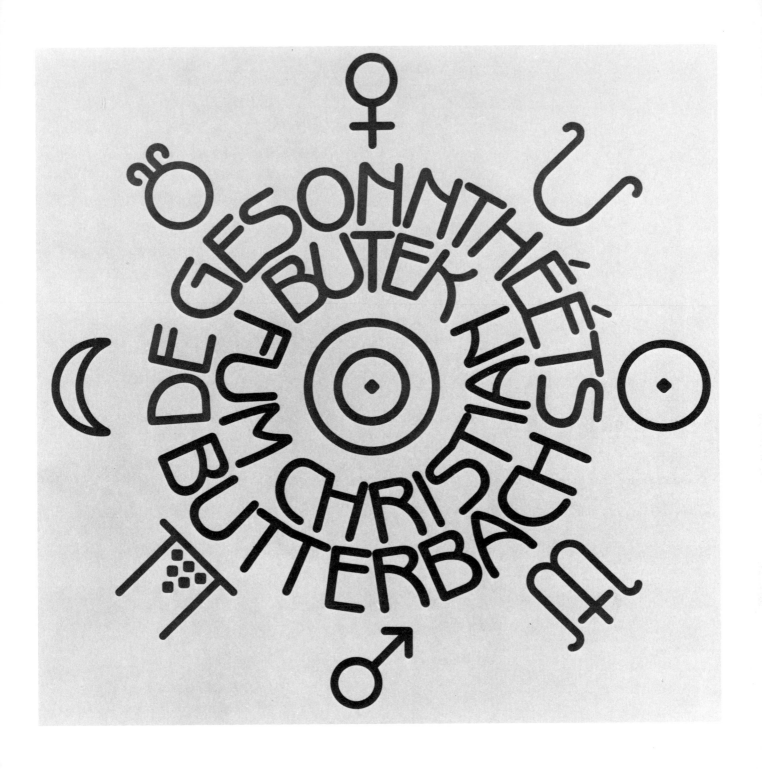

Typography/Design	Christof Gassner
Typographic Supplier	Typo Bach GmbH
Studio	Christof Gassner
	Grafik-Design
Client	Christian Butterbach
Principal Type	Benguiat Gothic Medium
Dimensions	20 x 25½ in. (50 x 65 cm)

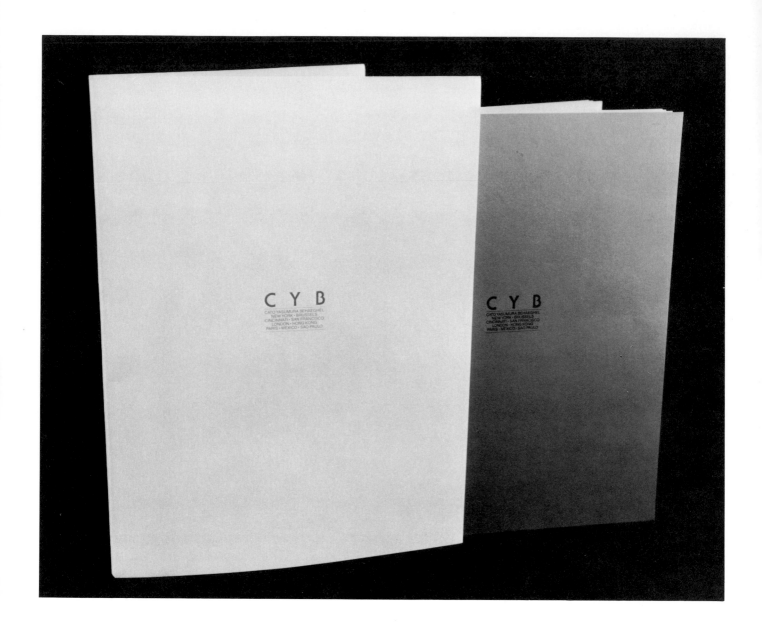

Typography	Richard Hsiung
Design	Muts Yasumura
Typographic Supplier	Pastore DePamphilis Rampone Inc.
Studio	Yasumura & Associates
Client	Cato Yasumura Behaeghel
Principal Type	Serif Gothic/Helvetica
Dimensions	9 x 12 in. (23 x 31 cm)

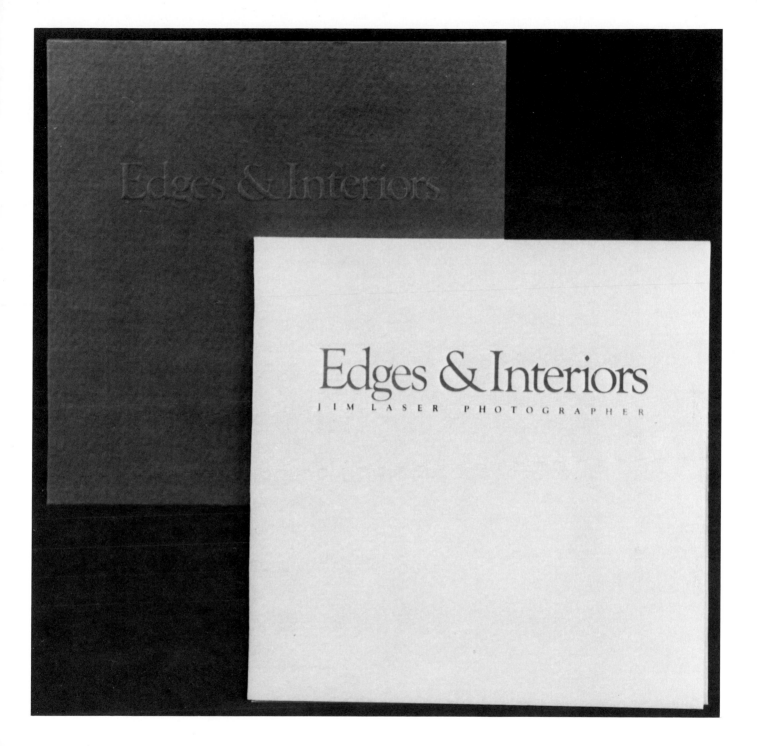

Typography/Design	Jack R. Anderson/
	Cliff Chung
Typographic Supplier	The Type Gallery
Studio	Cole & Weber Design Group
Client	Jim Laser, Photographer
Principal Type	Goudy Old Style Roman
Dimensions	5⅛ x 5⅛ in. (13 x 13 cm)

Typography/Design | Erwin Roeth ·
Typographic Supplier/Studio | Atelier Erwin Roeth
Client | Typo Bach GmbH
Dimensions | 12 x 17 in. (29 x 42 cm)

154

Schlüssel des 16. Jahrhunderts

Typography/Design | Erwin Roeth
Typographic Supplier/Studio | Atelier Erwin Roeth
Client | Typo Bach GmbH
Dimensions | 12 x 17 in. (29 x 42 cm)

155

Typography/Design | Beth Kosuk
Typographic Supplier | Rand Typography, Inc.
Studio | Beth Kosuk • Graphic Designer
Client | M. W. Stohn Associates
Principal Type | Goudy Bold/Bookman Light
Dimensions | 8½ x 11 in. (22 x 28 cm)

Typography/Design/Calligraphy	Tony Agpoon
Typographic Supplier	Design & Type
Studio/Client	Tony Agpoon Design
Principal Type	Palatino Italic

157

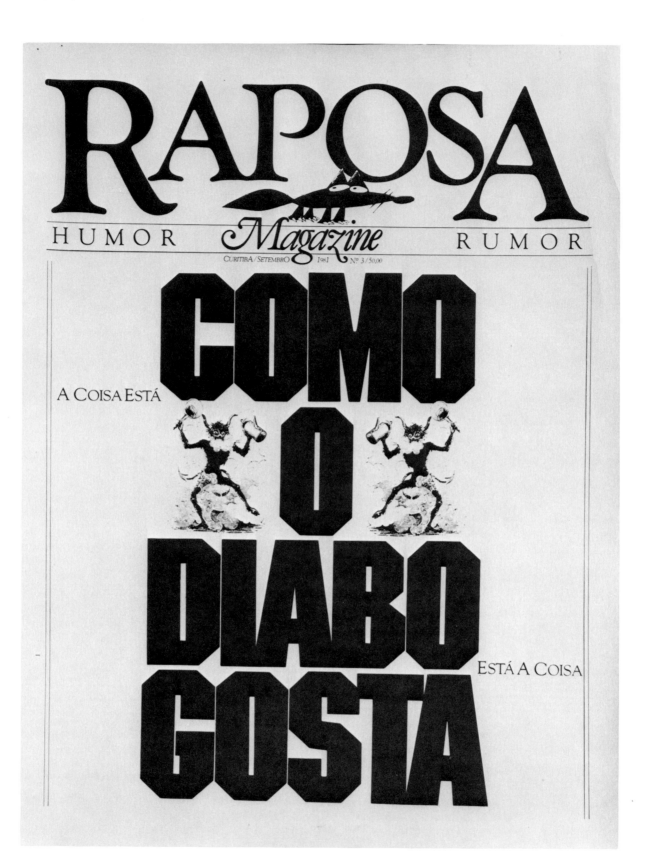

Typography/Design	Oswaldo Miranda (Miran)
Typographic Supplier	Digital
Studio	Miran Studio
Client	*Raposa* newspaper
Principal Type	Heads: Machine Body: Goudy
Dimensions	10 x 13⅛ in. (25 x 34 cm)

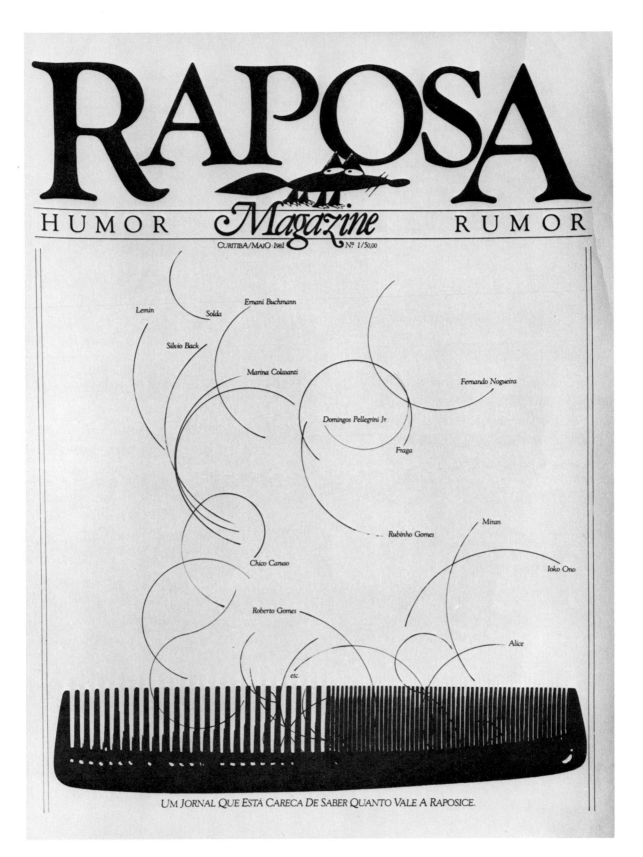

Typography/Design	Oswaldo Miranda (Miran)
Typographic Supplier	Digital
Studio	Miran Studio
Client	*Raposa* newspaper
Principal Type	Goudy Old Style
Dimensions	10 x 13⅜ in. (25 x 34 cm)

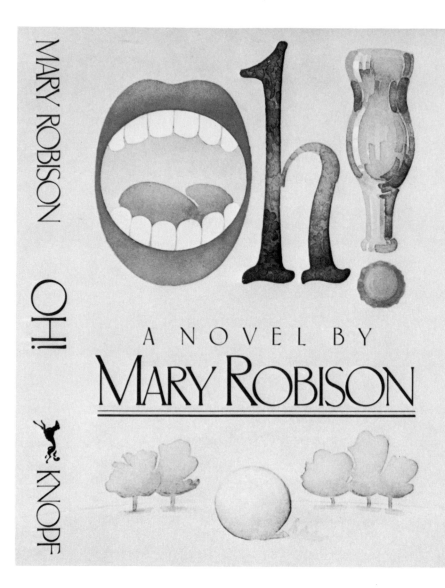

MARY ROBISON

OH!

KNOPF

$10.95

Those who know Mary Robison's work from her much-discussed appearances in *The New Yorker* and from *Days*, her recent collection of stories, will not be surprised that her first novel leaps from one prodigal moment to the next, for as Kenneth Burke has said of this startling young writer, "Robison outguesses the shrewdest reader —even several times on a single page."

In *Oh!*, these marvels have their source in a summer's romp with a madcap Midwestern family flourishing under the eccentric protection of a father like no other. He is the wifeless Mr. Cleveland, now an enthusiast at gardening and insobriety since passing from active service as ruler of his soda-pop and miniature-golf domain.

Cleveland's is the contented life of the man who knows who he is. The same might be said for his motherless children, Mo and Howdy, though they are scarcely children still. The loutish, loafing Mo is, in fact, a young mother although she has no husband to go with the job. Nor is she the least bit interested in finding one—not that she would have very far to look if she were. Standing where no one could miss him, even buzzing her with a helicopter and storming the house hand over hand, there's Chris, the unregenerate but undeterred rogue who gave Mo little Violet to be a listless unwed mother to.

Mo is slumbrous. She is committed to sleep. Sleep, anywhere she can manage it, is Mo's overmastering career choice in life. Older brother Howdy, however, has energy in abundance, and this he mainly devotes to pursuits of the social-comment variety, chief among which are painting everybody naked and suing for the hand in marriage of the yardman's dim-witted daughter.

Observing all from her vantage as the family maid is hard-headed Lola, whose role as smart-aleck domestic may already have been compromised by her pie-eyed employer. But the more evident and eager object of Cleveland's besotted wooings is Miss Virginia, a dopey mistress-of-ceremonies whose televised Christian mission to small-fry young Violet is quick to pass up in favor of the usual junk.

Like the rest of the Clevelands, Violet is nobody's fool. For in all their seeming misadventures, the Clevelands are guided by the reliable intelligence of the heart—a

(continued on back flap)

Typography/Design	Lidia Ferrara
Typographic Supplier/Calligraphy	John Alcorn
Client	Alfred A. Knopf, Inc.
Principal Type	Carlton
Dimensions	12 x 18 in. (31 x 46 cm)

Also illustrated by Leonard Baskin

HOSIE'S ALPHABET
HOSIE'S AVIARY

HOSIE'S ZOO

Pictures by
LEONARD BASKIN

Words by Tobias,
Hosea, Lucretia, and
Lisa Baskin

THE VIKING PRESS NEW YORK

Design	Barbara G. Hennessy
Typographic Supplier	Royal Composing Room
Client	Viking Penguin, Inc.
Principal Type	Aldus
Dimensions	7¾ x 11¼ in. (20 x 29 cm)

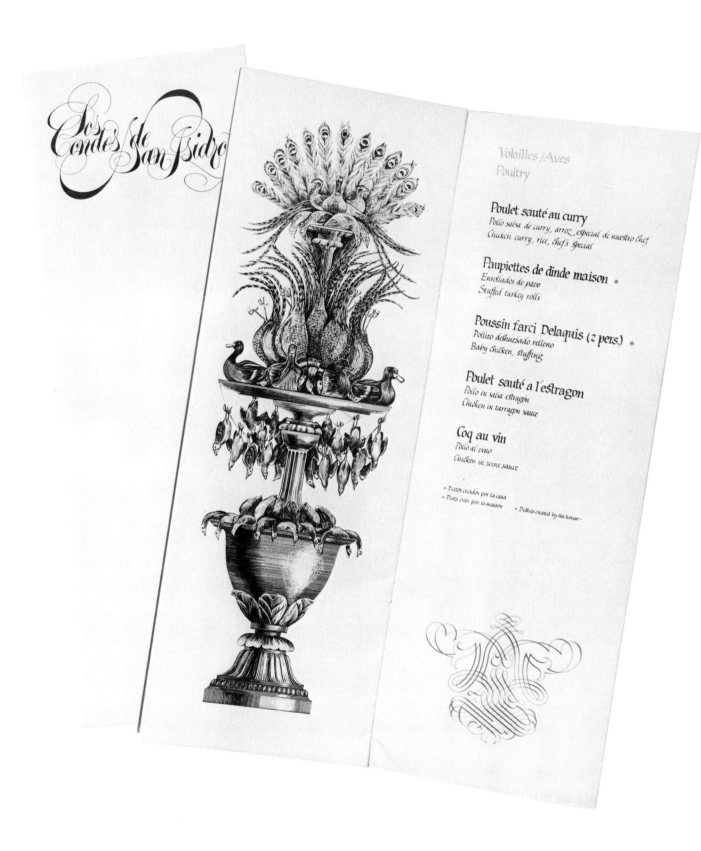

Los Condes de San Isidro

Volailles / Aves
Poultry

Poulet sauté au curry
Pollo salsa de curry, arroz, especial de nuestro chef
Chicken curry, rice, chef's special

Paupiettes de dinde maison *
Enrollados de pavo
Stuffed turkey rolls

Poussin farci Delaquis (2 pers.) *
Pollito deshuesado relleno
Baby chicken, stuffing

Poulet sauté a l'estragon
Pollo en salsa estragón
Chicken in tarragon sauce

Coq au vin
Pollo al vino
Chicken in wine sauce

* Platos creados por la casa
* Plats crées par la maison * Dishes created by the house~

Typography/Design/Calligraphy	Claude Dieterich
Client	Los Condes de San Isidro (Lima, Peru)
Dimensions	6 x 17 in. (15 x 43 cm)

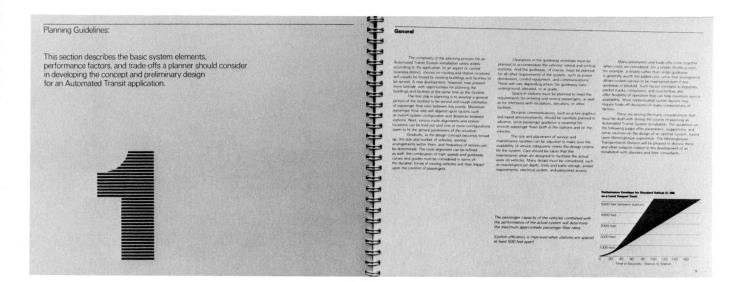

Typography/Design	Don Moyer
Typographic Supplier	Davis & Warde
Studio	Agnew Moyer Smith Inc.
Client	Westinghouse
	Transportation Division
Principal Type	Univers
Dimensions	11 x 8½ in. (28 x 22 cm)

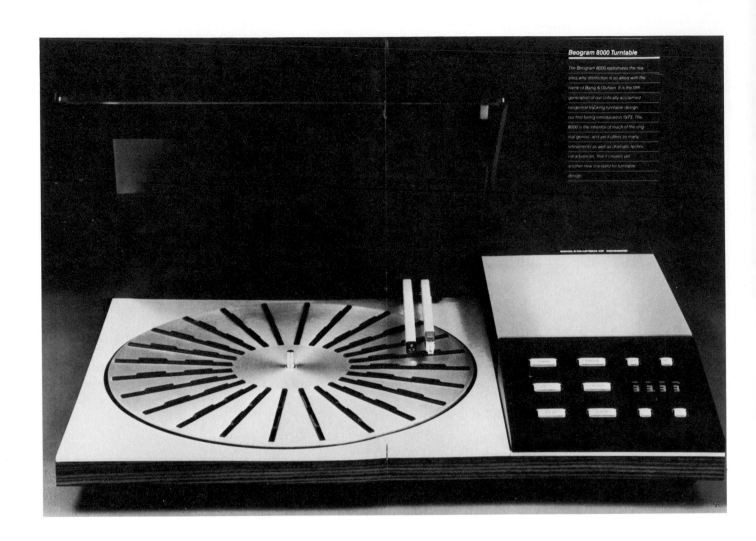

Beogram 8000 Turntable

The Beogram 8000 epitomizes the reasons why distinction is so allied with the name of Bang & Olufsen. It is the fifth generation of our critically acclaimed tangential tracking turntable design, our first being introduced in 1973. The 8000 is the inheritor of much of the original genius, and yet it offers so many refinements as well as dramatic technical advances, that it creates yet another new standard for turntable design.

Typography/Design	Hayward Blake/ Rebecca Michaels
Typographic Supplier	Design Typographers
Studio	Hayward Blake & Company
Client	Bang & Olufsen of America, Inc.
Principal Type	Helvetica
Dimensions	11 x 15 in. (28 x 38 cm)

164

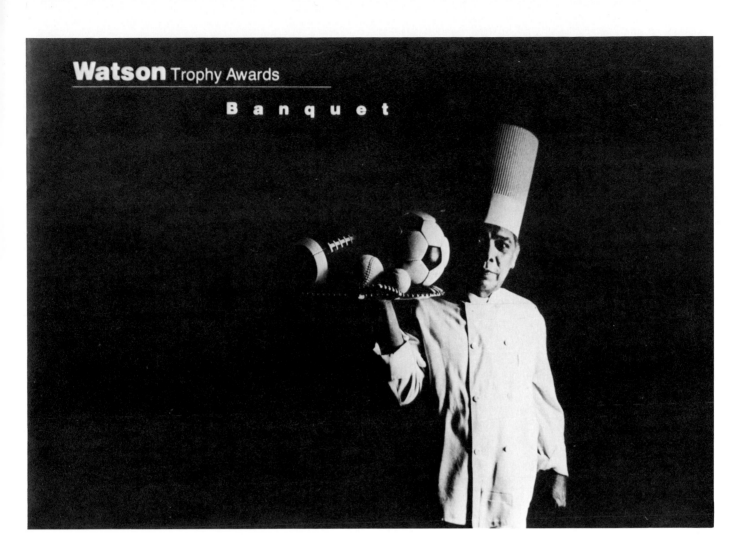

Watson Trophy Awards
Banquet

Design	Kurt W. Gibson
Typographic Supplier	Tucson Type
Studio	IBM Tucson Design Center
Client	IBM Tucson
Principal Type	Helvetica
Dimensions	7 x 5 in. (18 x 13 cm)

MAX YAVNO

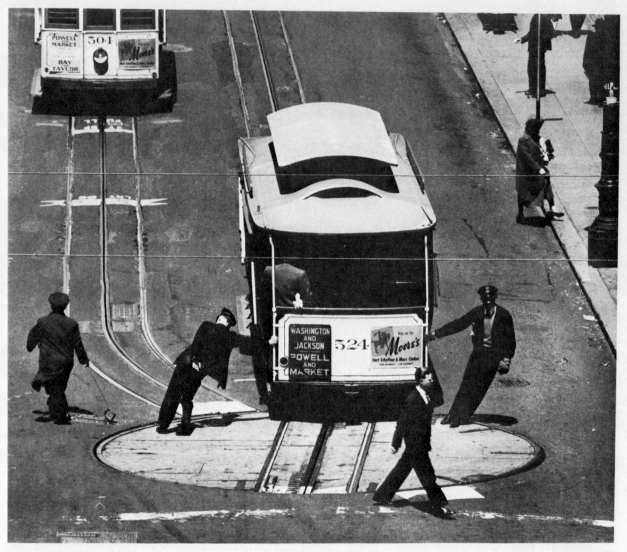

Text by Ben Maddow

Design	Carl Seltzer
Typographic Supplier	Central Typesetting Company
Client	University of California Press at Berkeley
Principal Type	Palatino
Dimensions	12 x 12 in. (31 x 31 cm)

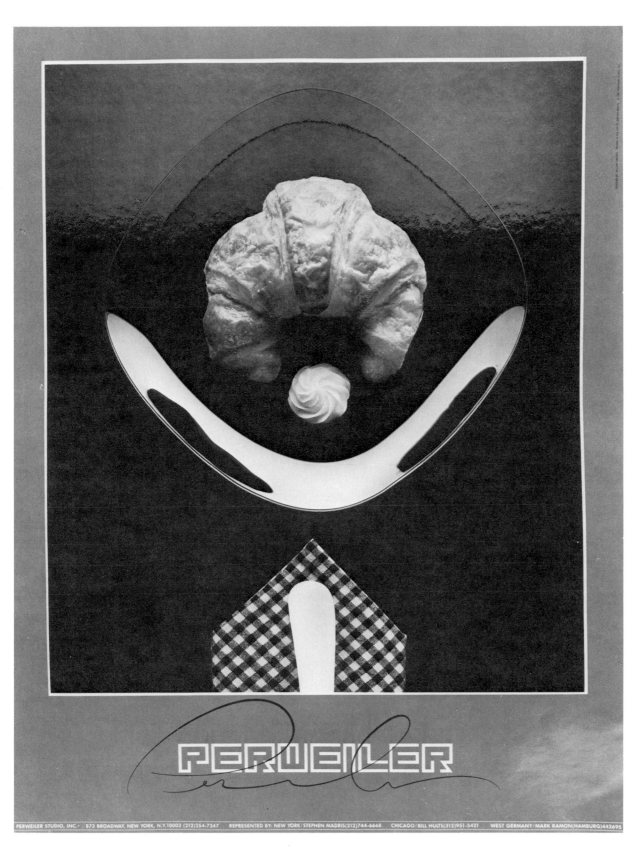

Typography/Calligraphy	William Naegels
Design	Gary Perweiler
Typographic Supplier	Pulsar Photographics
Studio	William Naegels Graphic Design
Client	Perweiler Studio, Inc.
Principal Type	Spartan Heavy
Dimensions	18¼ x 24½ in. (46 x 62 cm)

167

Die Ablehnung schematischer Formen, die Befreiung aus einem fest umrissenen Stil...

Die unbeschwerte Komposition vielfältiger Stilelemente...

Die Ursprünglichkeit unverfälschter Naturmaterialien...

Die Natürlichkeit als Antwort für die Einrichtung...

Le refus d'un schématisme conformiste et d'un style déterminé...

Des styles différents, réunis dans une harmonie sans contrainte...

Le respect du caractère profond de matériaux naturels...

Le naturel comme réponse aux aspirations de l'habitat...

MARKTEX

Typography/Design	Fritz Hofrichter/Olaf Leu
Typographic Supplier	Team '80 GmbH, Frankfurt/Main
Calligraphy/Studio	Olaf Leu Design & Partner
Client	Marktex Palmiotta & Co., KG, Kronberg/Ts
Principal Type	Heads: Optima Regular Body: Optima Regular & Italic
Dimensions	10 x 17⅛ in. (25.5 x 43.5 cm)

Lily © 1982 Jim Laser

A	U	T	U	M	N	82
September			1	2	3	4
5	6	7	8	9	10	11
12	13	14	15	16	17	18
19	20	21	22	23	24	25
26	27	28	29	30		
October					1	2
3	4	5	6	7	8	9
10	11	12	13	14	15	16
17	18	19	20	21	22	23
24	25	26	27	28	29	30
31						
November	1	2	3	4	5	6
7	8	9	10	11	12	13
14	15	16	17	18	19	20
21	22	23	24	25	26	27
28	29	30				

JIM LASER PHOTOGRAPHER
ROUTE ONE ATHOL IDAHO 83901 208 683 2651

Typography/Design	Jack R. Anderson/ Carole Jones
Typographic Supplier	The Type Gallery
Studio	Cole & Weber Design Group
Client	Jim Laser, Photographer
Principal Type	Goudy
Dimensions	9 x 12 in. (23 x 31 cm)

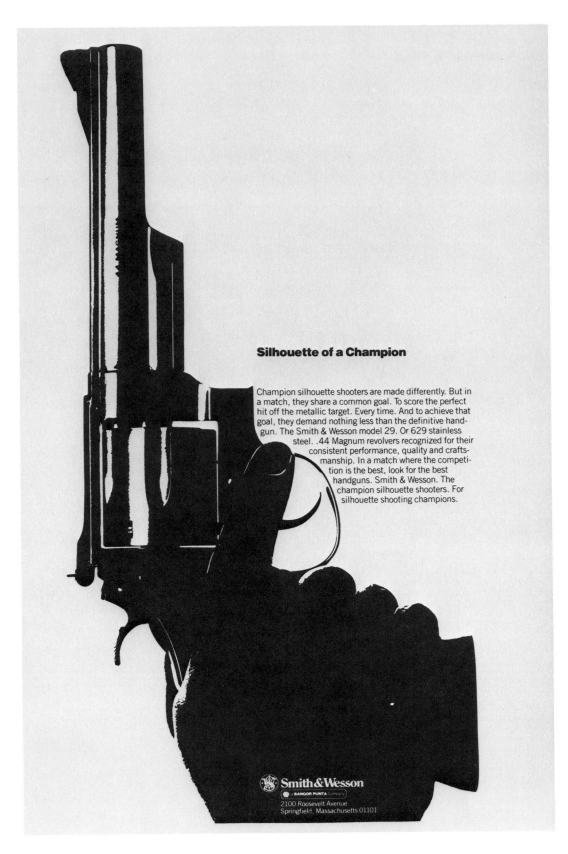

Silhouette of a Champion

Champion silhouette shooters are made differently. But in a match, they share a common goal. To score the perfect hit off the metallic target. Every time. And to achieve that goal, they demand nothing less than the definitive handgun. The Smith & Wesson model 29. Or 629 stainless steel. .44 Magnum revolvers recognized for their consistent performance, quality and craftsmanship. In a match where the competition is the best, look for the best handguns. Smith & Wesson. The champion silhouette shooters. For silhouette shooting champions.

Smith & Wesson
BANGOR PUNTA Company
2100 Roosevelt Avenue
Springfield, Massachusetts 01101

Typography/Design	Jeffrey Abbott
Typographic Supplier	Typographic House
Studio	Charles Palm and Company
Client	Smith & Wesson
Principal Type	Heads: Helvetica Bold
	Body: News Gothic Light
Dimensions	10 7/16 x 16 in. (26.5 x 41 cm)

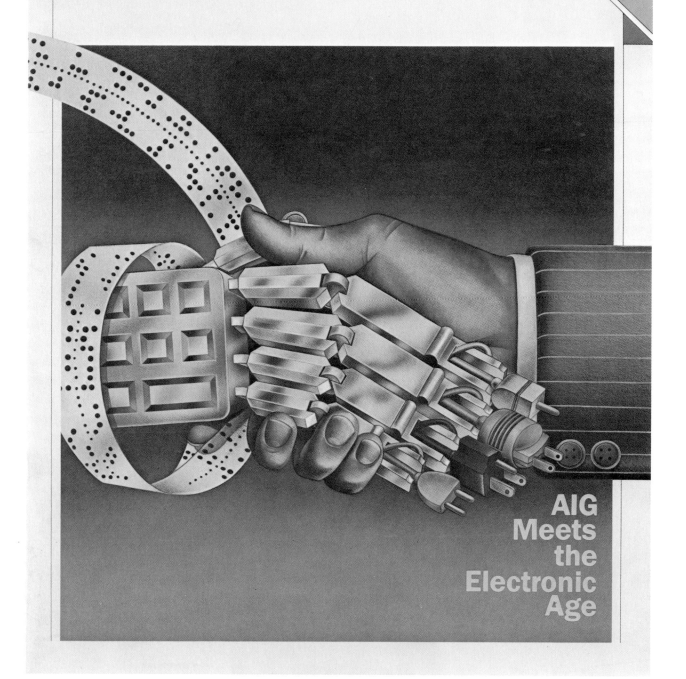

Fall 1981

CONTACT

C & I CENTENNIAL

AIG
Meets
the
Electronic
Age

Design	Dennis & David Barnett
Typographic Supplier	Concept Typographics, Inc.
Studio	Barnett Design Group, Inc.
Client	American International Group
Principal Type	ITC Garamond Light/
	ITC Franklin Gothic Demi
Dimensions	8½ x 11 in. (22 x 28 cm)

171

George Tscherny

Born in Budapest, Hungary in 1924, George Tscherny studied at the Newark School of Fine and Industrial Art and at Pratt Institute, New York. He has since returned to Pratt to teach design in addition to teaching at the School of Visual Arts, New York. Mr. Tscherny has also lectured at Cooper Union Art School as Mellon Visiting Professor.

He began his career as packaging designer with Donald Deskey & Associates in 1950. He joined George Nelson & Associates as graphic designer in 1953, and became an associate and head of the graphics department before leaving there in 1956 to open an independent design office. Soon after, he was appointed design consultant to the Ford Foundation with design responsibility for all publications. Since then other clients have included: American Can Company, Burlington Industries, Champion Papers, General Dynamics, Goethe House, N.Y., IBM, J. C. Penney, Rockwell International, Overseas National Airways, Pan American Airways, Air Canada, RCA, Mobil, Morgan Stanley, Johnson & Johnson, Texasgulf, and Bankers Trust Company.

Assignments in the past have ranged from the design of a commemorative postage stamp for the U.S. Government to vast identification programs for corporations.

Solo exhibitions of Mr. Tscherny's work have been held in Stuttgart, Munich and New York. He was represented in "Images of an Era: The American Poster 1945-1975" at the Corcoran Gallery of Art,

Washington, D.C., and won a silver medal at the Warsaw International Poster Biennale in 1976.

His work has been the subject of articles in such publications as *Novum Gebrauchsgrafik*, *Graphis*, *Communication Arts*, *Idea*, and *Print*. It was also covered in *Graphic Designers in the USA*, published by Bijutsu Shuppan-sha, Japan.

A New York resident, Mr. Tscherny served two terms as president of the American Institute of Graphic Arts and is a member of Alliance Graphique Internationale.

Four-color process. An 8" x 10" color transparency was made from the three-dimensional artwork under the artist's supervision. The Hell 300B laser scanner was used for color separation. The art was scanned twice, once for the inside color art and once for the outside area. This was necessary because of the intricacies of the artwork. The two sets of separations were combined to make the plates for printing. Stripping and double plate burning required extra precision.

The artist turned to Percy Bysshe Shelley's "Ode to the West Wind" when asked to comment on his work for the Tyler Offset Workshop: "If winter comes, can spring be far behind?"

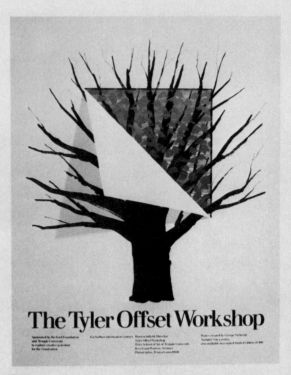

Poster
17" x 22"
Edition: 100
Paper: Warren's
Cameo 80 lb. Dull
Cover

Typography	Warren Infield
Design	George Tscherny
Studio	Infield + D'Astolfo
Client	Tyler School of Art, Temple University

Typography/Calligraphy	Tim Girvin
Design	Chris Spivey
Typographic Supplier	Type Gallery
Studio	Tim Girvin Design
Clients	Friends of Asian Art, Detroit Institute of Arts
Principal Type	Eras
Dimensions	24 x 11½ in. (61 x 29 cm)

The Boston Globe Magazine

April 26, 1981

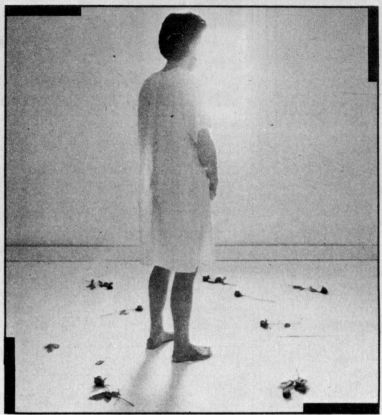

❝*I WANT TO KNOW WHY A COUNTRY* *that has produced a weapon able to destroy the earth ten times over has not created another bomb that can kill an evil cell in the human body.*❞ DIARY OF A CANCER PATIENT

BY WALTER HAYNES

Typography/Design	Ronn Campisi
Typographic Supplier	Headliners/Boston
Client	*The Boston Globe Magazine*
Principal Type	Venus Extended/Century
Dimensions	10¾ x 12½ in. (27 x 32 cm)

Also: Ralph Houk—Fenway's optimist

The Boston Globe Magazine

October 4, 1981

NISA'S WORLD
From Marjorie Shostak's chronicle of an African tribeswoman

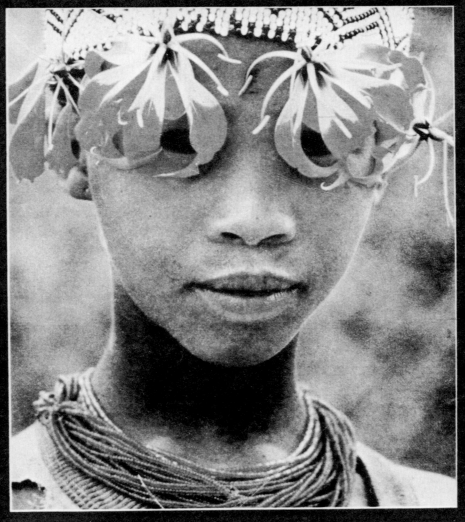

Typography/Design	Ronn Campisi
Typographic Supplier	Headliners/Boston
Client	*The Boston Globe Magazine*
Principal Type	Anzeigen/Century
Dimensions	10¾ x 12½ in. (27 x 32 cm)

John M. Harbert III
Chairman of the Board and
Chief Executive Officer

Since its beginning in the late 1940's, when capital assets consisted of little more than a single dump truck and several wheelbarrows, Harbert Corporation has developed and matured into a worldwide enterprise with operations on five continents. Harbert entered the 80's with annual revenues exceeding $500 million and net worth exceeding that of most general contractors in the United States. The company's principal activities today are: design, construction management, civil and mechanical construction, mine planning and management, natural gas transportation, and land development.

From the company's earliest days, there have been mutual pride and dedication between Harbert and its employees which is expressed in a strong commitment to the company's philosophies and objectives and in a quality of workmanship unparalleled in the industry. Harbert's dedication to its employees, in turn, is expressed in the company's long-standing commitment to promotion from within, combined with on-the-job training programs at all levels. The result is that Harbert attracts people who have unlimited opportunities to move upward within the company.

What kind of value can be put on the admiration and support Harbert has earned over the years as a good corporate citizen — in cities from Birmingham to Bogota? Harbert's reputation is not merely the result of charitable contributions and civic activities, but also its continuing positive involvement with clients and their respective communities. Harbert has never failed to complete a project to the owner's satisfaction, and for that reason our clients invite us back to do additional work for them.

Harbert has the capability of rapidly deploying its vast fleet of heavy construction equipment and managerial capabilities to projects in distant and remote locations. Although Harbert has become a large and diversified company, it still retains the organizational flexibility to quickly respond in a controlled manner to customer and market needs virtually anywhere in the world and to meet ever-changing market requirements or even fast-changing climatic conditions.

What kind of value can be placed on experience — on a time span of more than three decades — during which Harbert has been tempered by the fire of adversity and challenge, and has emerged with great strength, stability and resiliency?

In short, Harbert's most valuable assets and strengths cannot be quantified — no more so than one can quantify the human spirit, or the blessings of living in a free society.

We at Harbert Corporation have entered the new decade with the unswerving belief that ours is a winning company living in the solutions rather than in the problems of this era. We are also firmly convinced that we have begun a dramatic new chapter in our development.

In past decades, we have built our strength in management, marketing, natural resources, financial and fixed capital resources. In the decades ahead, we intend to capitalize on the success of that building program, seeking new ways to serve our customers' needs and meet the unlimited challenges of tomorrow.

By virtue of long experience, record of performance, and organization of seasoned specialists, Harbert is able to proudly offer regional, national and international clients a broad spectrum of capabilities.

John M. Harbert III

John M. Harbert III
Chairman of the Board
and Chief Executive Officer

Desde su comienzo, a fines de 1940, cuando el capital activo consistia en poco mas que un camion de volteo y varias carretillas, la Corporacion Harbert se ha desarrollado en una empresa de caracter mundial, con operaciones en cinco continentes. La compania Harbert comenzo la decada de los ochenta con un ingreso anual que excede a los quinientos millones de dolares y con una ganancia liquida que sobrepasa a la de la gran mayoria de las empresas en los Estados Unidos. Las actividades principales de esta compania hoy son: diseno, construccion, administracion, ingenieria mecanica y civil, planificacion y administracion de minas, transporte de gas natural y explotacion de tierras.

Desde los primeros dias de esta compania, ha existido un orgullo y dedicacion mutua entre Harbert y sus empleados, que ha sido expresada en un fuerte compromiso hacia la filosofia y objetivos de la compania, y en una calidad de trabajo unica en la industria. La consagracion de Harbert para con sus empleados, en cambio, es expresada en el compromiso a largo plazo de la compania, de promover al personal existente, en conjunto con el programa de entrenamiento de trabajo a todo nivel. Como resultado, la compania Harbert atrae a personas que saben que tendran posibilidades ilimitadas de ascender dentro de la misma compania.

¿Que tipo de valor se le puede dar a la admiracion y apoyo que Harbert ha ganado a traves de los años, como una corporacion de ciudadanos respetables, en ciudades desde Birmingham hasta Bogota? La reputacion de Harbert no es solamente el resultado de contribuciones de caridad, o actividades municipales, tambien lo es por su continua relacion positiva con sus clientes y con sus respectivas comunidades. La compania Harbert nunca ha fallado en el termino de un proyecto, y siempre ha sido con la plena satisfaccion de su dueno, por esa razon, nuestros clientes nos vuelven a llamar para la ejecucion de trabajos adicionales.

Harbert tiene la capacidad de desplegar rapidamente su enorme flota de equipo pesado para construccion, asi como sus capacidades administrativas en proyectos localizados en lugares distantes o remotos.

A pesar de que Harbert se ha convertido en una compania grande y de ramos variados, aun conserva la flexibilidad de una organizacion, para responder rapidamente y de una forma controlada a las necesidades de un mercado o cliente, virtualmente en cualquier parte del mundo, y satisfacer las diferentes demandas del mercado, o incluso, un cambio brusco en las condiciones climaticas.

¿Que tipo de valor se le puede dar a la experiencia obtenida en un lapso mayor a tres decadas, durante las cuales Harbert ha sido templado por el fuego de la adversidad y el desafio, y que aun asi, haya surgido con elasticidad, fuerza y estabilidad?

En pocas palabras, el valor del potencial y ventajas que la compania Harbert ofrece, no se puede medir, asi como no se puede medir o enumerar el espiritu humano, o la suerte de vivir en una sociedad libre.

Nosotros en la Corporacion Harbert, hemos comenzado la nueva decada con la firme creencia, de que la nuestra, es una compania con exito que crea las soluciones, en vez de los problemas de esta era. Tambien, estamos firmemente convencidos de que hemos comenzado un nuevo capitulo, muy interesante en nuestro desarrollo.

En epocas pasadas, hemos cimentado nuestro poder en administracion, mercadeo, recursos naturales, arreglo de capitales y recursos financieros. En las decadas por venir, intentamos sacar provecho del exito obtenido en el programa de construccion, buscando nuevas formas de satisfacer las necesidades de nuestros clientes y confrontar los miles de desafios del manana.

Por virtud de una larga experiencia, record en su cumplimiento y organizacion de excelentes especialistas, Harbert se siente capaz y orgullosa de ofrecer un amplio espectro de aptitudes a clientes regionales, nacionales e internacionales.

John M. Harbert III

John M. Harbert III
Presidente de la Junta
Directiva
y Jefe Ejecutivo Oficial

Typography/Design	Robert Miles Runyan
Typographic Supplier	Composition Type
Studio	Robert Miles Runyan & Associates
Client	Harbert Corporation
Principal Type	Helvetica
Dimensions	9 x 12 in. (23 x 30 cm)

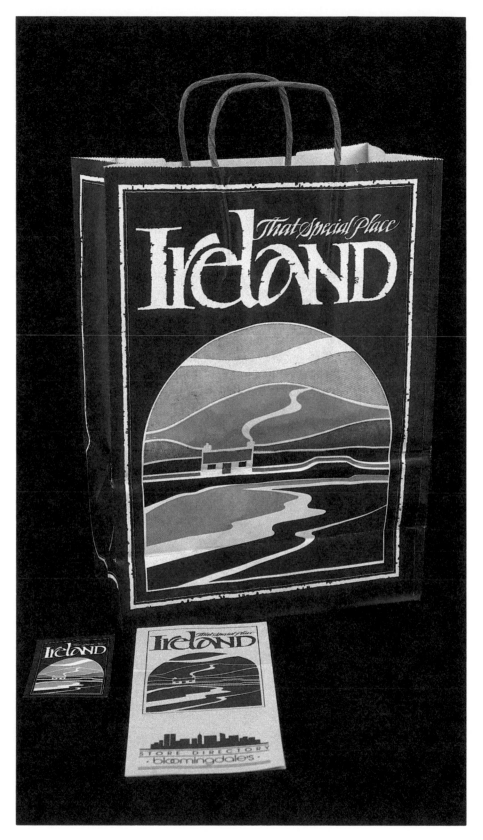

Typography	John Jay
Design	Brian Burdine
Calligraphy	Tim Girvin
Studio	Tim Girvin Design
Client	Bloomingdale's
Dimensions	12 x 16½ in. (31 x 42 cm)

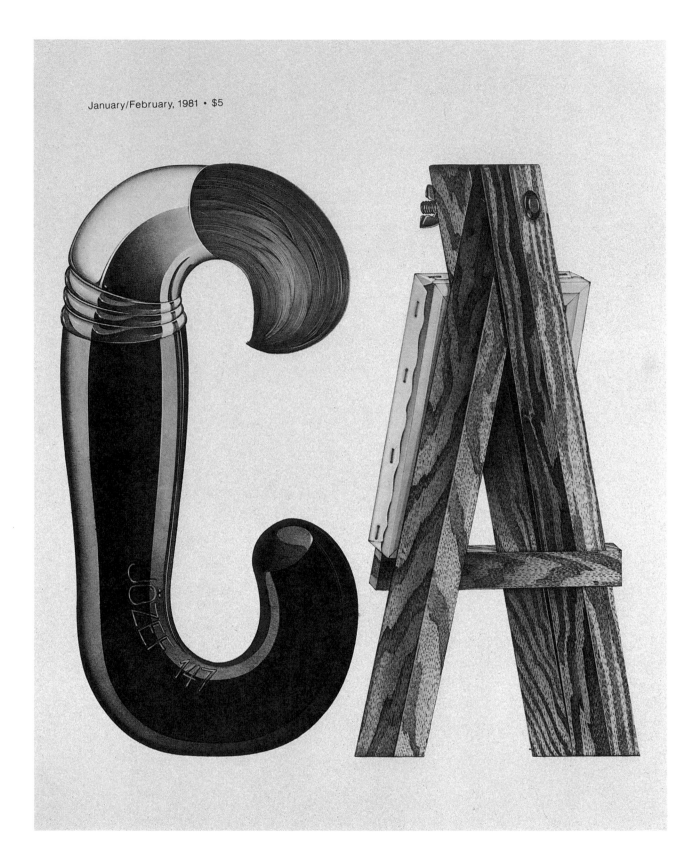

January/February, 1981 • $5

Typography	Richard Coyne
Design	Jean A. Coyne
Calligraphy	Jözef Sumichrast
Studio	Jözef Sumichrast Inc.
Client	*Communication Arts* Magazine
Dimensions	8¾ x 11 in. (22 x 28 cm)

178

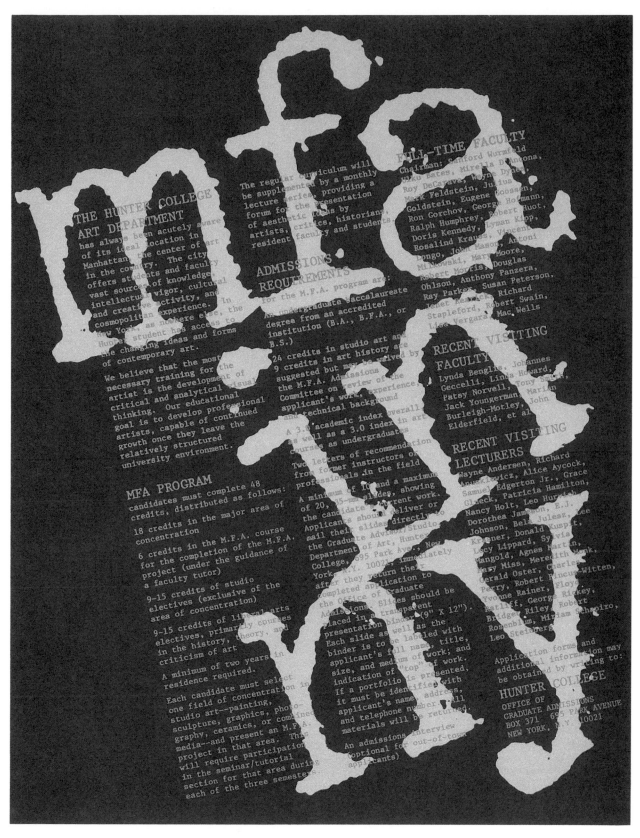

Typography/Design | Joseph Bednar/Ellen Emmerich
Studio | Joseph Bednar–Graphic Design
Client | Hunter College

Principal Type | Typewriter
Dimensions | 17½ x 23 in. (44 x 58 cm)

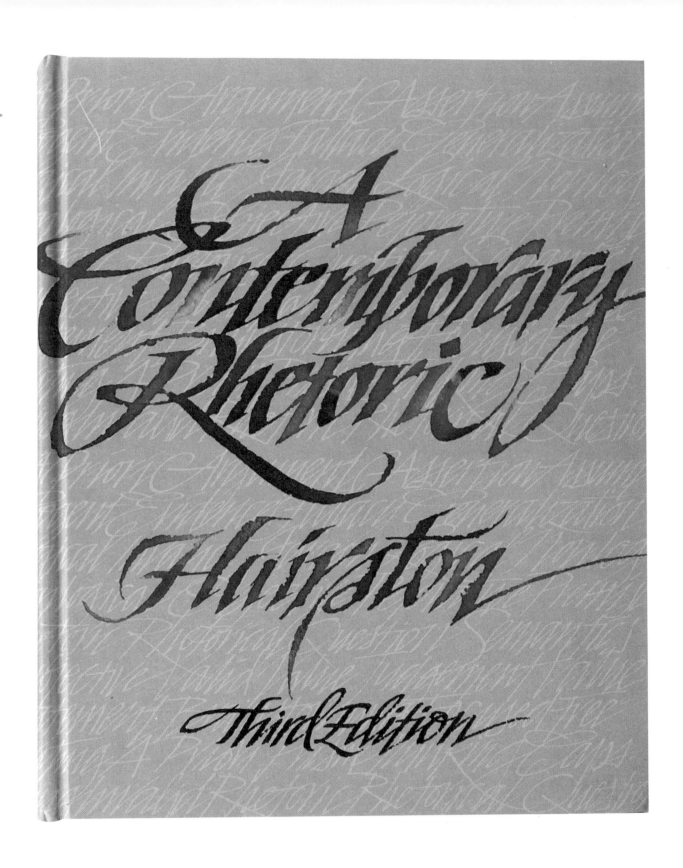

Typography/Design	Judy Arisman
Typographic Supplier	P & M Typesetting
Calligraphy	Tim Girvin
Client	Houghton Mifflin Company
Principal Type	Caslon
Dimensions	7½ x 9¼ in. (19 x 24 cm)

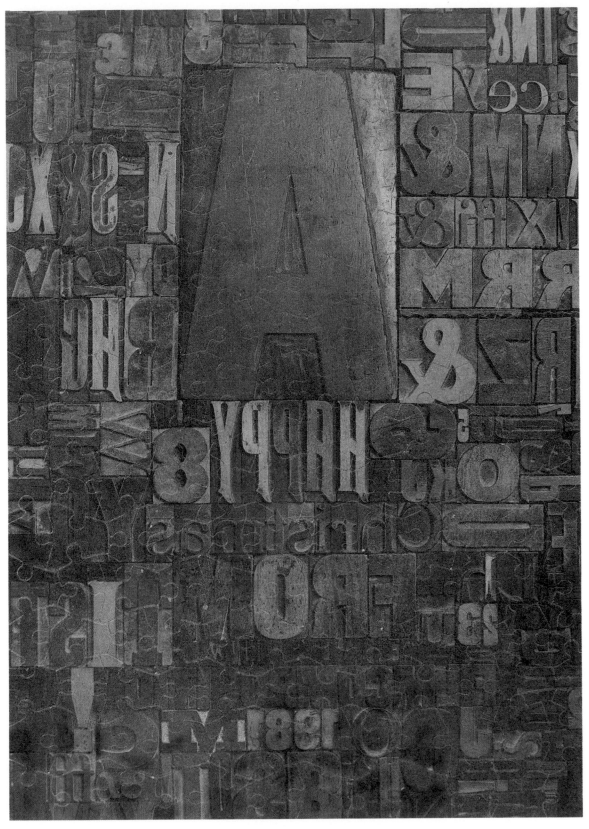

Typography	Ed Cleary, MSTD
Design	Ken Kirkwood
Typographic Supplier	Norwich College of Art
Studio/Client	Filmcomposition

181

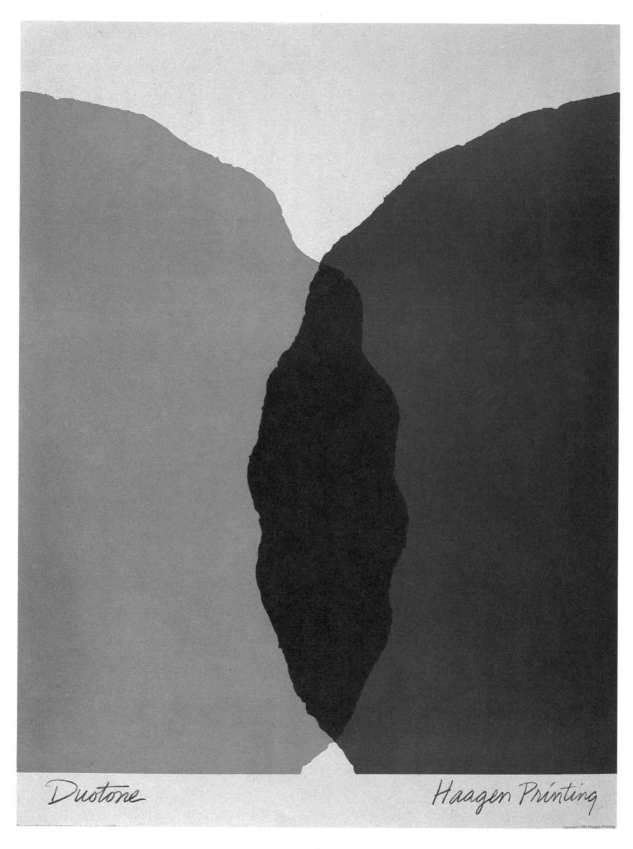

Duotone

Haagen Printing

Copyright 1980 Haagen Printing

Design	Marty Neumeier/Byron Glaser
Calligraphy	Marty Neumeier
Studio	Neumeier Design Team
Client	Haagen Printing
Dimensions	18 x 24 in. (46 x 61 cm)

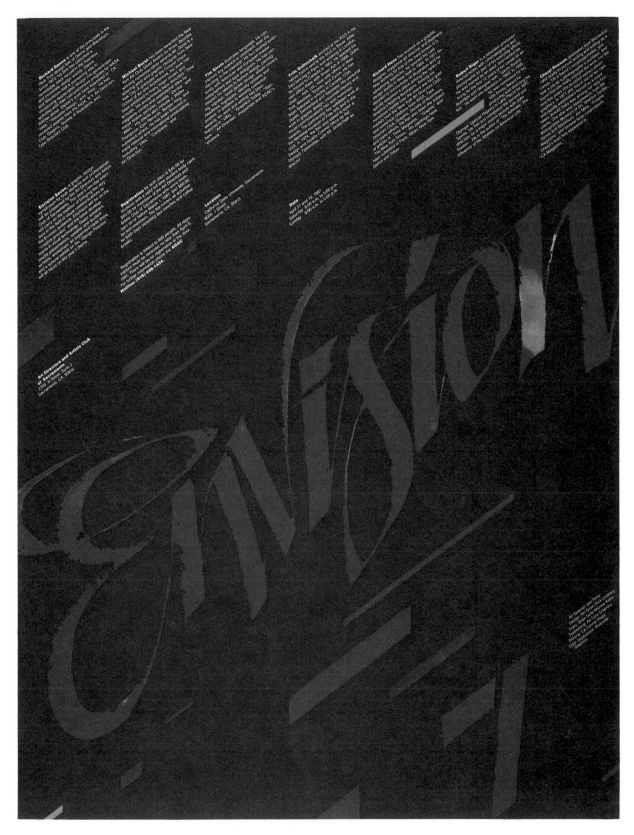

Typography/Calligraphy	Tim Girvin
Design	Don Price
Studio	Tim Girvin Studio
Client	ADAC Envision
	Design Conference
Dimensions	18 x 24 in. (46 x 61 cm)

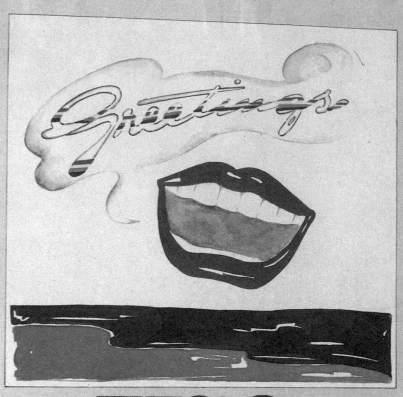

ستجد ايها المسافر في هذا الدليل المعلومات التي تحتاج اليها لكي تستمتع بزيارتك لشيكاغو ولكي تشعر انك في بيتك في الولايات المتحدة .

كما يتضمن هذا الدليل معلومات وافية عن اجل الاماكن التي يمكن ان تراها مثل شاطىء بحيرة ميتشيجان والفن المعمارى المشهور عالميا .

كما يوجد ايضا شرح لعاداتنا وطريقة معيشتنا .

وستجد ايضا اقتراحات بخصوص التجول ومعلومات عن وسائل النقل ، والفنادق واستخدام التليفون وتغيير العملة وكلها مترجمة باللغة العربية . وبعد كل باب ستجد دليل كامل باللغة الانجليزية لارقام التليفونات والعناوين المذكورة في الباب .

*I*n this brochure, you will find the information you need to feel at home in the United States and enjoy your visit to Chicago.

Descriptions of our city's attractions from our scenic lakefront to our world famous architecture are included as well as explanations of our way of life from food to entertainment.

You'll also find useful suggestions for "getting

*D*ans ce guide vous trouverez, cher voyageur international, tous les renseignements dont vous avez besoin pour profiter de votre séjour à Chicago et pour vous sentir vraiment chez nous ici aux Etats-Unis.

Y compris vous trouverez les points d'intérêt de notre ville; par exemple, la vue panoramique au bord du lac et notre architecture célèbre dans tout le monde.

*D*eseamos que esta guía le sea útil e informativa durante su visita a Chicago y los Estados Unidos.

En esta guía se incluyen descripciones breves y detalles sobre los lugares de interés en Chicago, desde el litoral del lago Michigan hasta ejemplos de arquitectura.

*I*n questa guida, lei, visitatore internazionale, troverà le informazioni necessarie per effettuare una piacevole visita di Chicago e per sentirsi a casa negli Stati Uniti.

Vi sono comprese dettagliate informazioni sulle attrazioni di Chicago, dal nostro spettacolare lungolago all'architettura famosa in tutto il mondo—ed anche spiegazioni sul nostro stile di vita.

Typography/Design	Arnold Goodwin
Typographic Supplier	Tele-Typography
Calligrapher	Ted Havelicheck
Studio	Arnold Goodwin Graphic Communications
Client	Illinois Office of Tourism
Principal Type	Heads: Columna Open Body: Baskerville
Dimensions	11⅛ x 14⅛ in. (28 x 36 cm)

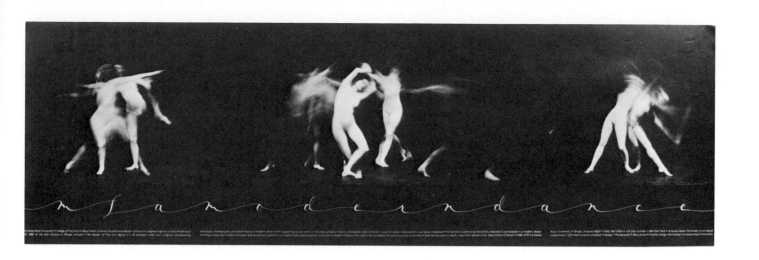

Typography/Design/Calligraphy	Mary Jones
Typographic Supplier	Somers Graphics, Inc.
Studio	Workshop, Arizona State University
Client	Department of Dance, Arizona State University
Principal Type	Zapf International Italic
Dimensions	32 x 11 in. (81 x 28 cm)

*H*yvän mainoskampanjan perustana ovat markkinoiden todellinen tuntemus, omien mahdollisuuksien analysointi, oikein vedetyt johtopäätökset ja realistisesti asetetut tavoitteet. Terävästi valittu mainonnan strategia, oikea sanoma ja puhutteleva esitystapa luovat kampanjalle sisällön ja hengen. Harkiten valitut mediat, osuva ajoitus ja sopiva panostus vievät sanoman perille. Mainonnan ja myynnin välinen saumaton yhteistyö johtaa täydelliseen tehoon ja hyviin tuloksiin. Näistä tekijöistä rakentuvat kampanjat, jotka useimmiten johtavat toimintaan, jossa panostus vastaa tuloksia ja tulokset asetettuja tavoitteita. Tämä kunniakirja annetaan tunnustuksena kampanjalle, joka kokonaisuutena täyttää esimerkillisesti hyvän kampanjan tunnusmerkit tänä vuonna Suomessa.

HELSINGISSÄ 30. PÄIVÄNÄ LOKAKUUTA 1980.
SUOMEN MARKKINOINTILIITTO SML JA MARKKINOINTIJOHDON RYHMÄ MJR

Typography/Design	Erkki Ruuhinen
Typographic Supplier	Graphic Team
Studio	Anderson & Lembke Oy, Helsinki
Client	Finnish Marketing Association
Principal Type	Palatino Light
Dimensions	16⅛ x 23 in. (41 x 58 cm)

UPPER AND LOWER CASE, THE INTERNATIONAL JOURNAL OF TYPOGRAPHICS PUBLISHED BY INTERNATIONAL TYPEFACE CORPORATION, VOLUME EIGHT, NUMBER THREE, SEPT 1981

OUT OF OUR HAT, WITH SLEIGHT OF HAND AND FLASH OF WIT, WE CONJURE UP EIGHT PAGES OF MAGIC POSTERS NOT BLACK MAGIC, NOT WHITE MAGIC, BUT MAGIC IN FULL COLOR

Typography/Design	Alan Peckolick
Typographic Supplier	Photo-Lettering, Inc.
Studio	Lubalin, Peckolick Associates Inc.
Client	U&lc
Principal Type	Various ITC typefaces
Dimensions	11 x 14½ in. (28 x 37 cm)

**Massachusetts Institute
of Technology**

**Sloan School of
Management**

**Annual Report
1980-81**

Typography/Design	Ralph Coburn
Typographic Supplier	Typographic House
Studio	MIT Design Services
Client	MIT, Sloan School of Management
Principal Type	Helvetica
Dimensions	8½ x 11 in. (22 x 28 cm)

**The story of
Moore**

▲ *Samuel J. Moore*
1859-1948

1882

▶ *Research Centre*
Grand Island, New York

INTO

Typography	Roslyn Eskind
Design	Malcolm Waddell
Typographic Supplier	Cooper & Beatty Ltd.
Studio	Eskind Waddell
Client	Moore Corporation Ltd.
Principal Type	Heads: Univers 75
	Body: Univers 55
Dimensions	8⅜ x 11⅜ in. (21 x 29 cm)

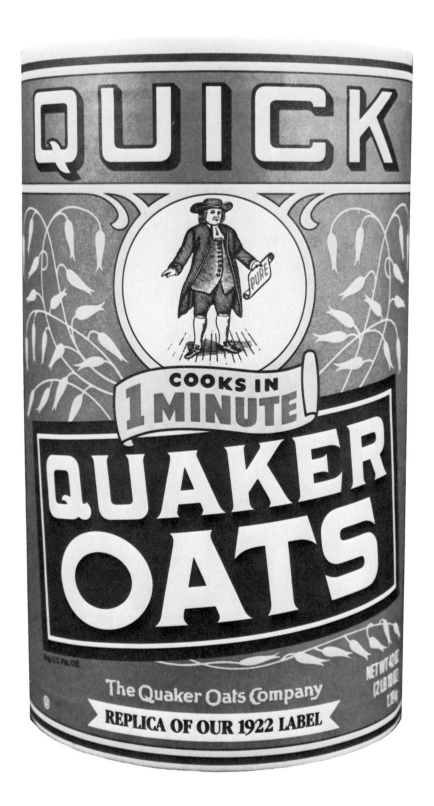

Typography/Design	John A. Flesch
Typographic Supplier	Chicago Franchise
Calligraphy	Horst Mickler
Studio	Murrie, White, Drummond, Lienhart & Associates
Client	The Quaker Oats Company
Principal Type	Garamond/Neo Mini-Jensen
Dimensions	16^{15}/₁₆ x 9³/₁₆ in. (43 x 23.4 cm)

Typography/Design	John A. Flesch
Typographic Supplier	Chicago Franchise
Calligraphy	Horst Mickler
Studio	Murrie, White, Drummond, Lienhart, & Associates
Client	The Quaker Oats Company
Principal Type	Garamond/Neo Mini-Jensen
Dimensions	16¹⁵⁄₁₆ x 9³⁄₁₆ in. (43 x 23.4 cm)

Typography/Design/Calligraphy | Thomas Q. White
Typographic Supplier | Letraset
Studio/Client | California Dreamers Inc.
Principal Type | Parsons

V1 **S2** **D3** L4 M5 M6 J7 V8 **S9** **D10** L11 M12 M13 J14 V15 **S16** **D17** L18 M19 M20 J21 V22 **S23** **D24** L25 M26 M27 J28 V29 **S30** **D31**

Typography/Design	John Gorham
Typographic Supplier	Face Photosetting
Calligraphy/Illustration	Michael Foreman
Client	Face Photosetting, Paris/London
Principal Type	News Gothic
Dimensions	16 x 12 in. (40.3 x 30.5 cm)

193

Typography	Stephen Sieler
Design	Robert Miles Runyan
Typographic Supplier	Composition Type
Studio/Client	Robert Miles Runyan & Associates
Principal Type	Helvetica

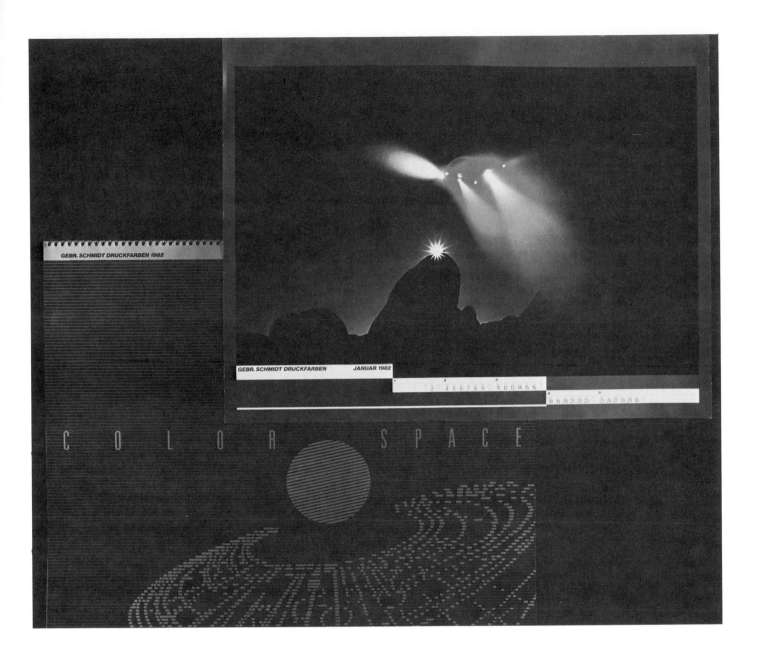

Typography/Design	Olaf Leu/Fritz Hofrichter
Typographic Supplier	Team '80 GmbH, Frankfurt/Main
Calligraphy/Studio	Olaf Leu Design & Partner
Client	Druckfarbenfabriken
	Gebr. Schmidt GmbH
Principal Type	Heads: Univers 49
	Body: Helvetica
Dimensions	25 x 20 in. (63 x 51 cm)

GRAPHIC COMMU- NICATION '80s

Edward M. Gottschall

Typography/Design	Jurek Wajdowicz
Typographic Supplier	Type by Battipaglia Inc.
Studio	Jurek Wajdowicz
Client	Prentice-Hall Inc.
Principal Type	Heads: ITC Franklin Gothic/ Helvetica Compressed Body: Memphis
Dimensions	8¾ x 11 in. (22 x 28 cm)

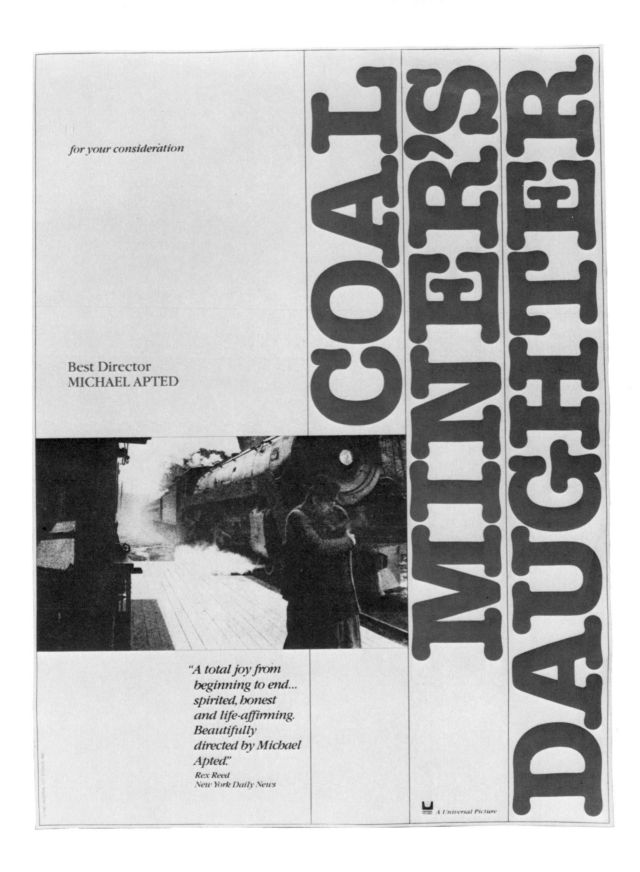

for your consideration

Best Director
MICHAEL APTED

"A total joy from
beginning to end...
spirited, honest
and life-affirming.
Beautifully
directed by Michael
Apted."
Rex Reed
New York Daily News

COAL MINER'S DAUGHTER

A Universal Picture

Typography/Design	Anthony Goldschmidt/ Judith Nissenbaum
Typographic Suppliers	Bill Johnson/ Fotoset of California
Studio	Intralink Film Graphic Design
Client	Universal Studios
Principal Type	American Typewriter Bold
Dimensions	10¼ x 14 in. (26 x 36 cm)

197

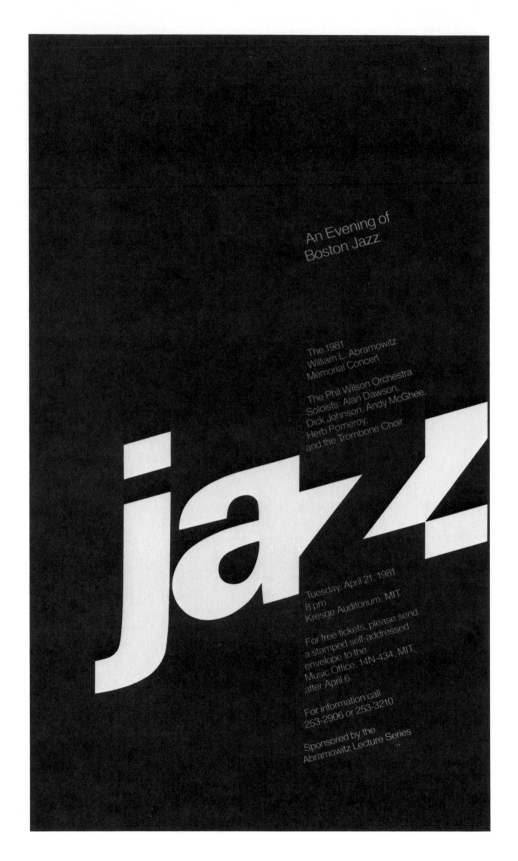

Typography/Design/Calligraphy	Ralph Coburn
Typographic Supplier	Typographic House
Studio	MIT Design Services
Client	MIT, Humanities Department
Principal Type	Helvetica
Dimensions	12⅝ x 22 in. (32 x 56 cm)

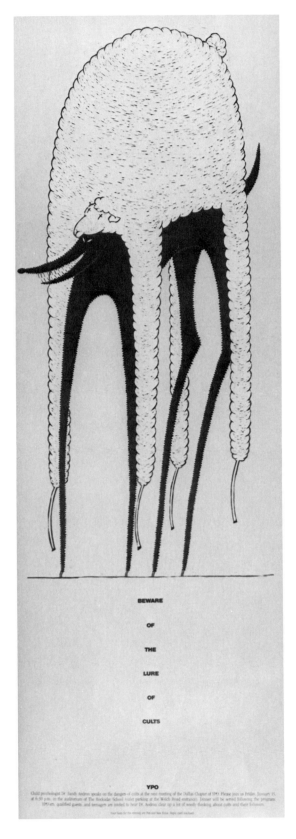

Typography/Design	Chris Rovillo
Typographic Supplier	Typographics
Studio	Richards, Sullivan, Brock & Associates
Client	Young Presidents Organization
Principal Type	Heads: Helvetica Black
	Body: Garamond Light Condensed
Dimensions	12 x 36 in. (31 x 91 cm)

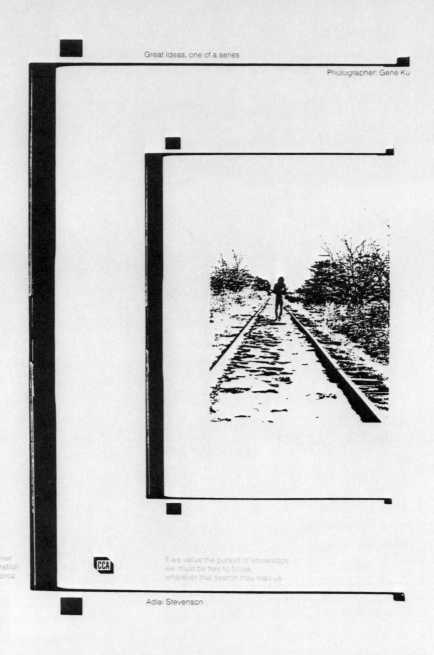

Great Ideas, one of a series

Photographer: Gene Ku

Container
Corporation
of America

CCA

If we value the pursuit of knowledge
we must be free to follow
wherever that search may lead us

Adlai Stevenson

Typography/Design	John Massey
Typographic Supplier	RyderTypes
Studio	CCA Communications Department
Client	Container Corporation of America
Principal Type	Helvetica
Dimensions	11 x 14 in. (28 x 36 cm)

200

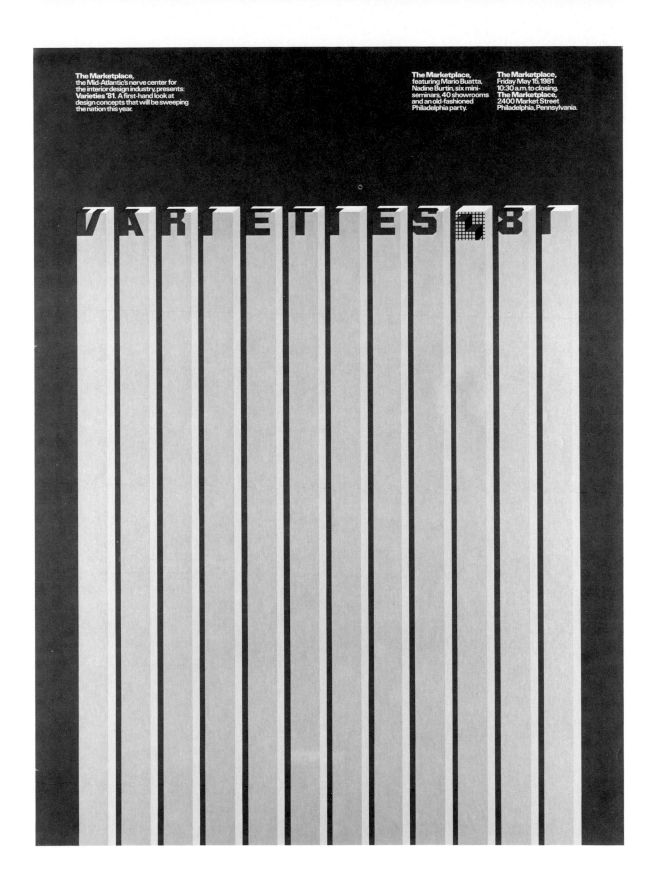

The Marketplace,
the Mid-Atlantic's nerve center for
the interior design industry, presents:
Varieties '81. A first-hand look at
design concepts that will be sweeping
the nation this year.

The Marketplace,
featuring Mario Buatta,
Nadine Burtin, six mini-
seminars, 40 showrooms
and an old-fashioned
Philadelphia party.

The Marketplace,
Friday May 15, 1981
10:30 a.m. to closing.
The Marketplace,
2400 Market Street
Philadelphia, Pennsylvania.

Design	Robert Cooney
Typographic Supplier	JCH Graphics
Calligraphy	Gregg Sibert
Studio	R. A. Cooney, Inc.
Client	The Marketplace in Philadelphia
Principal Type	Helvetica
Dimensions	24 x 32 in. (61 x 81 cm)

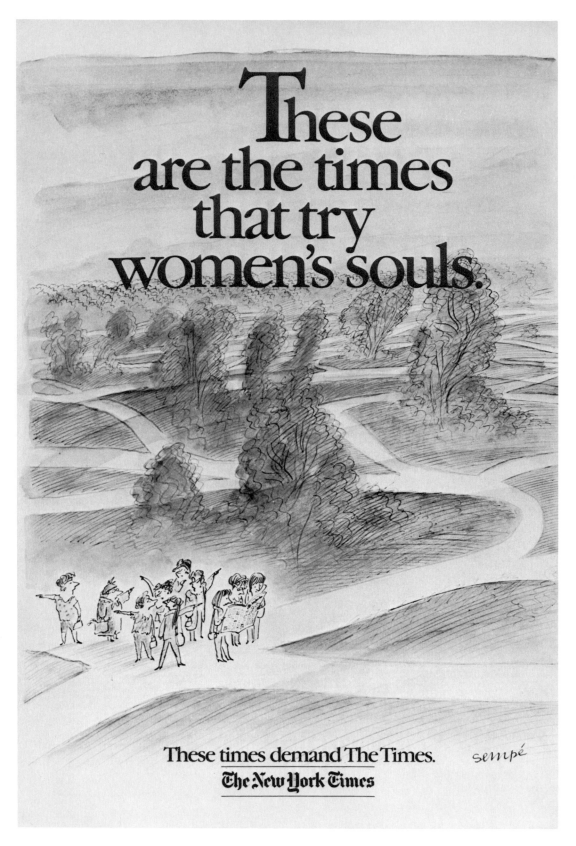

Typography	Bonnie Hazelton
Design	Ira Madris/Bruce Nelson
Typographic Supplier	Photo-Lettering Inc.
Agency	McCann-Erickson
Client	*The New York Times*
Principal Type	ITC Garamond Book
Dimensions	10½ x 15½ in. (27 x 39 cm)

Typography/Calligraphy	Tim Girvin
Design	Chris Spivey
Studio	Tim Girvin Design
Client	Davidson Galleries
Dimensions	28 x 22 in (71 x 56 cm)

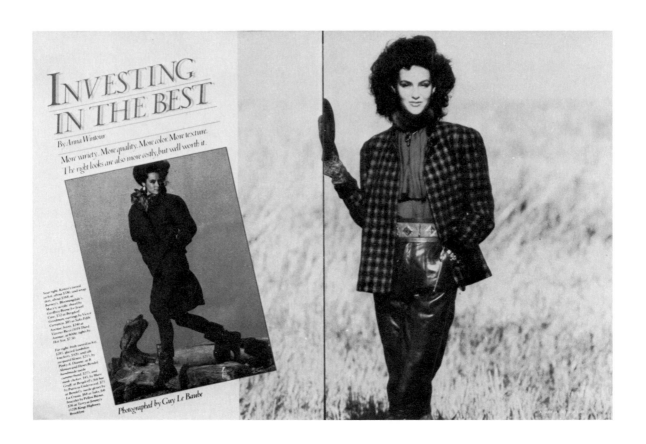

INVESTING IN THE BEST

By Anna Wintour

More variety. More quality. More color. More texture.
The right looks are also more costly, but well worth it.

Photographed by Guy Le Baube

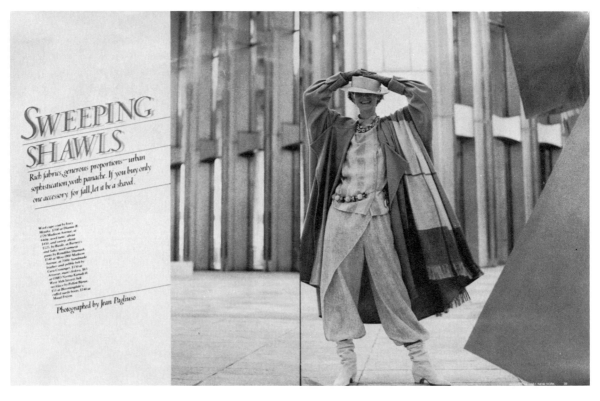

SWEEPING SHAWLS

Rich fabrics, generous proportions—urban
sophistication, with panache. If you buy only
one accessory for fall, let it be a shawl.

Photographed by Jean Pagliuso

Typography	Patricia Bradbury
Design	Robert Best
Typographic Supplier/Client	*New York* magazine
Principal Type	Heads: Centaur Italic
	Body: Life Italic

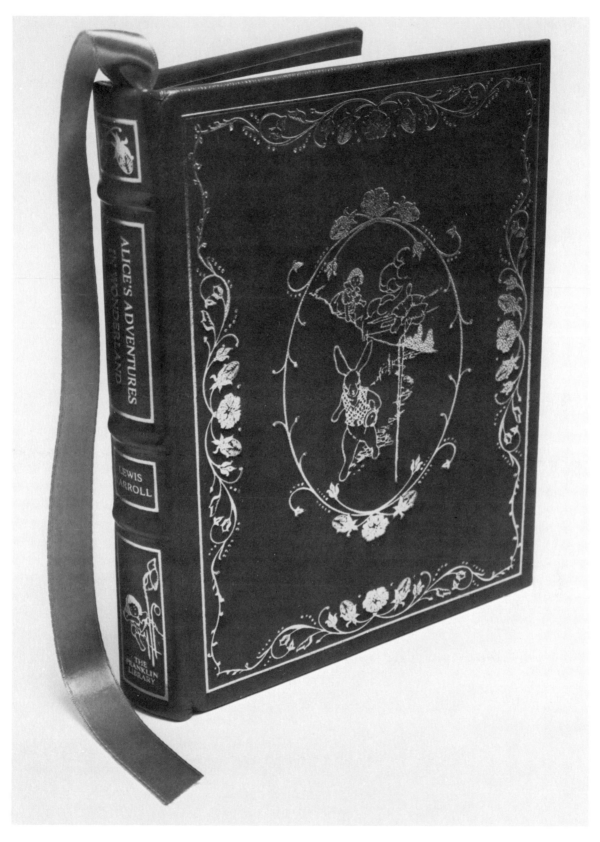

Typography Design	M. Jane Heelan
Typographic Suppliers	Waldman Graphics/RyderTypes
Clients	The Franklin Library/ Sloves Bindery
Principal Type	Heads: Lys Calligraphic Body: Baskerville
Dimensions	5¾ x 7¾ in. (14 x 19 cm)

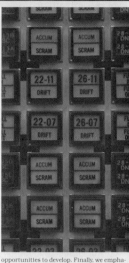

development of our technical and management personnel and the maintenance of Impell's values and successful style of operating.

Recognizing the Company's critical dependence upon quality people for continued success, we continue to emphasize the area of human resources to meet the future management and technical manpower needs of the Company. This effort is given substance by the strict adherence to some basic values. First, we set high performance standards and measure achievement against those standards. Second, we candidly critique individual performance to assure steps are taken to achieve improvement. Third, we draw sharp distinction between average and outstanding performance in our compensation and recognition decisions. Fourth, we move quickly and decisively on inadequate performers so high potential individuals do not become discouraged while waiting for opportunities to develop. Finally, we emphasize the philosophy of giving individuals additional responsibilities as fast as they demonstrate the ability to absorb them.

A goal of our personnel development strategy is to encourage our managers to be the primary developers of their subordinates.

 Public utilities with operating nuclear power plants are placing increasing emphasis on the development of emergency plans to comply with regulations promulgated as a result of experiences at Three Mile Island. We developed expertise in this new service area and have prepared programs for several utilities.

The need to evaluate reliability of existing operating nuclear power plants which were designed under older criteria has given rise to a new service area called reliability and risk assessment. Sophisticated engineering analysis is necessary to assess the reliability of these plants in order to avoid unnecessary costly in-plant modifications.

Typography/Design	Michael Barile/ Richard Garnas
Typographic Supplier	Spartan Typographers
Agency	Landor Associates
Client	Impell Corporation
Principal Type	ITC Bookman
Dimensions	8½ x 11 in. (22 x 28 cm)

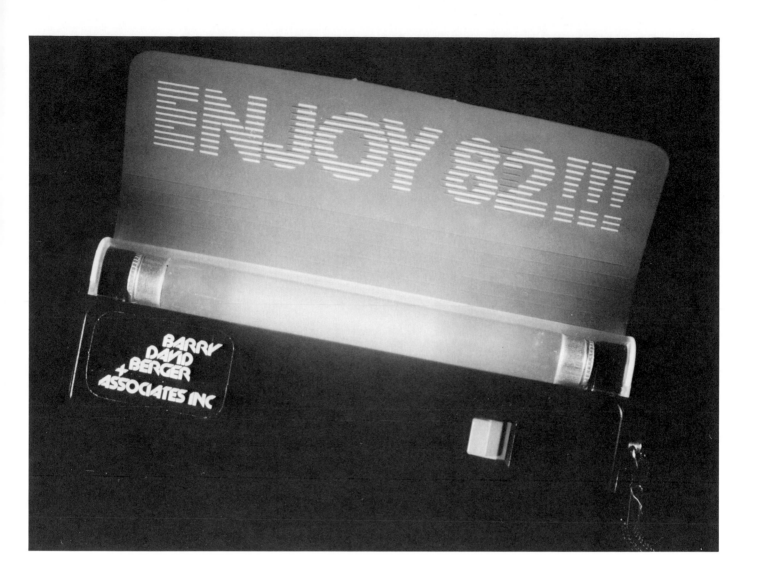

Typography	Sharon Reiter Lindberg
Design	Barry David Berger
Typographic Suppliers	Gerard Associates/
	Phototypesetting, Inc.
Studio/Client	Barry David Berger
	+ Associates, Inc.
Principal Type	Avant Garde
Dimensions	6⅛ x 4⅜ in. (16 x 11 cm)

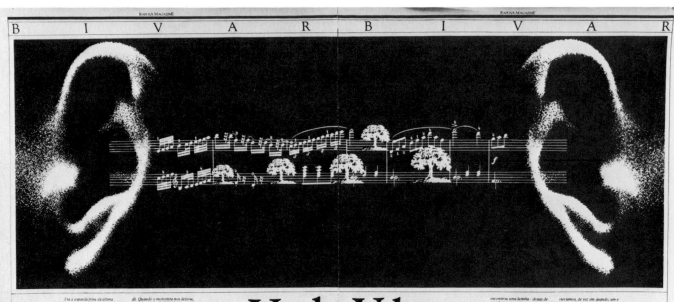

Verdes Vales do Fim do Mundo.

Memórias de um Festival

Typography/Design | Oswaldo Miranda (Miran)
Typographic Supplier | Digital
Studio | Miran Studio
Client | *Raposa* newspaper
Principal Type | Heads: Goudy Old Style
 | Body: Times New Roman Italic
Dimensions | 21¼ x 13⅜ in. (54 x 34 cm)

BRIEM AT CITY & GUILDS

LETTERFORM STUDIES: LECTURES, DISCUSSIONS, WORKSHOP

GUNNLAUGUR SE BRIEM
AT THE CITY AND
GUILDS OF LONDON
ART SCHOOL
124 KENNINGTON PARK
ROAD LONDON SE11

TELEPHONE 735 2306
BEFORE 23 MARCH

Calligraphy	Gunnlaugur SE Briem
Studio	Second Hand Press
Client	City & Guilds
	of London Art School
Dimensions	20 x 30 in. (51 x 76 cm)

TYPE DIRECTORS CLUB OFFICERS

1981–1982

President	Bonnie Hazelton
First Vice President	Stanley Markocki
Second Vice President	Gene Krackehl
Secretary	John Luke
Treasurer	Roy Zucca
Governor-at-Large	Jack George Tauss
Chairman Board of Governors	William Streever

TYPE DIRECTORS CLUB OFFICERS

1982–1983

President	Jack George Tauss
First Vice President	Klaus Schmidt
Second Vice President	John Luke
Secretary	Bob Knecht
Treasurer	Roy Zucca
Governor-at-Large	Stanley Markocki
Chairman Board of Governors	Bonnie Hazelton

COMMITTEE FOR TDC-28

Chairperson	Klaus Schmidt
Co-Chairperson, Design	Lucy Tuttle
Co-Chairpersons, Operations	Roy Zucca, Stan Markocki
Coordinator	Jerry Singleton
Assistant Coordinators	Joan Kan, Walter Pretzat, Walter Stanton
Typographic Supplier	Pastore DePamphilis Rampone Inc.
Printing	Milo Press
Calligraphy	Robert Boyajian
Receiving Facilities	Ad Agencies/Headliners
Traffic	Jay Berman
Operations Assistants	Jeff Biscardi, Jane Blömquist, Derek Dalton, David Gatti, Neil Goldwasser, Bonnie Hazelton, Rachel Katzen, Peggy Kiss, Caryn Dickman, Zoltan Kiss, John Luke, Walter Pretzat, Jack Robinson, Ena Schmidt, Lucy Tuttle, Cameron Williams, Hal Zamboni

Some of the previous TDC
Exhibits are available in
32-page Catalog form at $1.50
each, postpaid.
See Type Directors Club
address.

TYPE DIRECTORS CLUB
60 East 42nd Street
New York, N.Y. 10165
212-867-2290
Bernard J. Ellis, Executive Secretary

TYPE DIRECTORS CLUB MEMBERSHIP

George Abrams
Kelvin J. Arden
Leo Avila
Leonard F. Bahr
Don Baird
Arnold Bank**
Clarence Baylis
Edward Benguiat
Ted Bergman
Peter Bertolami
Emil Biemann
Godfrey Biscardi
Roger Black
Art Boden
Friedrich Georg Böes
David Brier
Ed Brodsky
Werner Brudi
Bernard Brussel-Smith*
Bill Bundzak
Aaron Burns
Joseph F. Camolli
Tom Carnase
Alan Christie
Edmund Cleary
Travis Cliett
Mahlon A. Cline*
Tom Cocozza
Robert Adam Cohen
Freeman Craw*
James Cross
Ray Cruz
Derek Dalton
Ismar David
Whedon Davis
Robert Defrin
Cosmo DeMaglie
Ralph DiMeglio
Louis Dorfsman
John Dreyfus**
William Duevell
Curtis Dwyer
Joseph M. Essex
Eugene Ettenberg*
Elizabeth Fabian
Bob Farber
Sidney Feinberg*
Roger Ferriter
Holley Flagg
Glenn Foss*
Mari E. Fox

Dean J. Franklin
Adrian Frutiger**
David Gatti
Stuart Germain
Vincent Giannone
Lou Glassheim*
Howard Glener
Edward Gottschall*
Sandi Governale
Norman Graber
Austin Grandjean
Allan Haley
Edward A. Hamilton
Mark L. Handler
Sherri Harnick
Horace Hart
Bonnie Hazelton
Thomas Henshaw
Diane L. Hirsch
Fritz Hofrichter
Glenn Hughes
Russell Ingui
Donald Jackson**
Mary Jaquier
Allen Johnston
R. M. Jones
R. Randolph Karch**
Rachel Katzen
Louis F. D. Kelley
Michael O. Kelly
Tom Kerrigan
Lawrence Kessler
Wilbur King
Peggy Kiss
Zoltan Kiss
Robert Knecht
Steve Kopec
Gene Krackehl
Bernhard J. Kress
James Laird
Jean Larcher
Mo Lebowitz
Arthur Lee*
Acy R. Lehman
Robert Leslie**
Olaf Leu
Irving Levine
Ben Lieberman
Clifton Line
Wally Littman
John Howland Lord*

Anthony Loscalzo
John Luke
Ed Malecki
Sol Malkoff
Marilyn Marcus
Stanley Markocki
John S. Marmaras
Frank Marshall III
James Mason
Jack Matera
John Matt
Frank Mayo
Fernando Medina
Douglas Michalek
R. Hunter Middleton**
Paul D. Miller
John Milligan
Oswaldo Miranda
Deborah J. Mix
Barbara Montgomery
Ronald Morganstein
Minoru Morita
Tobias Moss*
Ted Muldoon
Leslie Mullen
Keith Murgatroyd
Louis A. Musto
Alexander Nesbitt
Ko Noda
Jack Odette
Thomas Ohmer
Motoaki Okuizumi
Brian O'Neill
Gerard J. O'Neill*
John H. Ott
Professor G. W. Ovink**
Zlata W. Paces
Robert C. Parmelee
Luther Parson
Charles W. Pasewark
Eugene P. Pattberg
Raymond Pell
Roma Plakyda
Jan van der Ploeg
George Podorson
Roy Podorson
Ann Pomeroy
Louis Portuesi
Janice M. Prescott
David Quay
Erwin Raith

Ed Richman
Jack Robinson
Edward Rondthaler*
Robert M. Rose
Herbert M. Rosenthal
John Rynerson
Sal Sabaj
Gus Saelens
Fred C. Salamanca
Bob Salpeter
David Saltman
Arthur Sammartino
John N. Schaedler
Klaus F. Schmidt
Michael G. Scotto
Sheldon Seidler
William L. Sekuler*
Lorna Shanks
Elizabeth Sheehan
Julie Silverman
Richard Silverman
Martin Solomon
Harvey R. Spears
Vic Spindler
John Sposato
Robert Spurgeon
Walter Stanton
Herbert Stoltz
William Streever
Rick Stubbins
Ken Sweeny
William Taubin
Jack George Tauss
Don Taylor
Anthony J. Teano
Bradbury Thompson
Professor Georg Trump**
Lucy Tuttle
Edward Vadala
Eileen Vincent-Smith
Jurek Wajdowicz
Herschel Wartik
Kurt Weidemann
Ken White
Cameron Williams
Hal Zamboni*
Hermann Zapf**
Carl Zeichner
Roy Zucca
Milton Zudeck*

SUSTAINING MEMBERS

Ad Agencies/Headliners
Arrow Typographers Inc.
M. J. Baumwell Typography
Cardinal Type Service, Inc.
Compugraphic Corporation
Craftsman Type Inc.
Gips + Balkind + Associates, Inc.
Harris Composition Systems
International Typeface Corp.
Mergenthaler Linotype Company
Pastore · DePamphilis · Rampone

Photo-Lettering Inc.
Royal Composing Room
Spindler Slides
Techni-Process Lettering
Tri-Arts Press Inc.
TypoGraphics Communications Inc.
TypoGraphic Designers
Typographic House, Boston
Typographic Innovations Inc.
Typovision Plus
U.S. Lithograph Inc.

*Charter Member **Honorary Member

AGENCIES

CALLIGRAPHY

TYPOGRAPHIC SUPPLIERS

CALLIGRAPHY/ ILLUSTRATION
❦

STUDIOS
❦

CLIENTS
❧